SACRED LANDS OF INDIAN AMERICA

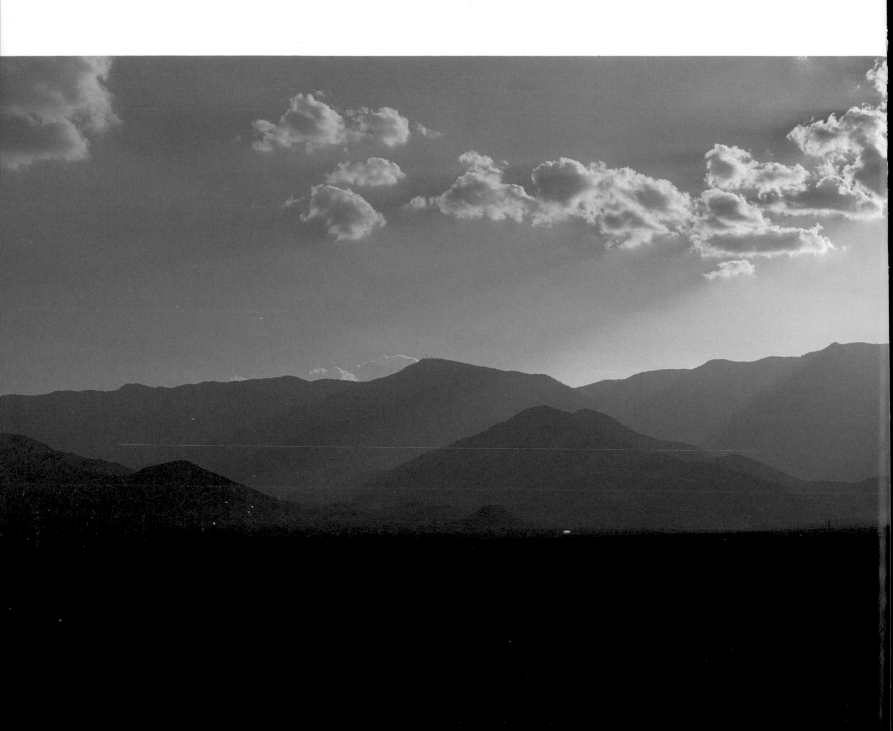

SACRED LANDS
OF INDIAN AMERICA

Edited by Jake Page

Foreword by Charles E. Little

Photography by David Muench

Text by Charles E. Little, Jake Page, and Ruth Rudner

Essays by Paula Gunn Allen, Rennard Strickland, and James Parks Morton

This book is a Liveoak Edition, created by the Center for American Places, a geographical research and conservation organization established in 1990 and devoted to enhancing public understanding of our heritage of land, landscape, and community. Research, creative work, and educational activities are supported by foundation grants and individual contributions. For further information write Liveoak Editions, Center for American Places, P.O. Box 917, Placitas, NM 87043, or visit the website, www.liveoak.org.

for Liveoak Editions

Designer	Tom Suzuki
Picture Editor	Susanne Page
Assistant Designers	Hea-Ran Cho
	Connie Dillman
Managing Editor	Janice M. Fowler
Copy Editor	Karen Taschek

for Harry N. Abrams, Inc.

Project Manager	Robert Morton

Frontispiece: Arizona's Mount Graham rises over the San Simon Valley, former Apache country.

Library of Congress Cataloging-in-Publication Data

Little, Charles E.

Sacred lands of Indian America / text by Charles E. Little, Jake Page, and Ruth Rudner; essays by Paula Gunn Allen, Rennard Strickland, and James Park Morton; David Muench, photography; edited by Jake Page.

 p. cm.

 ISBN 0-8109-0603-1

1. Indians of North America—Religion. 2. Sacred space—United States. 3. Indians of North America—Land tenure. I. Page, Jake. II. Rudner, Ruth. III. Muench, David. IV. Title.

E98.R3 L357 2001

299'.793—dc21

2001001350

Harry N. Abrams, Inc.

100 Fifth Avenue

New York, N.Y. 10011

www.abramsbooks.com

CONTENTS

From the Land, Gifts of the Spirit

As part of a centuries-old pilgrimage, Hopi priests pause on the South Rim of Grand Canyon to pray on behalf of a sacred deposit of salt below.

THIS IS A BOOK OF GIFTS—gifts of the spirit of the land, such as the time, twenty years ago, when the photographer Susanne Page, along with her husband, Jake, was invited to accompany several Hopi priests to document for *National Geographic* magazine a sacred pilgrimage that Hopis have made for a millennium. The Pages were taken to eight special shrines that defined the ancestral Hopi lands, their *tusqua,* a very large area of northern Arizona for which the Hopis feel spiritually responsible. The precise locations of the shrines—atop a mountain, alongside a stream, at the base of a red-rock cliff—are known to only a handful of priesthood people who every four years set out (formerly on foot, and today in automobiles) to place prayer feathers called *pahos* and deposit cornmeal, spirit food, at the eight shrines.

The pilgrimage is itself a gift to the world, and Susanne and Jake were honored and profoundly moved, just as those of us who have written chapters of this book about other sacred places have been moved. We have been given the opportunity to tell the stories of American Indian sacred lands, and we are deeply grateful. To be sure, we've covered only a small number of them, but perhaps enough, eighteen, to give the reader a sense of their significance and of the necessity that these lands, and the culture they represent, be respected and preserved. To provide perspective on our reportage (by Jake Page, Ruth Rudner, and me) essayists Paula Gunn Allen and Rennard Strickland write of their struggle as American Indians to maintain their identity and

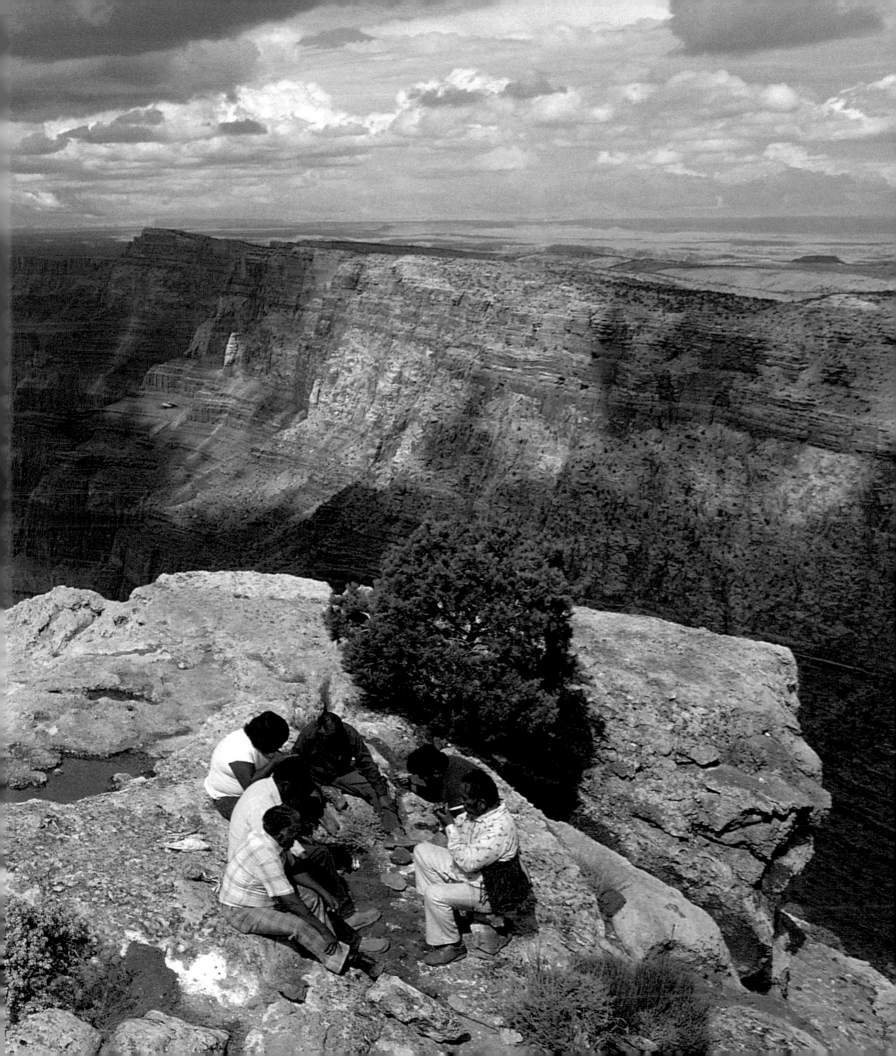

spiritual connection to the land despite the odds offered by the modern world. At the end of the book, the Very Reverend James Parks Morton makes a plea to people of all faiths to extend their homage to American Indian sacred lands.

Please understand that the places we are writing about are not just natural areas, however they may be valued as such. They are holy places—lands associated with particular origin myths, or considered to be portals to the spirit world, or revered as traditional cultural sites. Sometimes a place is all three of these. What is more, they are not remnants of bygone days. They are all places presently used by Native Americans for ceremonial purposes. They are, therefore, religious sites, sanctuaries in a very real sense.

How is it, then, that what is called the "dominant culture" of our society, which prides itself on its religious sensibility, has spurned these cathedrals of the spirit? For it is an absolute certainty that as I write these words a bulldozer is digging up an ancient shrine somewhere, a sacred cliff is being dynamited, a hallowed stream diverted, in order to put it to "practical" use.

One of poet W. H. Auden's better aphorisms makes the point cogently. "The value of a profane thing," he writes, "lies in what it usefully does. The value of a sacred thing lies in what it *is*." The book you are now holding in your hands is all about that distinction—the tension between profanity and sacredness when it comes to the sacred lands of Indian America.

For me, understanding concretely the difference between the sacred and the profane came about through a pilgrimage of my own, an event that led directly to the creation of this book. The pilgrimage—with many kindred souls—took place because the owner of several thousands of acres of desert land west of Albuquerque, New Mexico, thought he could cash in on the growth of that city by getting the politicians to build a road through the Petroglyph National Monument, a sacred landscape that has been used for religious observances by southwestern Indians for more than one hundred generations.

In the fall of 1997 when I was working with the New Mexico Conference of Churches, a group of young Indian activists asked for help in fighting off the road-building plan, and our committee agreed. So with our new friends, we organized an interfaith "Petroglyph Pray-in" despite the fact that most local, state, and federal officials did not see what all the fuss was about or even cared that there was one. The petroglyphs covered a large area, after all, and just one highway would be built through it.

Even so, 200 faithful showed up in the middle of a late-spring snowstorm in 1998. After the ceremony I asked the young pray-in organizers if other American Indian sacred places like the petroglyphs had received such short shrift from politicians and others in government. Rueful smiles all around. They handed me a long list of similarly threatened sites prepared by the Indigenous Environmental Network. That list became the starting point for this book.

For the New Mexico Conference of Churches, supporting the Pueblo Indians' plea not to destroy the integrity of their sacred landscape wasn't easy and very nearly led to a sectarian rupture in the conference. One powerful board member hailed our committee before a board meeting and demanded that the Conference of Churches apologize for the pray-in and disassociate itself from the religious observances we had organized. He said that if a highway were not built through the sacred petroglyphs, the road in front of his church might have to be widened (actually it would not). The widening would take, he claimed, about 20 feet of his asphalted parking lot.

"That's sacred land, too," he said.

By the time the pastor was finally winding up—something condescending about "a young Indian girl" who had come to plead with him—I was furious, but I left without saying a word. There's a maxim to the effect that "living well is the best revenge." I've never subscribed to that view: justice, not revenge, should be the goal. For me the way to bring out the truth, and to set things straight, is with books. Let us produce a book, I thought, that will tell the story of American Indian sacred lands with as much impact as possible—with the best reporting, with the most powerful essays, with the most affecting photographs that could be found.

For such a job, I needed a little help from my friends. In fact, a lot of help. So I asked George F. Thompson, president of the Center for American Places, to loan me his tax-exempt organization to establish the publishing program we now call Liveoak Editions. I contacted David Muench in California, the finest of our landscape photographers. I got in

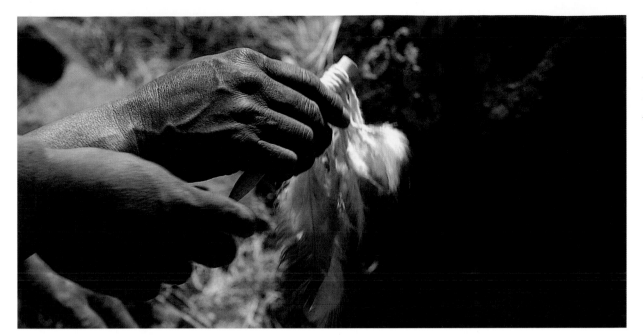

touch with another colleague, Ruth Rudner of Bozeman, Montana, who had written a long, impressive article on sacred lands in the Northern Rockies and Great Plains for *Wilderness* magazine. I asked Tom Suzuki of Fairfax, Virginia, a former art director of Time-Life Books and a Fellow of the American Institute of Graphic Arts, to design our book.

And, most fortuitously of all, I went to see Susanne and Jake Page. As it turned out, Susanne, photographer of the Indians of the Southwest and elsewhere, served as our picture editor; and in Jake Page, founder-director of Smithsonian Books and a frequent writer on American Indian history, we had an experienced picture book editor at the helm. Soon enough, we received a wonderful start-up grant from the Pleasant T. Rowland Foundation and found our co-publisher, Harry N. Abrams, Inc., of New York.

For nearly three years this has been our book. But now it is yours. I should like to make a suggestion to you. Think of this volume as a two-by-four—a book that can be used to get the attention of people who make a difference—the members of Congress, the federal and state officials, the business and civic leaders who have all too often demonstrated a woeful ignorance about the loss of sacred land.

This vaguely subversive activity is part of what we call "the Liveoak Idea"—to create books, in partnership with other nonprofit organizations, not only to get the word out on land conservation issues of importance, but also to encourage decision-makers to take action. In the case of *Sacred Lands of Indian America,* our partners include the Indigenous Environmental Network, the Indigenous Women's Network, the SAGE Council, the Seventh Generation Fund, and the Native American Land Conservancy. We are grateful and honored to be working with these important Native American organizations, especially as we move to the next phase of our project, which is to promote new policies that will help preserve sacred lands.

A final word. During the Persian Gulf War in 1990, the United States government ordered its pilots to avoid harming Muslim religious sites even though this might prolong the war and cost millions of dollars. At that time Peterson Zah, the president of the Navajo Nation, the largest tribe of American Indians, wondered aloud about an odd inconsistency he saw in this otherwise admirable military order.

Isn't it strange, he observed, that the restraint implicit in such orders to avoid destroying sacred places is not accorded by the United States government to its own citizens, the American Indians? "Respect," said Peterson Zah, "should be given to a religion that does not involve going to church one day a week, but...whose church is the mountains, rivers, clouds, and sky."

I don't think that is too much to ask. Do you?

Charles E. Little
Director, Liveoak Editions

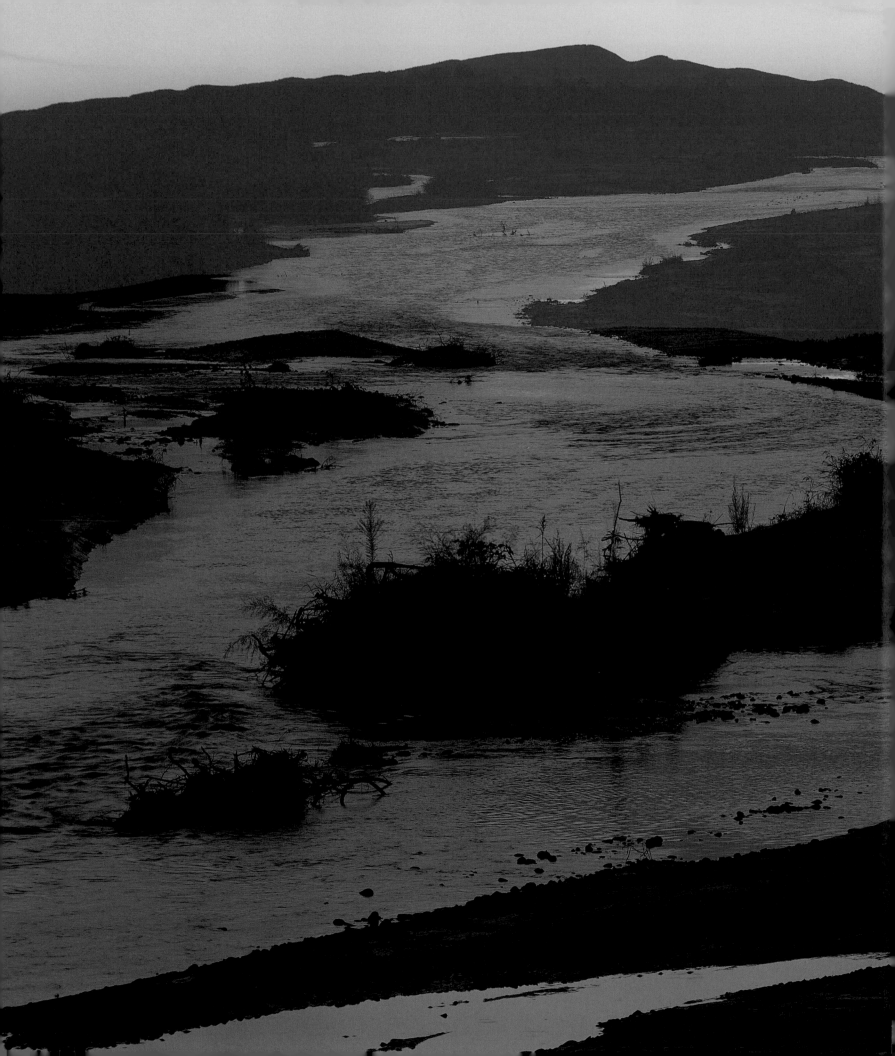

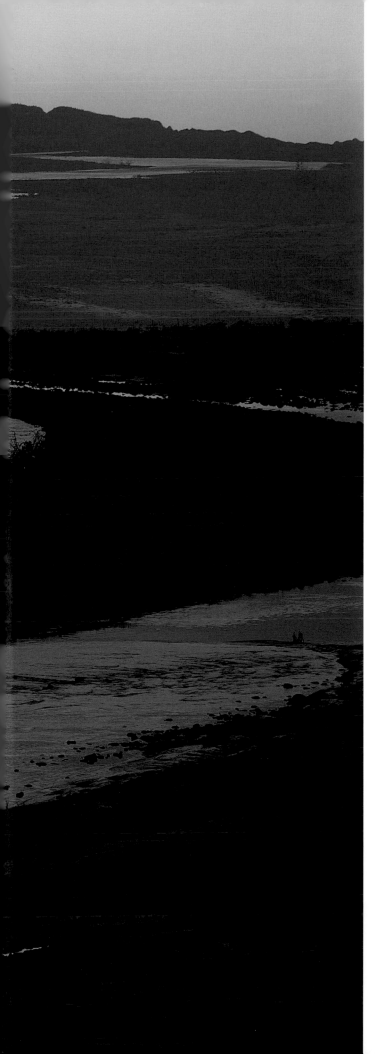

Contested by astronomers, wildlife conservationists, and Apaches and a pawn of national politics, Mount Graham appears serene, looming above a free-flowing stretch of the Gila River in southern Arizona.

THE CONQUEST OF EMERALD PEAK

San Carlos Apache

I encourage you as native people belonging to the different tribes and nations in the East, South, West, and North to preserve and keep alive your cultures, your languages, the values and customs which have served you well in the past and which provide a solid foundation for the future.

—Pope John Paul II,
speaking in Phoenix, Arizona,
September 14, 1989

Every now and then the sky over Emerald Peak in southern Arizona is so clear you are sure a sharp noise could make it crack and descend in a cataract of starlit fragments. And that is the problem. For Emerald Peak, one of several peaks that make up Mount Graham in the Coronado National Forest northeast of Tucson, seemed like a good place to observe the heavens.

So it was that Emerald Peak, beginning in the late 1980s, became the center of a controversy involving more conflicts of interest than a Shakespeare tragedy, a tale dripping with irony and awash in that most corrosive of human sins, hypocrisy. Among the players were Big Science (the astronomy community, represented by the University of Arizona), Big Government (the U.S. Congress and the Fish and Wildlife Service), Big Religion (the Vatican), and their perpetual handmaiden, Big Money. These forces were ranged against a few hundred red squirrels, resident on Mount Graham and a U.S. endangered species, and some mountain spirits who taught the San Carlos Apaches to hunt long ago and who since then had not

The Heinrich Hertz
Submillimeter
Telescope rises in
fearful symmetry
through the forest of
Emerald Peak on
Mount Graham.

had the forethought to leave physical footprints on the mountain as proof of their existence.

Beginning in the 1970s, the University of Arizona set out to put together a consortium of institutions to build a $200 million, seven-telescope observatory and, having canvassed available sites, decided on Mount Graham as the ideal spot. In fact, the university had first picked a place on San Francisco Peaks near Flagstaff, but the U.S. Forest Service shot that idea down since the Peaks are sacred to both the Hopi and Navajo tribes as well as the Apaches and others. Then they tried Mount Baldy in southern Arizona, but the White Mountain Apache owned the top of the mountain and said no.

Mount Graham is in fact subject to a lot of cloud cover, wind, and thunderstorms, and in a National Science Foundation study of fifty-seven likely astronomy sites, it ranked thirty-eighth. It enjoys good viewing conditions only 60 percent of the time…but never mind. And never mind, too, that this was a time when the orbiting Hubble Telescope was under construction, a multi-*billion*-dollar project designed and sold as the instrument that would render all land-based telescopes passé.

By 1987, it was clear that Mount Graham presented a knotty non-astronomical problem: the endangered red squirrel population. Arizona senator John McCain came to the rescue in 1988, pushing the Congress to grant an exemption to the endangered species law, allowing the observatory to proceed. The construction of such installations brings megabucks into the state, along with a huge annual stipend for operating costs. At the time, one member of the consortium was the Smithsonian Institution, another was Ohio State University, and a third was the Vatican Observatory. When it became clear that Mount Graham involved not only an endangered species but a sacred Indian site, the Smithsonian, which not only does astronomy

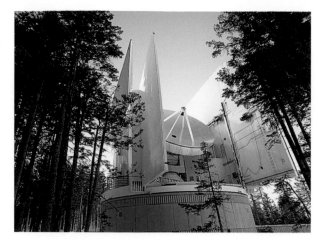

but natural history and was also in process of founding a national Indian museum, backed out. Ohio State also opted out, but the Max Planck Institute of Germany joined up and the Vatican persevered with missionary fervor with the project, by then sensitively called the Columbus Project (for a figure who is not among the panoply of Apache or other American Indian culture heros).

In 1989, a sixty-six-year-old Apache woman, Ola Cassadore-Davis, founded the Apache Survival Coalition to stop the project. The San Carlos Apache tribal council unanimously affirmed that the mountain was central to Apache beliefs and gave Cassadore-Davis's group its blessing. In 1991, the Apache Survival Coalition sued the Forest Service to stop the building of observatories on what the world began to learn was called *Dzil Nchaa Si An* (Big Seated Mountain), the home of *Ga'an*, the Apache mountain gods. It is dotted here and there with some unnoticeable shrines (Apaches have always traveled light, leaving little behind for archeologists).

At this time, Pope John Paul himself was calling for respect for the traditions of indigenous peoples, and condemning both the degradation of ecosystems and the rampant and unconsidered spread of science and technology. But he had already blessed the Vatican Observatory's role in the Columbus Project. The debate, the building of observatories, and the court squabbles continued. In early 1992, Father George V. Coyne, head of the Vatican Observatory, wrote that the Apaches had failed to convince the Church that Mount Graham "possesses a sacred character which precludes responsible and legitimate use of the land." Indeed, Father Coyne went on record as saying that Apache "reli-

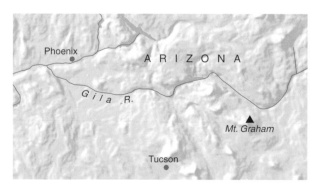

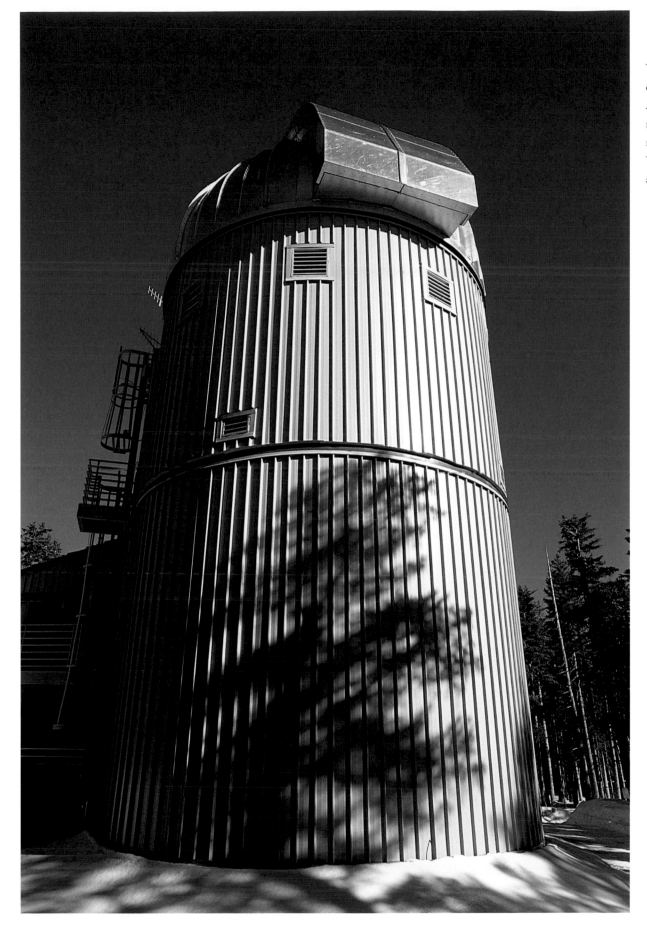

The mountain gods of the San Carlos Apaches, called Ga'an, now must share the mountain with the Vatican's observatories among others.

giosity" should be "suppressed." Pointing out that the mountain had been logged in the past, he went on to say, "In fact, we believe that responsible and legitimate use of the land enhances its sacred character. Land is a gift of God to be used with reason and to be respected." Thus, as one commentator put it, did the Crusades come to Arizona.

At the same time, another Jesuit priest, Father Charles Polzer, a historian at the Arizona State Museum, attacked the findings made by field anthropologists among the Apaches during the first eighty years of the twentieth century: they had all found that Mount Graham was indeed a vital sacred site for the San Carlos people. Father Polzer even denied that the Apaches were mountain people, which is about the same as asserting that the College of Cardinals is made up of Baptists.

Polzer later referred to the opposition to the telescope complex as "part of a Jewish conspiracy," and Father Coyne dismissed the entire matter by announcing that he would only accept physical evidence of religious use such as the foundation of a building that could be a church. Certainly, he announced, he would not accept affidavits from anthropologists who spoke Apache or specialized in Apache culture.

Meanwhile, as various academic departments of the university took sides in the controversy, the university administration (and the astronomers), with a fine modern apostasy, sat mute when it came out in the discovery process before a court hearing that Fish and Wildlife apparatchiks had ordered the department's field biologists that, in analyzing the planned observatory's effect on the red squirrel population, they should find for the observatory, thus traducing the very integrity of science.

Suits and countersuits proceeded and the Vatican went on with its telescope, dedicating it in September 1993. The Germans were not far behind with a second one, and an Italian group was planning theirs. It came out later that the mirror installed in the Vatican's scope was a gift from the U.S. government, having been created in the first place for a failed Star Wars effort. Thus, U.S. taxpayers (a group that includes San Carlos Apaches) helped finance a telescope owned by the world's wealthiest church and self-appointed arbiter of the validity of Apache religion.

Meanwhile, university officials had realized that

the designated spot on Emerald Peak for the third telescope—a complicated $60 million project—was too windy, so they chose another site nearby that was outside the parcel of land originally authorized by Congress. The Fish and Wildlife Service and the Forest Service both eventually okayed the move—without any further resort to Congress. A permanent injunction was soon obtained, but in 1996, Representative James Kolbe (R. Ariz.) attached a rider to the omnibus appropriations bill, exempting the project further from environmental laws. President Clinton was in no position to veto the entire bill, though he had earlier expressed his strong opposition to the measure. That same year saw the House of Representatives specifically exempting Mount Graham (and California's Mount

Shasta) from the laws governing historic preservation of sacred sites on the grounds that they do not exhibit physical remains of sacred events.

In the early 1990s, attempting to sluice a bit of oil on troubled waters, Manuel T. Pacheco, then president of the University of Arizona, wrote a letter to the San Carlos Apache tribal council saying that the university was committed to "assuring that the construction and operation of the Mount Graham telescope project will proceed with the greatest possible respect and deference to San Carlos Apache religious values and interests." On August 30, 1997, Wendsler Nosie, a former tribal council member at San Carlos and a spokesman for Apaches for Cultural Preservation, was leaving *Dzil Nchaa Si An,* where he had gone to pray for his daughter's upcoming ceremonial passage into womanhood in the manner of his ancestors since time immemorial. On his way down, University of Arizona police officers arrested him, ordering him to appear in court for trespassing. He had been using an observatory access road to escape a hailstorm that blew up that day and had no permit to do so from the university or the Forest Service.

Four months later, a Graham County justice of the peace, Linda Norton, dismissed the case, saying the prosecutor was unable to prove that Nosie was knowingly trespassing. While a minor victory, the decision begged the question that persisted into the new millennium: should Apaches be required to obtain a permit to practice their traditional religion? Indeed, should any American? 🪶 JP

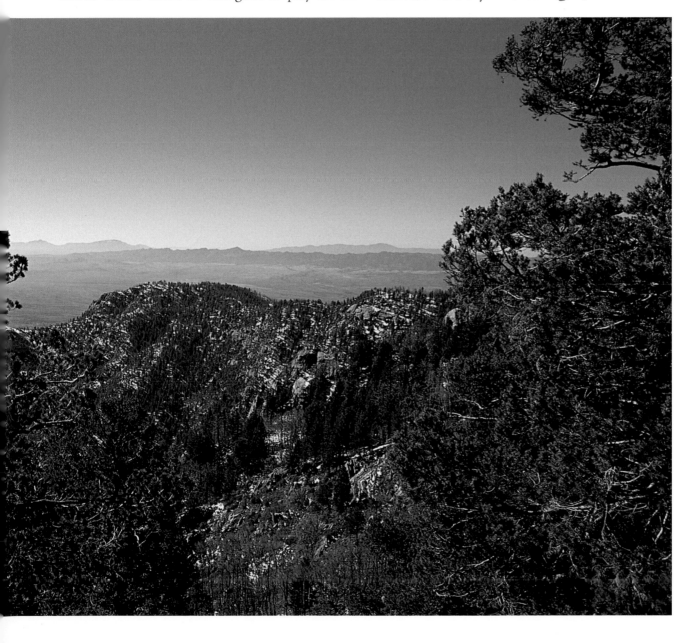

The mountain gods' view from the top of Mount Graham, Coronado National Forest.

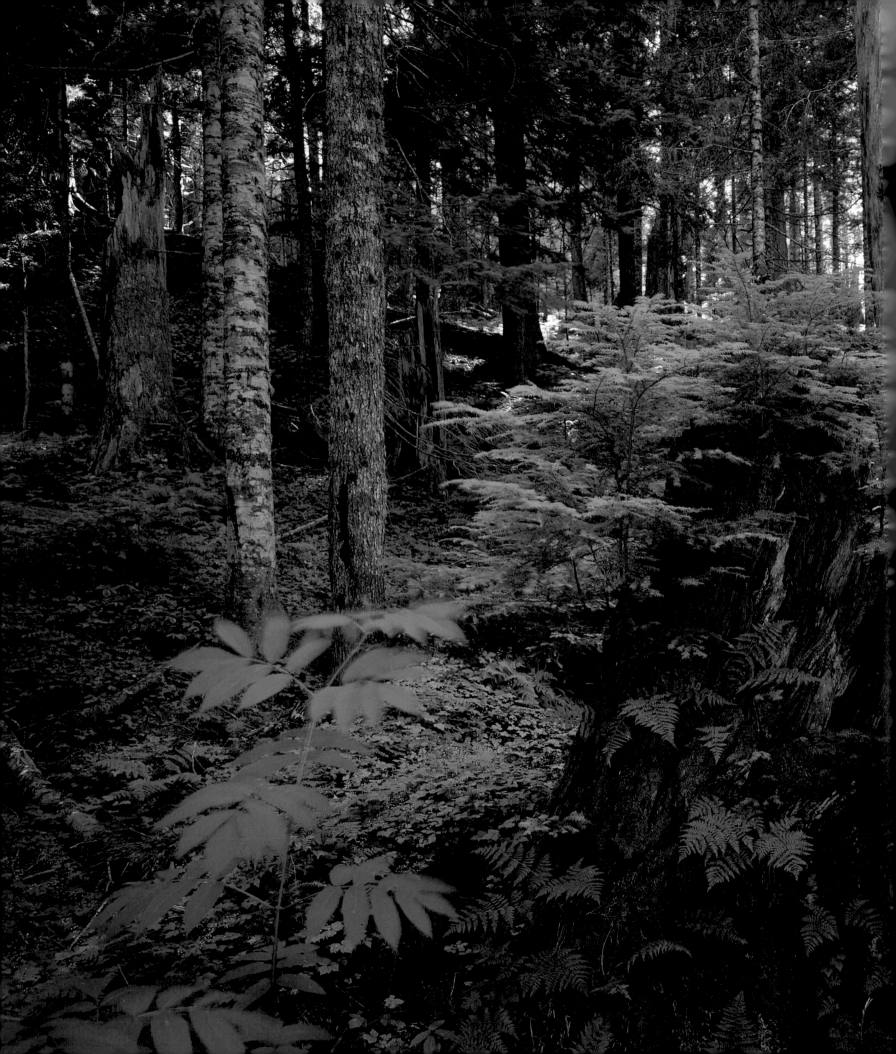

The Lummi Indians have managed to preserve this part of the woods in the Arlecho Creek basin in the Cascades near Washington State's Mount Baker, a lush and to them sacred island of old-growth forest amid widespread clear cutting.

THE SONGS OF ARLECHO

Lummi

Xwám-ik-sten is in prayer, always in prayer in this place, he says. At the moment, his dark eyes are looking inward as well as to the trees, the "standing people" as they are called. He is thirty-eight years old, and he is praying for Cha-das-ska-dum, a Lummi elder who lies struggling with angina on a hospital gurney in Bellingham, Washington, a coastal city fifty miles and, seemingly, several centuries away.

But Cha-das-ska-dum's spirit is not in Bellingham, Xwám-ik-sten says; it has left his body for a while and is here with us, guiding us, in this rare stand of remnant old-growth forest in the otherwise cutover Arlecho Creek basin in the Cascades near Mount Baker. These two Lummi men, a generation apart, had worked themselves to exhaustion in the effort to preserve this traditional place of religious observance and ritual. Xwám-ik-sten, who also goes by the name Tommy Edwards and is a biologist for the Lummi Nation, sings the prayer in his own language in the traditional way, with the hush-hushing syllables of the cedar and salmon tribes. For a non-native visitor, to whom he is showing these woods, Xwám-ik-sten also speaks part of the prayer, saying it in English. Then the song returns, punctuated by the steady beat of his drum, and finally ends. The visitor, greatly moved, says "Amen."

As for the woods of Arlecho, though damaged by the depredations of the clear cutters, its old-growth heart will remain intact, to be protected by a partnership Cha-das-ska-dum helped create between an Indian nation, an Indian college, a major conservation organization, and a forest products company. It is an achievement of incalculable importance to the Lummi Indians, and indeed to all those who find spiritual value and healing power in

big-tree, old-growth stands, which are now, sadly, reduced to a scatteration of patches that are in aggregate less than 10 percent of their original extent in these western mountains.

However rare such remnants of the ancient forest may be in these parts, Arlecho is rarer still. Generations of Lummis have come here for ritual cleansing in the icy spring waters, for vision quests,

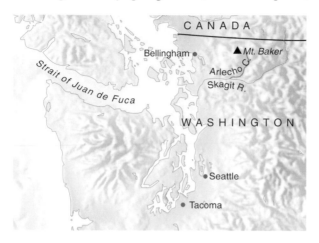

for obtaining spirit dreams (*skalatilud*), for the gathering of healing plants, for the cedar tree, which is used in ceremonial ways, and, most significantly of all, for the songs that only the ancient forest can teach. When Cha-das-ska-dum was invited to present testimony at a hearing of the Washington State legislature on the preserving of sacred lands, he was asked, rather testily, just what constituted a so-called sacred site for the Lummis. "Do you have time to listen to 132 songs?" Cha-das-ska-dum replied.

When one goes to the undisturbed woods, such as Arlecho, one sits and listens to the soughing of the wind in the tree branches, to the laughing waters of the creek, to the crack-branch footfalls of elk or bear, to the *kee kee* of the marbled murrelet calling from a mossy nest high in the old growth. For a Lummi, properly prepared by the elders, such sounds can become songs, rising from the lips of the listener into the heavens, where the songs reside until called to earth again. But they cannot return if the sacred, primordial place of their origin is destroyed, as by the snarl and rattle of the clear cutter's chain saw. In such a case, the song is lost. And as the songs are lost, another part of the traditional culture disappears.

"Old growth holds a lot of stories," says Xwám-ik-sten, "a lot of songs. It's a church. I pray for the safety of these trees."

Until recently, their safety was very much in doubt. Routine clear-cutting, zealously encouraged by government officials and the CEOs of the forest products industry, has thoughtlessly, even cruelly, destroyed a substantial number of the traditional sacred sites of the Lummis and other northwestern tribes. A reprieve, at least theoretically, appeared to come in the American Indian Religious Freedom Act of 1978. Belatedly admitting that Indians and other indigenous peoples had as much right to the free practice of their religion as everyone else, this act of Congress proclaimed,

> that henceforth it shall be the policy of the United States to protect and preserve for American Indians their inherent right of freedom to believe, express, and exercise the traditional religions…including but not limited to access to sites, use and possession of sacred objects, and the freedom to worship through ceremonials and traditional rites…. The President shall direct the various Federal Departments, agencies, and other instrumentalities responsible for administering relative laws to evaluate their policies and procedures in consultation with native traditional religious leaders in order to determine appropriate changes necessary to protect and preserve Native American religious cultural rights and practices.

Pursuant to this law, and at the insistence of the Lummis and neighboring tribes who managed to overcome the inertia of public officials, a comprehensive federal study of sacred lands was conducted in 1980 and 1981 by and for the tribes on the Mount Baker—Snoqualmie National Forest and adjacent areas all along the west side of the Cascades from Seattle to the Canadian border. Fourteen tribes identified a grand total of 314 sites in the 1.7-million-acre National Forest study area (the Lummis suggested ten of them), which thereafter would have to be given special consideration in forest management by Forest Service officials.

Despite the potential benefits of the study, the Indians' participation was not without misgivings. They had to reveal their religious practices in greater and more intimate detail than they had ever done before. Moreover, the sites had to be mapped, and even though the locations are kept confidential, the

very idea of putting boundaries on sacred land is foreign to the Indian way of thinking.

Although Arlecho Creek was on a corporately owned holding rather than on National Forest land, the sacred sites study, and the Religious Freedom Act that brought it about, did help to focus attention on this important tract and on its extreme vulnerability to destruction under the ownership (until recently) of a distant corporation, Mutual of New York, an insurance company. When MoNY (as they style themselves, in a not unconscious commentary on their purposes and values) started logging off the basin, ignoring the cultural significance of the land, Cha-das-ska-dum and Jewell Praying Wolf James, another Lummi leader, together with Kurt Russo, a non-Indian

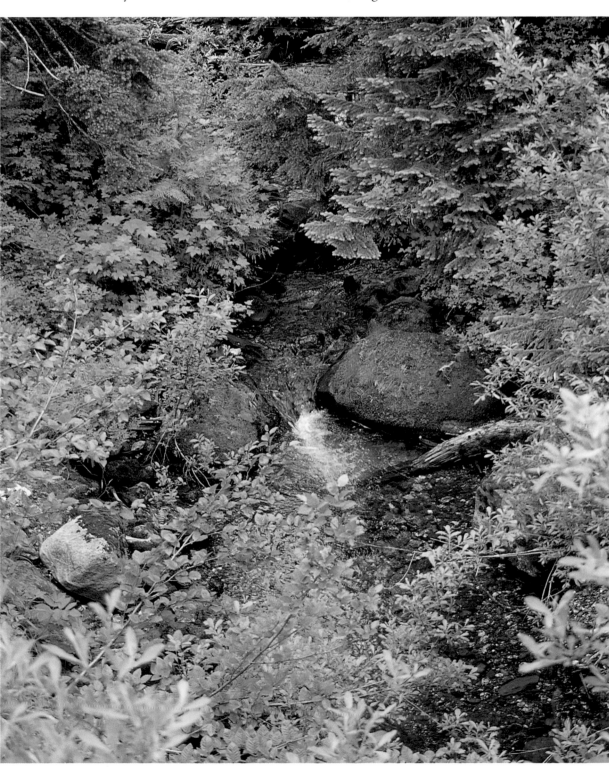

Arising modestly in the forest, Arlecho Creek plays a vital role in the lives of the Lummis as well as the salmon and other interconnected forms of life of the region.

and principal investigator for the Lummis' part of the sacred sites study, organized a protest.

And so it was, during the summer of 1992, that day after day a human barricade of Indians and their sympathizers took form across the road leading out of the Arlecho tract. Every logging truck was stopped, the big sixteen-gear Kenworths shifting down rapidly to avoid striking the protesters. But there was no violence. All the Indians wanted to do was to give each driver a pamphlet explaining the spiritual significance of the forest. Once the driver

Lummis call the western red cedar *(Thuja plicata)* the canoe cedar. It grows to canoe size only in old-growth forest.

agreed to read the pamphlet, he was sent on his way with thanks. This peaceable approach was in vivid contrast to the violence being done to the old-growth trees and caught the attention of the media. Confronted by a morally superior force, MoNY retreated to the canyons of Manhattan and sold the land back to Crown Pacific, Ltd., the Portland, Oregon, timber company that had owned it in the first place.

Some of the board members and executives of Crown Pacific were, fortunately, more sympathetic to the cultural needs of the Indians. And when they appointed a forester named Russ Paul as timber and land manager for the property, Arlecho got a highly trained professional with sensibilities concerning forest values other than mere quantities of board feet. Paul could understand the Lummis' views, just as he could understand the ecological needs of retaining old growth as part of a working forest. And, as he has confessed, he also knows how to keep a keen eye open for the corporate public relations needs of his employers. Accordingly, soon after he arrived, the Lummis and Crown Pacific were meeting at a conference table, talking about what could be done.

What could be done was this: Crown Pacific would sell the entire 2,240-acre Arlecho Creek basin tract—the standing timber of the old-growth portions (565 acres) as well as the cutover lands—to the Lummi Nation for $7.1 million and would cooperate with the tribe in the management of Crown Pacific lands surrounding the Arlecho Creek area. The price tag was at least $2 million less than the land could fetch commercially. One appraisal, in fact, put the value of the tract at $17 million.

Immediately the Lummis created the Arlecho Creek Forest Conservation Partnership to raise the money and provide for cooperative management of the land once acquired. Included in the partnership, besides the Lummi Nation and Crown Pacific, is The Nature Conservancy, a national conservation group, and Northwest Indian College, Lummi-run but serving Indian students from more than two hundred tribes and with a strong faculty in the biological sciences.

Once the funding is complete, Northwest Indian College will be the nominal owner of the land, conducting an active program of forest restoration on the cutover parts of the basin. The

Nature Conservancy, which has accumulated donations from various sources (including $3.75 million from Microsoft cofounder Paul Allen), will retain a "conservation easement" on the property to provide continuing oversight for the management of an area that the conservancy believes contains one of the most significant remnants of primeval forest on private land in the West.

Xwám-ik-sten, as a biologist for the Lummi Nation, is an authority on those aspects of the Arlecho Creek area that The Nature Conservancy values. It might be noted here that Tommy Edwards, the trained scientist, and Xwám-ik-sten, the Lummi spirit dancer and singer, are not warring elements in a single personality. To Xwám-ik-sten/Edwards, the habits of the threatened marbled murrelet, the water temperature of Arlecho Creek, and the health of the cedar tree can be analyzed ecologically even as they are understood spiritually.

Arlecho, says Xwám-ik-sten, is one of the densest known nesting sites for the murrelet, a pelagic bird designated as a threatened species by the federal government in 1995. In 1987 fewer than ten nests could be located in all of Alaska, Washington, and California. One reason for the scarcity is that the murrelet requires the mossy branches of old-growth forest trees—now greatly diminished—for its nests during breeding season. At such times the bird is in nondescript "marbled" brown plumage and flies from the nest to open water (which can be as much as fifty miles away) to return with a single fish for food. The chicks feed only at night and are not exposed to sunlight, needful of the half-light that only old-growth stands can provide. In winter the murrelet goes to sea to stay, transformed to a plumage of black and white.

Thus the murrelet is a *linking* creature, finding its place in both the mountains and the sea, as do the Lummis, a sea people of the Puget Sound islands and coastal areas who repair to the flanks of the Cascades for the renewal of the spirit and the teaching of their young in the traditional ways. The murrelet, Xwám-ik-sten says, "indicates that a place is undisturbed, a place where we can gather medicinal plants and conduct ceremonies. Like us, it travels from the waters to the forest. If the murrelet became extinct, it would be a great tragedy."

Salmon is another linking species with special ecological needs, cultural significance, and, into the bargain, economic importance. The Lummis, who control about 25 percent of the Puget Sound fishery, own a major fish hatchery, and Arlecho Creek is a major tributary to the waters of the hatchery. The significant datum, says Xwám-ik-sten, is that water temperature of fifty-eight degrees or more is considered fatal for salmon. Yet midsummer water temperatures of seventy-one degrees Fahrenheit have been recorded along portions of lower-elevation tributaries flowing into the hatchery. Clearly, it is urgent that the forest that shades and cools Arlecho Creek, perhaps the hatchery's most crucial upland water source, be preserved.

Among shaders, of course, is the giant canoe cedar, called the western red cedar by the forest products industry. It can grow to canoe size only in virgin forest conditions. Besides providing massive boles for canoes (that can carry up to two tons of cargo) and lumber for smokehouses, the cedar's inner bark is used for textiles, cordage, dip nets and drag nets, baskets, and the Indians' ceremonial regalia. For the most part, non-Indians see cedar as good for shingles and not much else—perhaps one of its worst uses, as those westerners who must hose down their exceedingly flammable cedar-shake roofs during forest fire season will attest.

Murrelets, salmon, Lummis, and cedar all fit together at Arlecho in an unbroken circle of life in which regeneration, not death, has dominion.

On August 7, 2000, the beloved Cha-das-ska-dum passed away. After Xwám-ik-sten's prayer for him at Arlecho, Cha-da-ska-dum had gone home for a few weeks, but then was readmitted to the hospital for bypass surgery. This time the spirit left his body, not to return. "I walked in the lush undergrowth of the old-growth trees," he had written of Arlecho before he died. "A gentle breeze drifted through and in these trees, the ones we call the 'standing people.' Far away I could hear the words of the old ones saying to stop the destruction of the Earth. All things are connected."

In this place at least, thanks to Cha-da-ska-dum and many others who have worked to preserve the sacred groves of Arlecho, the words of the old ones were heard and perhaps will not be forgotten. The songs that have risen are safe, and new songs can be sung by the oncoming generations in praise and thanksgiving for the eternal connectedness of life. ❧ CEL

Marbled murrelets require a heavily shaded forest to rear their young before returning to the sea.

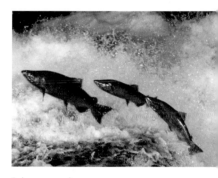

Salmon need waters cooled by the forest for their annual migration.

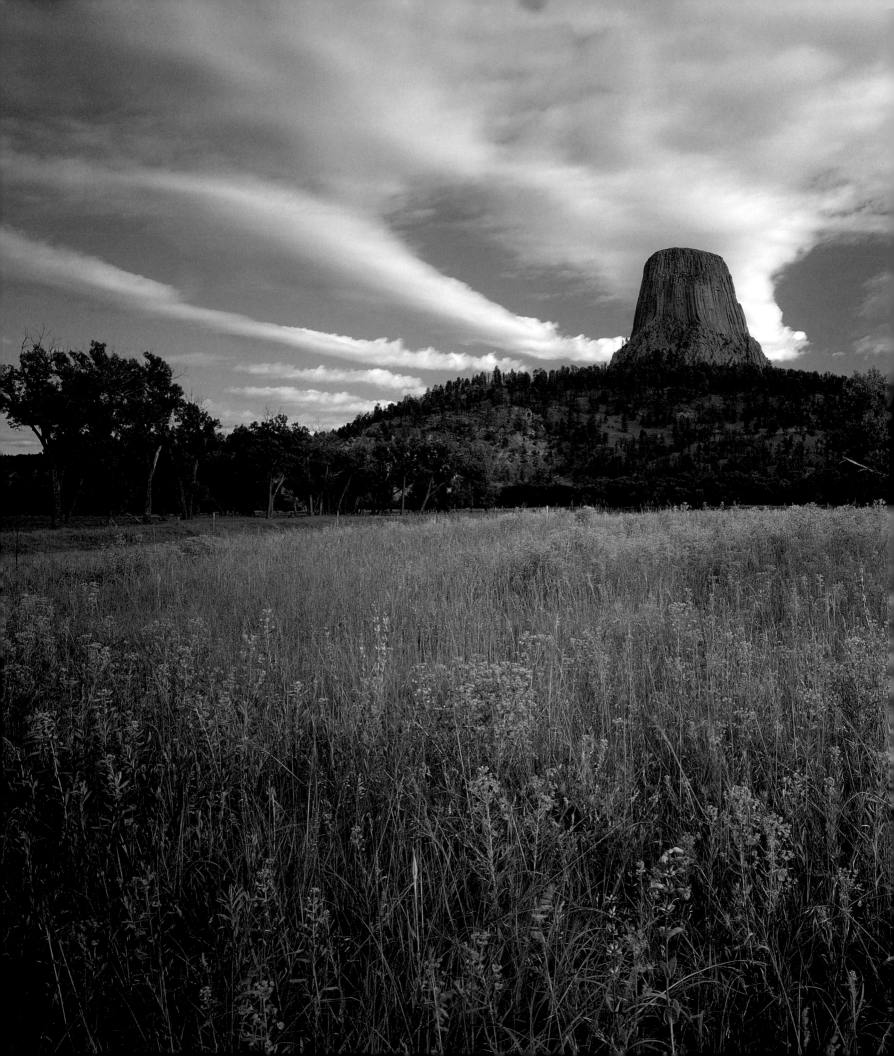

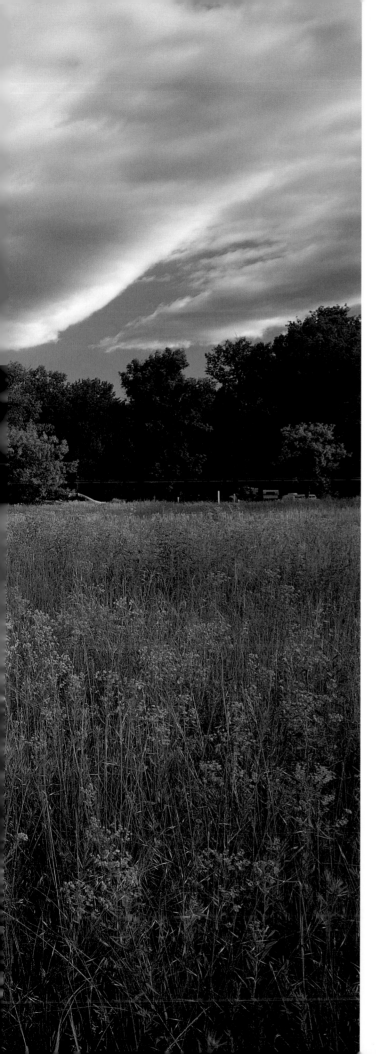

Devils Tower in northeastern Wyoming, the nation's first national monument, is sacred to the tribes of the Plains and known as Bear's Lodge. It is also a magnet for rock climbers, thus calling for a hard-to-achieve balance of tact and respect.

BEAR'S LODGE

Plains Tribes

Warm grasses sway like whispers along the edges of the Belle Fourche River in northeast Wyoming. The river carves a gentle landscape—grassland and ponderosa forest; a place of prairie dogs and deer, bluebirds, meadowlarks, falcons, and hawks. Suddenly, in cataclysmic upheaval, the land's heart thrusts upward. A great gray monolith erupts out of the forest in some ultimate joining of rock and sky—Mato Tipila. Bear's Lodge.

In the forest surrounding the base of this inexplicable tower, blocks of the massive igneous columns forming its outer shell lie scattered every which way. The huge boulders are themselves monuments to a monument, the rubble of eternity. There is silence here, grandeur, harmony. For some twenty Plains tribes, this is a sacred place.

Every tribe has its own story about the forming of this tower, its own name for it. Most of the names incorporate the word *bear*. Many of the stories have to do with seven sisters who climbed onto a tree stump for safety while being chased by a bear. The stump grew and grew, lifting the sisters with it into the safety of the sky while the bear tried to claw his way up it. In the sky, the sisters became the stars of the Big Dipper.

The tower forms one horn of a giant buffalo. Bear Butte, about eighty-two miles to the east, forms the other (see page 39). The buffalo's outline is formed by a track around the Black Hills that was beaten down in ancient time when an important race was held between the four-legged and the two-legged animals to determine whether the four-legged buffalos would continue to eat the two-legged people or if the order would be reversed. The two leggeds won, thanks to Magpie, who rode out most of the

race on the back of the buffalo and then, at the last moment, flew across the finish line just ahead of the buffalo. After the race the buffalo agreed to supply all of life to the people. It is appropriate the earth commemorates its form.

Non-Indians know this place as Devils Tower, America's first national monument, designated by President Theodore Roosevelt in 1906. Named by Colonel Richard Dodge, who led an 1875 gold hunting expedition into the area, its official U.S. name is deeply insulting to Indians, akin to calling St. Patrick's Cathedral Devils Church.

The tribes want the name changed to Bear's Lodge. This seems a simple enough reparation, but local non-Indians—many of whom live from tourism—and all the Wyoming legislators are heavily invested in the name Devils Tower, a name that attracts tourists. Tourism is a vital part of Wyoming's economy. A suggested compromise, that the tower itself be called Bear's Lodge while the name of the national monument remain Devils Tower, has gone nowhere. The issue is so highly polarized that it has stalled every other issue concerning the monument, a fact frustrating to monument superintendent Chas Cartwright because neither the monument nor the National Park Service has any power to change the name. Only Congress may do so. In an attempt to influence Congress, the tribes are now doing their own politicking. Superintendent Cartwright's hope is that they can bring Congress to a point where it will ask the Park Service's opinion.

The tribes have had experience in the political arena in the course of working with the Park Service on a climbing management plan for the tower. Implemented in 1995, the plan—essential because climbing was, and to some extent still is, a serious source of contention for the tribes—has had considerable success.

The 1995 plan calls for a voluntary climbing ban in June, a sacred month for these Indian people. The time of the solstice, of nesting birds and new plant growth, of rebirth, June is the time the tribes come in the greatest numbers to Bear's Lodge for prayer and vision quests, to present offerings and perform ceremonies. When climbers are on the tower during these times—which require absolute solitude—the vision quest cannot be completed; the prayers are interrupted.

Since the tower was first climbed in 1893 by two white ranchers who built a 350-foot wooden ladder to the summit, it has been a lure for climbers. Until the 1930s everyone used the ladder. After the first actual rock climb in 1937, the tower became a climbing mecca. Indeed, in its presence it is easy enough to understand why climbers are drawn to it.

Easy enough to understand if you are not Indian. For Indians, climbing the tower is an invasion of the sacred. One has to wonder what it would feel like to Christians if the steeples of churches and cathedrals suddenly became climbing destinations. There are plenty of challenging steeples out there, so why not?

The ban has cut the number of climbers in June from twelve or thirteen hundred a year to about two hundred. Most of the aberrant two hundred come as a result of guide Andy Petefish, who has refused to go along with the ban. He sued the National Park Service, saying climbing is his religion. The suit made it through the court system up to the U.S. Supreme Court before being thrown out. In June 2000 compliance with the ban declined from about 88 percent to the low 80s, mainly because another

Magpie tricked the buffalo in an important race long ago, and Bear chased some maidens up the tower, scraping it with his claws.

Like flies on a wall, two climbers ascend Devils Tower. Such activity, especially in June, disrupts ceremonies there that have been carried out for centuries.

guide moved into the area who, like Petefish, refused to relinquish his June climbs.

The climbing management plan also stipulates there will be no new physical impacts to the rock—no new bolts or fixed pitons. "It all might crumble if they kept chipping away at it," Elaine Quiver says. "The physical damage could be devastating. Centuries ago, there was no destruction."

Elaine Quiver is Lakota. (The Lakota are one of the Seven Council Fires—divisions—of the Sioux Nation.) Director of Volunteer Services on the Pine Ridge Reservation in South Dakota, she is a long-time fighter for protection for Devils Tower and other areas sacred to the Lakota. For her, protection of these areas is protection for all of life. "The Sioux ask for respect for the rebirth of the birds and sacred plants," she says, "and through them, the sacred land on which they live."

"If we were starting over," Superintendent Cartwright says, "would we allow climbing? I think not. But climbing now is an integral part of the history of the tower. The success we've had is because we've had the climbing community behind us. The climbers are making a personal decision. This is what the Indians said they wanted."

Even without 100 percent compliance, the ban has clearly had an effect. In the years since the initial June closure, falcons, eagles, and other birds that once nested on the tower have come back. (Some routes are closed from mid-March to midsummer to protect nesting prairie falcons.) Plants that grew before climbers trampled them have returned. Another outcome of the ban is the growing awareness of the rest of the world that this place is sacred and must continue to be honored in a sacred manner. In a move to aid that honoring, the new general management plan currently in process will look at zoning for particular uses, including a zone that will better accommodate Indians and provide for a quiet, undeveloped experience—not only for Indians, but for everyone.

Everyone is the current concern for Elaine Quiver. Since she began working on the issues surrounding places sacred to her people, some things have changed. Much of the change stems from the birth of several sacred white buffalo calves in recent years. It was White Buffalo Calf Woman who, long ago, brought the Sioux their most sacred pipe and

instructed them in their sacred ways. Elaine Quiver says, "When the white buffalo was born, that was the end of our Indian culture. Everybody was changed. Everyone will be together. Our Indian tradition entered into the millennium. There is no isolated sacredness anymore. We're all one. When the white buffalo were born, the legend finished."

She sees this not as an end, but rather as a time of hope in which discrimination will disappear among people of the earth. "Everybody is sacred," she says. "We can go to any church now and pray because we understand what is sacred. In protecting the sacred sites, they were protected for all people. We don't need to talk about them anymore because everybody knows what is sacred."

Does this mean the sacred places are less necessary? "The sacred sites for us are real because that's where we go to pray," Elaine Quiver says. "Every person knows about our sacred sites. And every person can go there. At least these places can be protected, instead of crushing them and making them into a wall."

In 1998 Romanus Bear Stops, a Lakota spiritual leader, testified in U.S. District Court, saying, "Those who use the Butte [Bear's Lodge] to pray become stronger." Prayer and ceremony are necessary to reaffirm the tribes' cultural identity, to constantly renew ties with both spirit and land. Spirit and land are the same thing. Bear's Lodge is an opportunity for non-Indians to honor this by observing the June ban and by petitioning Congress for the name change vital to life, to land, and to spirit. ✒ RR

The long-predicted appearance of the white buffalo is a major event in the world view of Plains tribes and makes sacred places like Bear's Lodge all the more important.

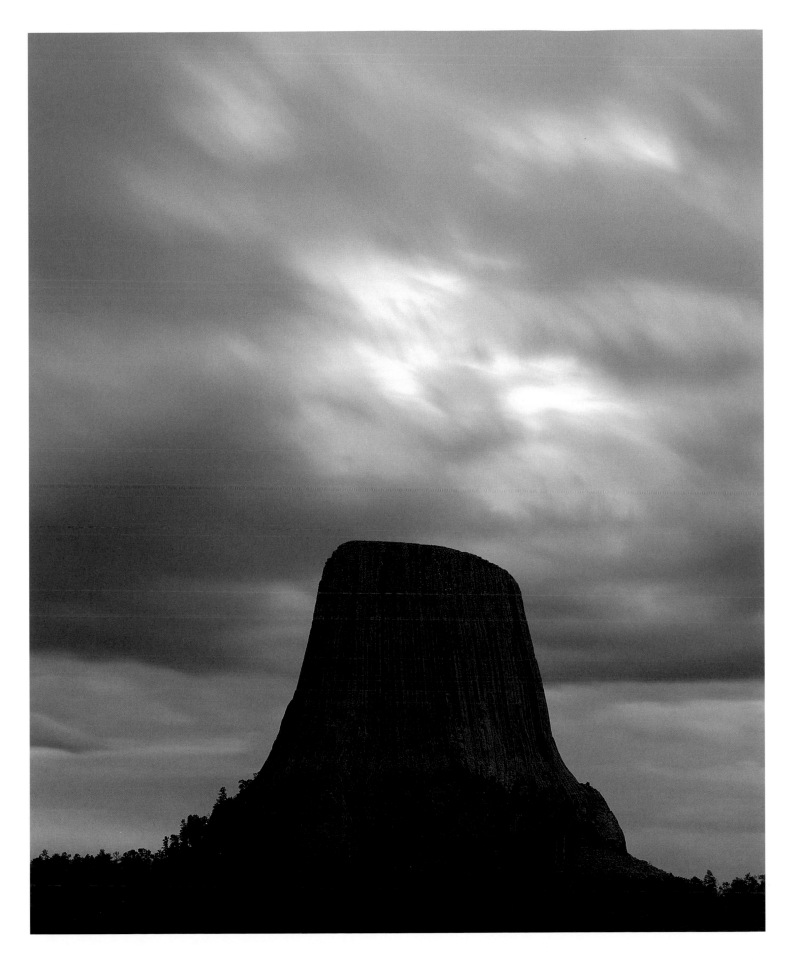

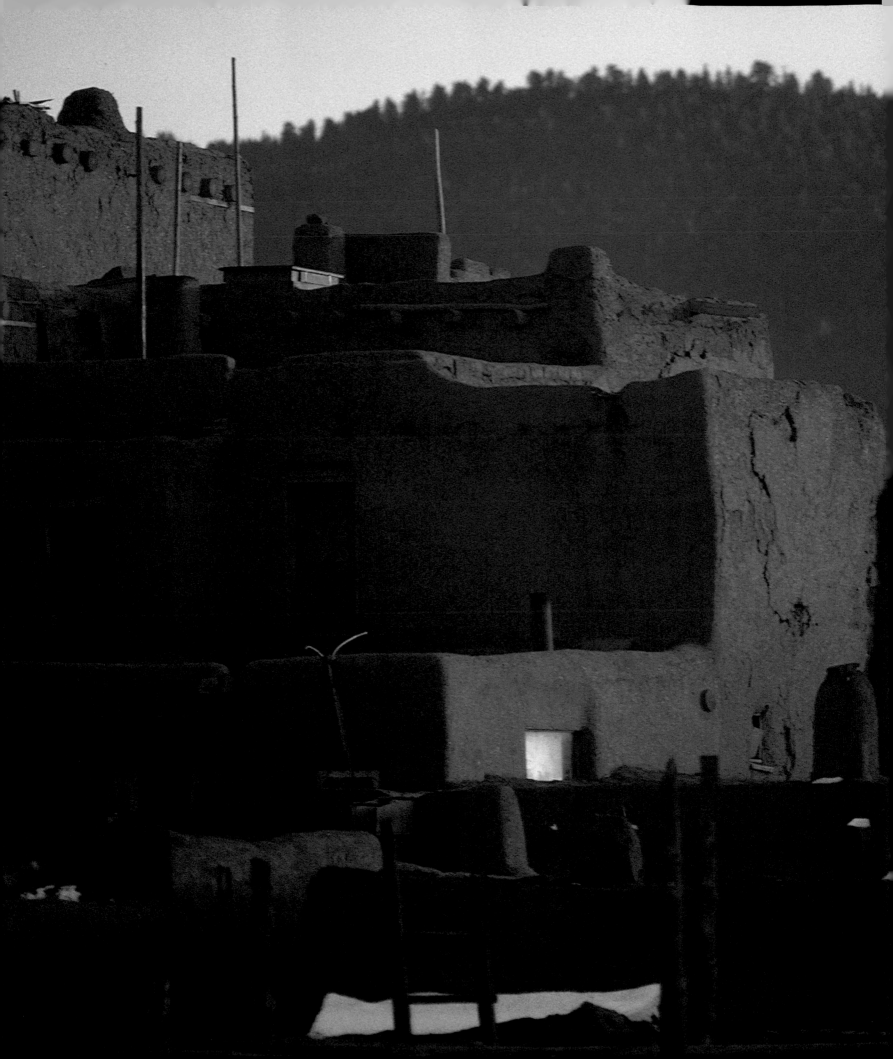

THE REPATRIATION OF BLUE LAKE AND SANDIA

Taos and Sandia

Inhabited for about a thousand years, Taos Pueblo in northern New Mexico is one of the most visited pueblos of the Southwest and also one of the most private. Pleading freedom of religion, it finally succeeded in obtaining the return of a sacred lake in the nearby national forest.

Say the word *pueblo* and the image that comes to most minds is of the awesome multistoried, brown-stuccoed buildings of Taos, the northernmost of the nineteen separate pueblos of New Mexico. Millions have visited Taos over the years, bought things of beauty from its craftspeople, and taken photographs. A camera-laden tourist, with a duly purchased permit to take pictures, would be forgiven for thinking that Taos Pueblo, settled a millennium ago, is now a very open, public place.

Yet the intrinsic aspects of life at Taos—the truly important features of social, religious, and ceremonial life—remain largely unknown to all outsiders, even those most persistent inquirers, the ethnographers. All of the older part of the pueblo, that which is inside a wall built in the seventeenth century to protect against Comanche raids, is considered sacred. Since the arrival of the Spanish in the sixteenth century, Taos has been not only a center of pueblo rebellion against Spanish, Mexican, and American intrusions, but also highly resistant to any changes impelled by the presence of potent alien cultures. It was, for example, the last of all the southwestern pueblos to allow electrical lines to snake into its precincts—and then, in the 1970s, only into the mostly secular part of the pueblo that lies outside the old wall.

As a result of its archconservatism, the language and culture of Taos are largely intact to this day, despite a gradual change from a reliance on hunting

and gathering in the mountainous surround and beyond on the plains to what is largely a cash economy from tourism, crafts, and work off reservation. On the other hand, the traditional lands—hunting grounds and sacred places—of Taos are not intact. Steadily encroached upon by Spanish-speaking settlers and then, after 1848, by Americans, most of their old hunting and gathering grounds in the Sangre de Cristo Mountains were placed in the Kit Carson National Forest in 1906. As a result, a mountain tarn called Blue Lake was put in the public domain—and Blue Lake was an especially sacred place to the people of Taos. The annual pilgrimage by Taos priests to this lake, and the ceremonies they performed there, were not, however, something they could discuss with outsiders. Partly as a result, their appeals to regain possession of that lake fell on deaf ears, some ignoramuses haw-hawing about demonic lakeshore rites.

In the 1930s, Taos elders decided to take the then Commissioner of Indian Affairs, the highly sympathetic John Collier, to Blue Lake to witness the ceremonies there. It was a four-day ride, and each night the elders themselves grew more uncomfortable with the idea, finally telling Collier that they simply couldn't let him be a witness. More than three decades later, another group of elders went to Washington, D.C., to talk about Blue Lake with a young U.S. senator who they had intuited might listen. This was Fred Harris (D. Okla.), who was thus given the opportunity to do "the most important thing I ever did in the Senate."

Harris, among other things, was married to a Comanche woman, LaDonna Harris, and he was soon convinced by the Taos elders' "impressive conviction" that Blue Lake was a centrally important

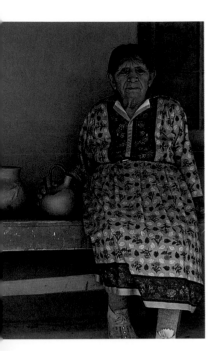

Taos potter Virgina Romero sits in the shade within the sacred confines of the pueblo.

sacred place. Harris introduced a bill returning Blue Lake to the exclusive ownership of the Taos tribe, based on the constitutional notion of freedom of worship—but many of the needles of Washington had first to be threaded.

It turned out that the Nixon administration had only recently failed to achieve a settlement of the Indian occupation of Alcatraz, a settlement that would have symbolized the administration's liberal outlook on race relations. They needed a comparable achievement in Indian affairs. Meanwhile, LaDonna Harris had spoken to a friend, Roberta Greene, then an intern in the White House, explaining the Taos problem, and she in turn spoke to John Erlichman and Leonard Garment, part of Nixon's praetorian guard. They in turn spoke to the president, and soon enough Michigan representative Robert Griffin, the Republican leader of the House, and other congressional Republicans were behind the Harris Bill.

Meanwhile, New Mexico's senior senator, Democrat Clinton Anderson, among whose constituents were the Taos people, told his colleagues on the Interior committee that he favored a use permit for the Indians but had environmental objections to simply giving the lake back. The committee Democrats told Harris that without Anderson, it was no go, so Harris gambled and announced, as was his right, that he would take it to a vote of the full Senate. (Harris recalls with a guffaw that Anderson came to him in the midst of this and asked, "Why are you doing this with *my* Indians?")

In any event, what with liberals like Senator Edward Kennedy on the same side of the issue as the Nixon administration, the bill soon passed both houses, and Blue Lake was again pristinely in the hands of the Taos Pueblo. Sometime later, Harris visited the pueblo, where he and his wife were guests of honor at a day of dancing and a "giveaway." With reverence, Harris recalls that the Taos elders said they now prayed daily that the spirits of Blue Lake always look after him and his wife.

Downstream from Taos, the Rio Grande slides by another pueblo, one with an issue similar to Blue Lake. Usually private and much less well known, the Sandia Pueblo and its reservation land extend from the river about twenty-five miles east to the foothills of the Sandia Mountains, whose craggy west face looms to almost a mile above the river val-

THE REPATRIATION OF BLUE LAKE AND SANDIA

ley floor. Sunset lights up the rocks a flamboyant red, hence the name, which is said to mean *watermelon* in old Spanish, and in these heights the Sandia people have long hunted and made necessary pilgrimages for religious purposes that they (like the people of Taos Pueblo) have long kept to themselves.

For several decades, Sandia Pueblo has been pointing out that only a surveying error took the west face of the mountain away from them and gave it to the U.S. Forest Service as part of the Cibola National Forest. The entire mountain sees millions of hikers, skiers, and other users annually. Hang gliders flutter off its topmost edge. Climbers scale its crags, and at least once a year, an inexperienced hiker or two take a spill and a major rescue operation is called for. The mountain, much of it designated a wilderness area in 1978, is a major recreational resource for the largest population concentration in the state of New Mexico, the Albuquerque metropolitan area. A handful of people live on about six hundred acres of inholdings on the mountain.

The Sandia Mountains east of Albuquerque, orange-red in the late afternoon sun, were lost to the Sandia Pueblo by a surveying error.

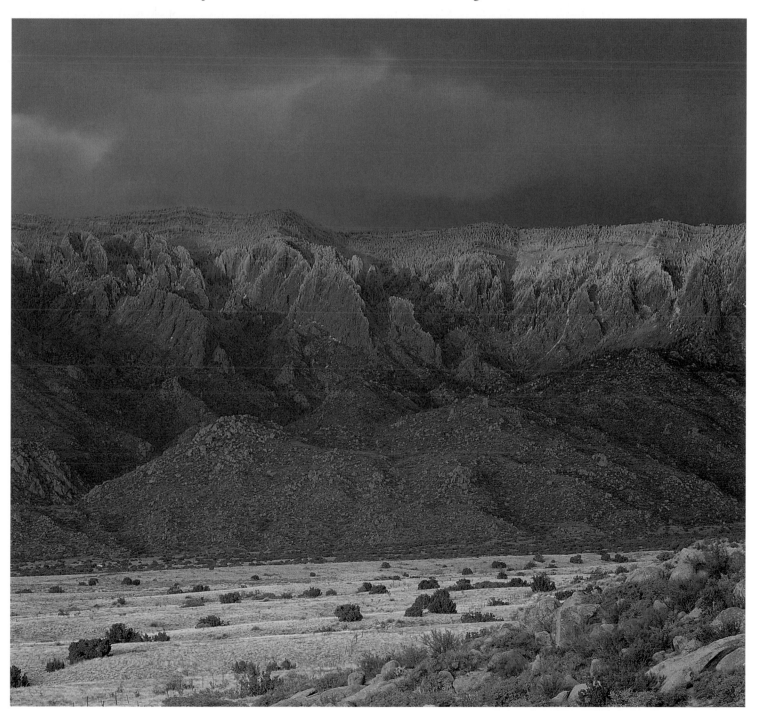

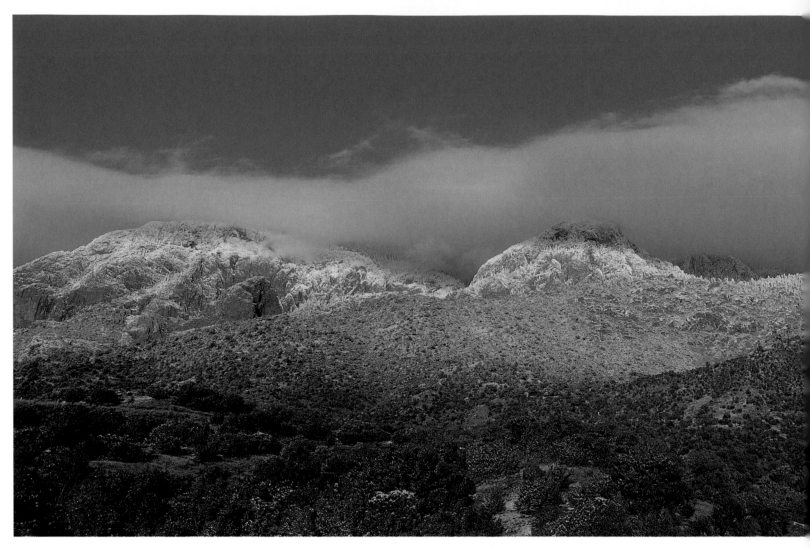

Winter snow dusts Sandia Crest as a winter storm clears and, *below,* autumn lights the crags with aspen gold. The people of Sandia Pueblo need Forest Service permission to practice their religion in these traditional sites.

In 1998 a federal judge concluded that the pueblo's claim on the land has merit and a new survey was in order: the original survey was in error, and much of the west face might properly be Indian land. What is at stake is about 9,890 acres, some few of which lie within the borders of the city of Albuquerque and some within the borders of Bernalillo County. Early in 2000, the pueblo and the Forest Service announced that they had reached an out-of-court settlement.

The Sandia tribe offered to give up forever its claim on the west face of the mountain in return for a guarantee from the U.S. government that the land would never be developed. The federal government would continue to own the land under this agreement and administer it but agreed to meet twice annually with the pueblo, which would have a right to veto any new proposed use (meaning such things as new roads). No one would be denied access to the mountain, even its wilderness

areas. All the present rules would apply. In return, the Sandia tribe could gather spiritual materials and perform their ceremonies without asking permission from the Forest Service.

A private company that runs what is billed as the world's longest tramway, a breathtaking ride up the west face, happily signed off on the agreement. The National Parks and Conservation Association applauded the settlement for protecting the area's wilderness status, calling it "a win-win."

But even before the settlement was officially announced, the city, the county, the handful of landowners on the mountain, the state's Republican senator, Pete Domenici, and the district's representative, Republican Heather Wilson, all erupted in a great fury. The two politicians demanded that the U.S. Justice Department appeal the court's original decision before Congress had a chance to approve the settlement. Representative Wilson called it a "backroom deal," negotiated in bad faith. It would

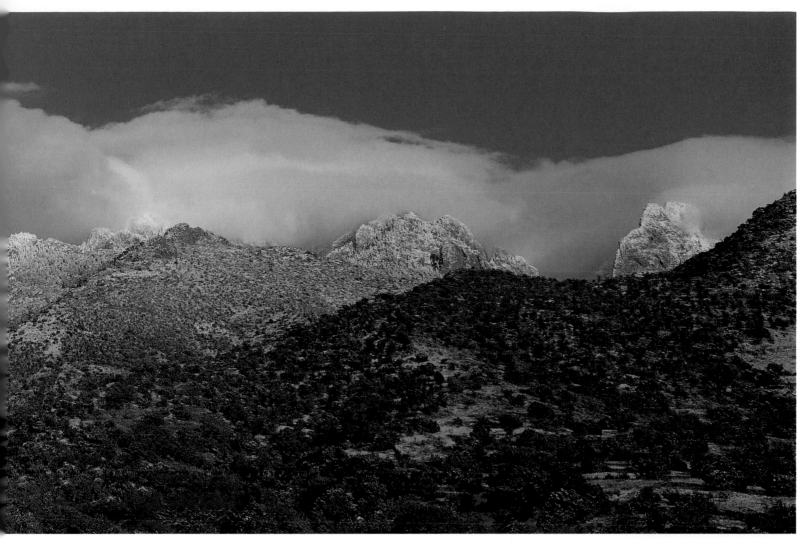

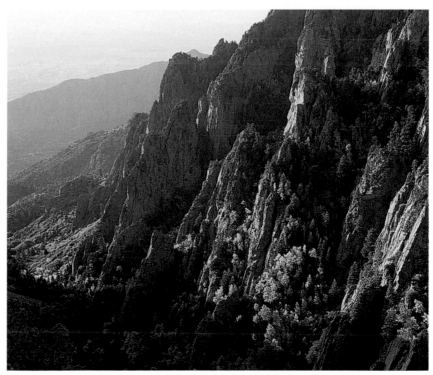

be DOA, she promised, when it reached Congress. The city and county governments complained that they had not been consulted, thereby rendering any such agreement void, in spite of the Forest Service protestations that the two governments had been kept abreast of the negotiation from the very beginning. The landowners protested that among other things, their titles would be clouded, and said without an ounce of irony that the settlement would make them islands in a sea of Indian lands.

Meanwhile, the Sandia Pueblo governor, a young and forward-looking man named Stuwart Paisano, was surprised and puzzled. "We thought we were doing something that was good for everyone."

The district court then ignored the complainers and sent the matter back to the Interior Department to decide. It recommended that the agreement be accepted, and the final decision awaited a new national administration. 🪶 JP

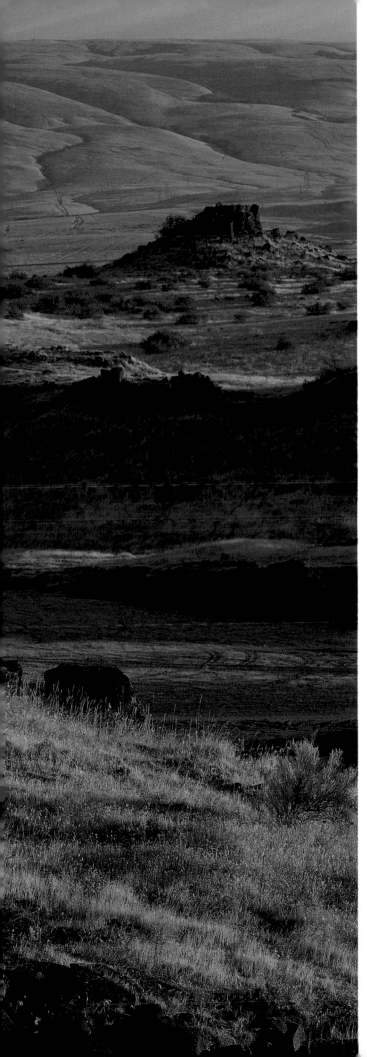

Just east of the Cascade Gorge in Oregon, the Columbia Hills and the great river that flows through them once supported thousands of the River People with plentiful salmon, game, and plant life. The river is now heavily dammed and the hills themselves are threatened.

AN ILL WIND ON NCH'I-WÁNA

Yakama, Cascade-Klikitat

Fed by half of Oregon, most of Washington, virtually all of Idaho, and substantial parts of Canada, this is the Nch'I-Wána, the Big River, the Columbia. Only the Mississippi exceeds it in terms of volume. Nothing exceeds it in terms of natural beauty as its waters gather from the northern Rockies and the Cascades and flow to the sea.

It was in the midriver region of the Columbia—passing through the hills just east of the Cascade Gorge—where the fabled aggregations of salmon, in from the sea, paved the river from bank to bank, a living, thrashing counter-river migrating upstream to the far pools of ancient memory. Sixteen million fish in the days before the dams, some of the salmon reaching a hundred pounds or more.

The embracing hills held so much food, so easily gathered, that no agriculture or husbandry was necessary. Roots, berries, deer, elk: here was a land of such plenty that it became the center of culture and trade serving all the Northwest and beyond. Wherever a tributary entered, there was a village—with sometimes as many as five hundred people.

"In those times," says Johnny Jackson, a Cascade-Klikitat chief and fisherman, "we were the River People, we were the river bands. My ancestor, Ta-wa-tash, had a vision that two men would come down the river from the east. One was a greedy man and one was a good man, but did he not know which was which. So he did not trust either one of them and would not speak to them. My ancestor saw in his vision that when the men came, they would corrupt the land. He said there was going to be trouble here. And then the war came, and Governor Stevens brought his army, and the

35

Klikitat people fought back, and the Cascade people fought with them, and the land was divided for the new people."

After the fateful 1855 treaty that divided the land, most of the River People were forced onto reservations far from the river, at Yakima, Washington, and Warm Springs, Oregon. But a few remained, carrying on in the old ways if they could. Among them, the ancestors of Johnny Jackson.

The Columbia Hills hold the bodies of those who fought for the river. In the high places are traditional sites for vision quests, where the young people were sent to wait for an understanding of who they were, what they were a part of, and a sense of how they should conduct their lives. Eagles still ride the wind over the hills and the deer browse there as the Nch'I-Wána slides toward the Pacific Ocean, two hundred miles away. Here a strong, steady breeze ruffles the grass.

Here also is where the Enron Corporation of Houston, Texas, wishes to install an industrial phalanx of huge wind turbines, hundreds of them along a fifteen-mile stretch of hills on the Washington side. Each of the turbines, as tall as a center-city high-rise building and with hundred-foot scimitar blades, will slice the wind to produce forty to sixty megawatts of power. It is as if building the hydroelectric dams, which have turned the mid-Columbia into a series of lakes with only a tiny fraction of the wild salmon remaining, was not enough: even the hills must be destroyed.

Johnny Jackson: "The people of Enron say, why is it that native people are so touchy about these

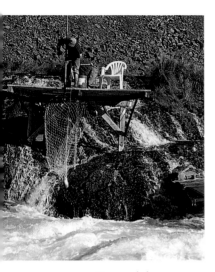

Here and there, salmon fishing is still done the old way.

An Indian fishing platform languishes below the Dalles Dam.

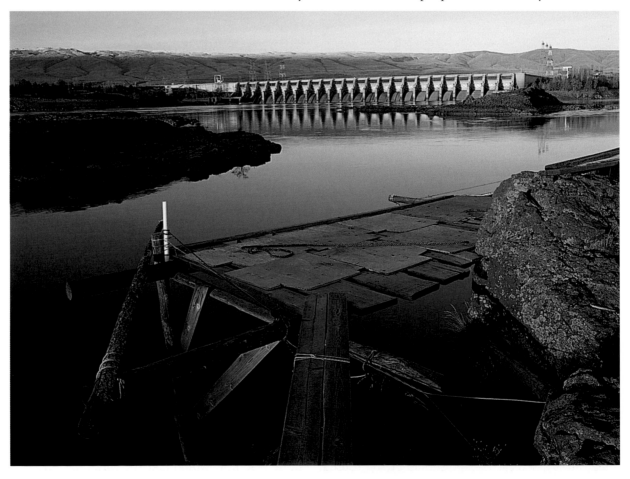

places that are bare and don't have anything on them? But in the springtime, when the plants come up, my people go there to get medicines. There are foods up there that we use in our ceremonies. The businessman says this land is going to waste. But I see people all over that land, the people who are buried there. When the elders found out about the windmill farm, they said they did not want the hills disturbed. We want those people to rest in peace. It is our job to protect that right. It is our job to protect our historical vision quest areas. These things are important. That is all we've got left."

What is to happen, then? In fact, this is not an easy issue to resolve and so far remains unresolved after ten years of contention. Wind power is a good thing in the view of the environmental community, sometimes an ally in the Indian effort to save sacred lands. Wind power is better than another dam, better than a coal-fired power plant, isn't it?

Perhaps not always.

The wind blows in many places that do not happen to be as sacred to indigenous peoples as are the Columbia Hills. The Yakama Nation, which represents the remnant River People of the mid-Columbia, brought a lawsuit against the project. The objective of their legal action, they said, was "not to stop windpower siting altogether, but to ensure, given the special and sacred landscape of the Columbia Hills, that the proposed project be resited to another locale."

The same, reasonable view was taken up by the Indigenous Environmental Network (IEN), which wrote to the Enron Corporation in 1999 in support of the Yakama Tribe's position. Coordinator Tom Goldtooth observed in his letter that the IEN (representing two hundred Indian tribes and organizations) had supported wind-power projects in the Midwest but begged the corporation to "set an example for others" by taking heed of the cultural and religious values of the Columbia Hills area.

Not reasonable enough (in the eyes of their opponents) are Dennis and Bonnie White, organic orchardists and leaders in the Columbia Gorge Chapter of the National Audubon Society. As indefatigable partisans for the preservation of the Columbia Hills as a natural flyway, the Whites have been working closely with Johnny Jackson, also a leader in the Audubon group, stressing not only their outrage that sacred land should be so misused,

but also calling vigorous attention to the potential death toll on birds, especially raptors, that the wind turbine blades would necessarily exact on this important migratory route.

However valid the Whites' views may be, as part of the conservation movement they are lonely defenders. Standing by Enron (or at least not altogether against them) is the powerful Bullitt Foundation, which supplies grants to many environmental efforts in the Northwest. Another is an

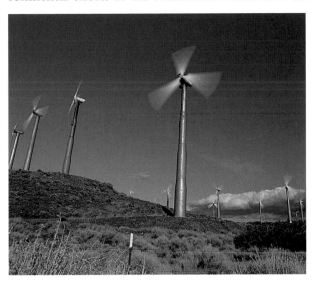

Energy developers seek to plaster the Columbia Hills with wind farms like this one in California, disturbing the ancestral River People who lie below in the ground.

ecological consultant once an official of the Trust for Public Land. And yet another is, quite possibly, the national headquarters of the Audubon Society itself, which Dennis White fears may in the end not wish to alienate a powerful corporation and a powerful foundation that provides funding to the society. "I am concerned," says White, "that the National Audubon Society may tell us that the Columbia Hills must be sacrificed because the NAS is negotiating with Enron at a higher level for higher purposes."

There is, of course, a purpose even higher than what the executives of multinational corporations and foundations and conservation organizations may be thinking about in their corner offices and conference rooms—a cultural and religious purpose that for some, like Chief Johnny Jackson, who lives in a shack alongside the river, is nonnegotiable.

"These are people who destroy," says Jackson. "For the dollar, for power." He is referring to those who long ago killed the River People whose bones are in the hills, to those who dammed the river and put factories on it and stopped the salmon, and to those who now would take the wind. 🪶 CEL

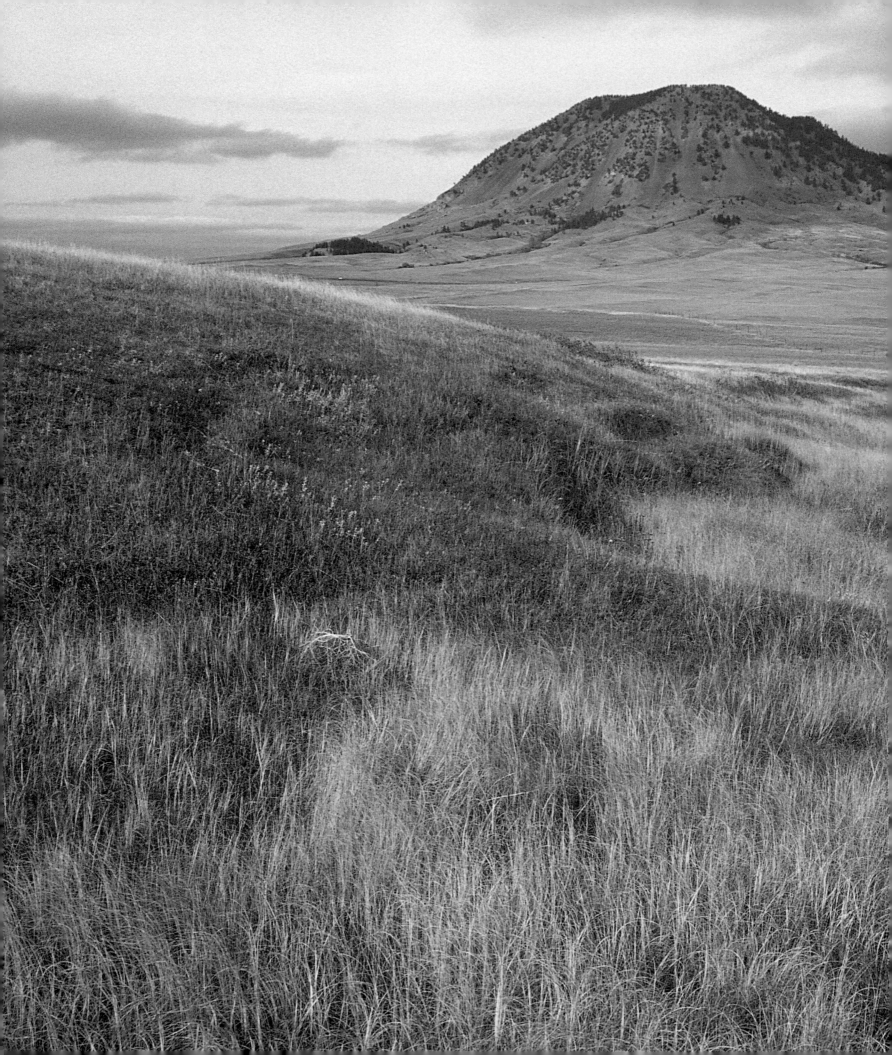

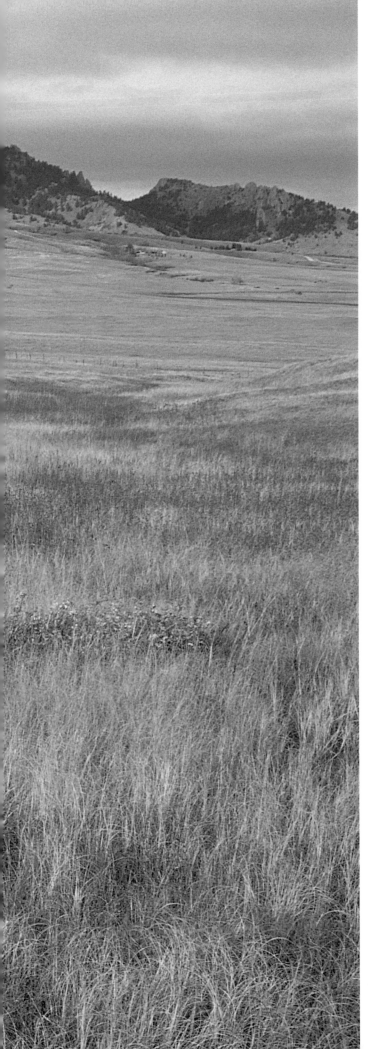

Autumn burnishes the prairie surrounding Bear Butte, part of a South Dakota state park, the birthplace of Crazy Horse, and the most sacred place in the Black Hills for Lakotas and Cheyennes.

ANOTHER HORN OF THE BUFFALO

Lakota, Northern Cheyenne

A few buffalo graze on the midgrass prairie at the foot of Bear Butte. Isolated on the South Dakota prairie, the mountain is dark with pine forest along its ridge and down the southern flank that rises behind the buffalo pasture. This is the *other* horn of the buffalo formed by the track around the Black Hills to the south and Devils Tower (see page 23) to the west. An ancient igneous intrusion, Bear Butte is connected to the Black Hills by all that is sacred for the tribes of the Northern Plains.

For the Lakota and Northern Cheyenne people, Bear Butte is among the most sacred ceremonial sites in the region, the place the Cheyenne received the four sacred arrows, and the teachings that go with them, from the spirits who lived in a cave on the mountain. On this mountain, the Creator gave the Lakota their sacred teachings and the seven sacred elements—land, air, water, rocks, animals, plants, and fire.

The great Oglala Lakota leader, Crazy Horse, was born at the foot of Bear Butte. It was here, as a teenager in 1857, that he received his name, the name of his father and grandfather. During a vision quest in the early 1870s, he saw the warfare that would come between whites and Indians. In 1876 George Armstrong Custer, having found gold in the Black Hills, camped at the base of Bear Butte. So did Crazy Horse. For Custer it seemed a kind of beginning. For Crazy Horse it was an end. The discovery of gold precipitated the order for all Indians to move to their reservations. Crazy Horse refused to go or to sell his homeland. In the summer of war that followed, the Cheyenne and Lakota, led by Crazy Horse, defeated Custer's army at the Little Bighorn, a huge victory, albeit temporary. Although

Tobacco left as an offering at the Bear Butte prayer site.

the Battle of the Little Bighorn provided the Lakota a triumph and a respite, it also stepped up the U.S. Army's campaigns against the free-roaming Lakotas. By winter, pursued by the army, Crazy Horse's band was starving because the United States had already wiped out the buffalo herds in an attempt to control Indians. The people had in essence lost everything. In May 1877 Crazy Horse surrendered, his band the last of the Lakotas to come in. Less than a year later he was killed by a prison guard in Nebraska while resisting an attempt to take him into custody. His parents took him north, probably burying him near Bear Butte, where he had been born.

In 1962 this mountain that had for centuries been the site of Indian pilgrimages, fasts, and ceremonies became a state park. In 1965 it was designated a National Historic Landmark. It is on the National Register of Historic Places. A National Recreation Trail runs through it.

With the exception of the Historic Landmark designation, which can offer some protection for Indian sacred land, all these other designations mean an ever greater influx of non-Indians seeking recreation. Recreation and sacred ceremonies have nothing in common. The South Dakota Department of Game, Fish, and Parks constructed access roads, parking lots, and viewing platforms to watch sacred rituals, all of which blatantly interfere with the ability of Indian people to conduct ceremonies with the necessary privacy. A 1982 lawsuit brought by the Lakota claimed that regulations issued by the department seriously impaired the tribes' right to conduct religious services, diminished the power of Bear Butte as a ceremonial area, and defaced the land.

The U.S. District Court had no argument with the idea that Bear Butte was the most sacred cere-

monial site in the Black Hills for the Lakota and Cheyenne people, but it ruled that the department's actions did not violate the tribes' First Amendment rights guaranteeing freedom of religion. Stating that the tribes did not hold property interests in Bear Butte, the court dealt with First Amendment rights by differentiating between religious belief and religious practice. It said that Indians were not forced to give up their religious beliefs or prevented from conducting their ceremonies by the developments at Bear Butte. The presiding judge ruled that Indians could not receive "full, unrestricted and uninterrupted religious use of Bear Butte," because if it were allowed, the "state might be establishing religion by protecting Native Americans' religious practices at the Butte."

The court actually sided with development, saying that because one of the department's objectives was to inform tourists of the "traditional Indian religious experience," those developments were in the public interest.

The problem at Bear Butte in essence stems from a perhaps necessary flaw in the U.S. Constitution. In providing for the separation of church and state, the Constitution does not allow for the practice of both at the same time. For most Indian cultures, religion and polity are inseparable.

After passing through a pay station (Indians coming for ceremonial reasons do not have to pay), you drive up the road to a visitor center at the edge of a large parking lot. An upper parking lot offers easy access to a well-maintained trail to the summit, almost a thousand feet above the trailhead. Trees along the public trail, back inside the forest and along the edges of cliffs, are tied with prayer flags and tobacco offerings and feathers. Every breeze waves the route alive with color and movement. Indian people also use other routes to the top, while the public trail is used by hikers and New Age groups, who flock to the site. You see groups of non-Indians carrying bags full of cloth and talismans and drums and pipes, making their way awkwardly up the trail, occasionally taking Indian prayer offerings, in the belief they are engaging in something sacred.

Aside from the fact that they sometimes crash Indian ceremonies, their behavior is insulting to some Indian people. For the most part, the tribes

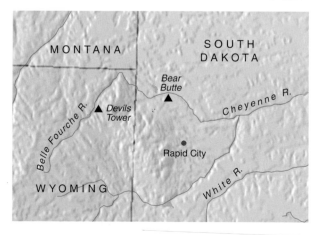

ANOTHER HORN OF THE BUFFALO

Prayer flags adorn trees on the way to the summit

would like to restrict access to the trails to people who have undergone the rigors that will provide them the spiritual power to undertake the journey to the top, although there are, among the medicine men, some who feel that the mountain is a place of worship for everyone. To the park's credit, rangers do ask non-Indians not to interfere with ceremonies, not to stop to look, not to get off the authorized tourist trail. Whether they comply or not is up to them.

The Game, Fish, and Parks Department would like to establish a formal policy to monitor use of the mountain, but the tribes believe they should be managing the area themselves and question the state's right to do it. At this point, the only monitoring consists of counting entrance fees. Because Indian people engaged in ceremonial use of the mountain do not pay entrance fees, there is no way to measure the number of Indians visiting Bear Butte, and because the entrance fee is per vehicle, there is also no way to count non-Indian use of the mountain. According to one Northern Cheyenne ceremonial leader, the state is supposed to consult with the tribes before doing anything on the mountain—construction, digging, etc.— but they don't always, or they do, but after the fact.

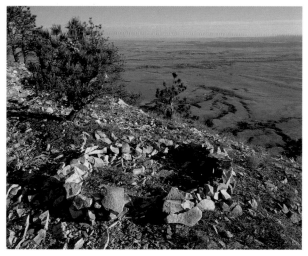

A vision quest circle awaits atop Bear Butte.

Yet there is a right track here. Since a Lakota Nation meeting when participants suggested the state hire tribal members as cultural advisers, both to "sensitize park staff to concerns of traditional Indian people" and to act as interpreters to the public, two seasonals have been hired, one as a naturalist and the other as a trail attendant. The park manager is Lower Brule Lakota. All three see as their mission the protection of Indian spirituality and the right of non-Indians to be on the mountain in a respectful manner. It is an appropriate balance, but a delicate one. ❧ RR

Growing Up Sacred

Growing Up Sacred in the light, under the forever skies of home, a bit south and west of our dear Mountain, The Woman Who Comes from the North, a.k.a. The Woman Veiled in Clouds. Living near the sacred Road that led to everywhere—Albuquerque, the Coast, the Dead. Growing up in the hollow of the land, a dip in the Road that was our Trinity, that led from us to Uptown, to Highway 66, to the Pueblo villages beyond. The Spaniards came to our land centuries ago. They were looking for the Seven Cities of Cibola. I grew up among them, those fabled cities, but all anyone could ever see was some mud and stone houses, silent, dusty, beleaguered, waiting eternally under a vast and unforgiving sky. Looking out a window in the bathroom that faced south, which I thought was East since we went that way to Albuquerque. Standing on tiptoes atop the toilet seat, gazing out the high pane late, maybe an hour or so after midnight, when everyone, even the birds and the cattle, was asleep, except for the shadowy figures who danced silently except for the soft shush-shush of their shoes on the quiet predawn grass. They wore old man three piece suits like my grandfather wore, and tan Stetsons like every man I knew wore, except for the tall crowns that were shaped like a rounded bishop's hat. I don't know who they are, and I don't ask. I'd be in trouble if anyone thought I was up and looking out the window when I was supposed to be asleep. Or at another nighttime seeing the animals—goats, dogs, house cats, mountain lions, bobcats, coyotes, I don't know whatall chasing each other around and around my grandmother's house "next door" to ours. And lying on the grass at night listening to the grown ups chatting softly about their day, falling into the dusty milkyway, the Spider Grandmother of all our dreams. The coyotes would call to each other from the sandstone hills, and the frogs would sing themselves delirious in the cattle wallow across the road. The smell of smoke from woodstove fires everyone in the village used to cook and heat wash water for baths and laundry, except my grandparents and us. We had running water, a hot water tank. Modern devices just

For more than a quarter-century, Paula Gunn Allen has been a major voice in American Indian literature. Of Laguna Pueblo and Sioux heritage, along with Lebanese and Scottish, she has been a college professor who has defined the ways to approach and study American Indian writings. A major focus has been on the role of Indian women in myth and storytelling, as in her anthology (Spider Woman's Granddaughters) *and criticism* (The Sacred Hoop). *Ms. Allen is, as well, a novelist* (The Woman Who Owned the Shadows) *and a poet* (Life is a Fatal Disease *and* Shadow Country). *Here she bares her capacious soul on the sacred geography of living.*

Paula Gunn Allen

installed when I was born, give or take a few months. Standing in a thick heavy snowfall in December just outside the soft lights from my father's grocery and general merchandise store, head raised until all I could see was the snow falling falling and spinning me around, endlessly around. Climbing the mesas, reading the Indian writing, knowing sacred meant I'm here, I'm here, and all is just as good as it gets. Learning to "leave things alone!" as my mother demanded over and over. *"Dejalo!"* So said my grandfather, my father's father, the one with the three piece suits, the one born in eastern Lebanon on the seaward flank of the Mediterranean. *Dejalo.* Let it be.

LET it be. Let it BE.

Growing up sacred is exploring Macano Valley where the dead of Cubero live. Most of them have been there since the great influenza epidemic. The one that came just after the human race changed. It went to war then too, and stayed at it for years and years. Growing up sacred is knowing that War is sacred. Bloody, terrible, sickening. Horrifying. But the sacred, I tell you, isn't nice; really, you wouldn't want it for a neighbor, and you'd pass laws against it. Indeed, you have. The best tomb markers in Macano were the children's. Macano Valley is where there is a huge sandstone rock, or there was one, with a round opening at one end, the high end. You had to climb to get there, rock climbing. You entered it with trepidation, and followed the tunnel down. There wasn't anything in it or beyond. Unless you knew how to see. There were petroglyphs along the iron red strips that dyed the stones bloody— magnetic whorls, I suppose, just like blood, which is also sacred, magnetic, fraught. Macano is where you learn to read.

It's Flower Mountain. Where you climbed and climbed, walked and walked, over hill and down, under barbed fence and on to the next, just like the Bear in the song that you sang, laughing, and the sun of summer beating down really pure and bright nearly 7,000 feet up in the air. Regarding the lava cliffs that towered far over your head with respect and astonishment. You hadn't seen them until the last hill, and standing beneath them they were huge. And up them you climbed, sisters, girl-friend, cousins and all of you, hauling a few oranges you'd brought along to drink. You didn't have lightweight plastic water bottles to hang so charmingly from your belt, then. And you finally got to the top and behold! The tree-bare top of the mountain was indeed filled with wildflowers, just like spring. Beautiful, beautiful. And you knew you must be grown, you'd gotten to go along with the big kids. You were just like the bear, and you laughed uproariously when one of the big kids joked about singing Gladly, the Cross-Eyed Bear at Sunday school. You knew all around it was holy because there were oranges, and climbings, and sunburned skin, and you'd worn your shoes even though it was June. Because you never left even a hint of your being there.

Sacred is endless sandstone mesas of home. It's the Thunderheads singing. It's the lightning blessing as it blasts. It's walking quietly, leaving as little trace of your passing as possible, it's learning to hear what the trees have to say, what the birds have to say, what the great sandstone rocks, those as big as suburban houses, have to tell. It's the wind, all of the Wind People, and there's lots let me say. It's the cactus thorns

in a child's bare foot and inadequately protected bum. It's thistles and rattlers, wasps and hornets, big red ants that mark you with their blessing painfully.

It's the Big Arroyo in summer flashflood, huge boulders, cars, trees, muddy roiling water roaring down down to the faraway Gulf of Mexico. It's the odd little one-eyed man who leads you up the blasted trunk of a towering trunk of a dead tree. It's the mudheads, the dancing cedar trees, the pumpkin and corn and beans talking to themselves and each other in the hot summer days. And in your pots and pies in the fall. It's the miraculous apple and peach trees, blooming and making babies whose flesh we joyously eat. It's roasted green chili so hot you know your mucous membranes will never feel again. It's knowing that beauty is so painful it makes you weep helplessly. Growing up sacred is knowing that when the dead cousin or uncle who comes from the Big Arroyo where he lives, or maybe he lives in Macano valley just across the road, and you've soul walked home from anywhere because someone is ailing, that someone will soon be dead. Well, not exactly. Changed. Transformed. Off line for awhile, or until you get the components or program or device that will connect you directly to them in the great By and By. Growing up sacred is knowing that some things can't be mended, some griefs can't be consoled, some horrors can't be sent to their rooms for a time out. That these are all part of the all that is, and without all that is, there's a lot less than nothing. At all.

I grew up in the Land of Enchantment, and I never thought the term referred to the mad vistas and the brutal, brilliant climate. I always thought, and I still do, that it meant what it said. Here there be milagros. This is the land Shakespeare described, where live "more things under heaven than are dreamed of in Horatio's philosophy." Where every dawn the land is born anew. No kidding. It morphs through the night, and only if we "think good thoughts" firmly swerve from bad thoughts will it come back day and day the same as before. Unfortunately, the people at the Pueblo said, too many came who thought bad thoughts. So the Rain People left, the *shiwanna,* and there was a terrible drought. Where the grass grew up to the Spaniard explorer's horse's belly, it now barely, grimly, grows at all. Where the deer and the antelope did indeed play abundantly there's little enough to feed the Wild People left. Even the coyotes quit singing by the time I was grown.

By the time my youngest child was born in 1972 the beautiful, sweet pure spring that nourished the land, the cattle, the alfalfa fields, all and all, had died. I never go back there anymore. The enchantment fled, to the mountaintops, to the back hills where few humans venture and even the shiwanna, the rain/cloud people, stay away. But times change, like the land, and that's another sort of enchantment. We mustn't get negative about all of this, because we live after all in the orbit of a new sun; and while we fear because change isn't something we embrace, and transformations scares our britches off, making us targets of righteous contempt and damnation, still what time it is matters. Literally.

Paula Gunn Allen 45

Or as the poet said, "Though nothing can bring back the happy hour / Of splendor in the grass and glory in the flower, / We shall not weep, but rather find / Strength in what remains behind."

And, this poor one might add, in what comes round at last. It's not the end of the world, that part happened. It's the beginning of the world, and all sorts of creatures, even air, even shiwanna and Yei / Holy People, are coming back on line—yes, online—for the ethernet, cyberspace, is as sacred as Flower Mountain and The Woman Who Comes from the North.

Growing up sacred, immersed in the sacred land is longing for us moderns to leave off beating ourselves and our relatives, other humans, harshly about the head and chest, and to get back to the holy—holy affirming, holy denying, holy reconciling. The birds keep on singing, the bees keep on keeping on; the dancers dance, more and more of them, and the whales, the bears, the buzzards, the hawks and eagles, the bobcats of my youth are showing up all over the screen of our consciousness. Where were they? They were on vacation, taking a holiday on the other side of the world. Boy, were we pissed!

Growing up sacred is thinking we must walk in beauty, walk in balance, walk in having a merry old time as long as we're here in the center of all-that-is. Can you imagine (Can't you imagine) how happy your dear mother, *Naya,* is when you are respectful, happy, alive, and walking in beauty? Why not give it a try? If 60 or 100 million people got with the program of the birds, the world would transform in the blink of an eye, the nano-blink. Instead of "ain't it awful" we every moment went "ain't it grand?" it would be. It is.

Growing up sacred is knowing that the great mystery isn't always user-friendly. That it is so VAST that our puny consciousness and even punier bodies are justifiably scared. But in our fear we need blessing the vastness, glorying in our being as we are—messed up for sure, but real. At the Pueblo they say "Are you here" when somebody comes home. That's what sacred means. Knowing exactly where you are, and when. Why you are is pretty self-evident, when "sacred" is the measure of your day.

It's sunset time, maybe winter, maybe spring, maybe fall. Growing up sacred is mother stopping her supper-getting busyness and standing by the stone-deep casement of the kitchen window looking north to the Mountain (Montaño) saying, "Paula, come here." Standing with her, both looking out at the flaming sky, the blackening mesas, the dimming Road, the Mountain so turned on she's glowing.

Believe me, growing up sacred isn't easy. It's often hard, hard, hard. And brutal. And terrible. Growing up sacred is growing up scared. And filled with beauty. Which is all around, if only we look and see it. Even in the city where I live now. The sacred pigeons, the sacred spiders biting me, the sacred trashdumps, the sacred derelict neighborhoods, the sacred sewers, the sacred electronic beams, the sacred cockroaches, the sacred rats, the sacred dogshit and kitty poo. The sacred television rays, the sacred cell-phone radiances changing our brains so soon enough they

will match the new sun, the new earth. So we go that way, the sacred way, the corn way, Iyani.

Growing up sacred is growing up to know that the earth is alive, and while she has her troubles, does her change of life and not very prettily, her hot flashes scare the living daylights out of us, her creations are about as bizarre as they can get and we don't like them very much, still she is a lot more in control of her destiny that we can ever hope to be of ours. Growing up sacred is knowing that she knows what she's doing, even if we don't. Even if she does scary stuff like getting humans to make nuclear weapons and string electric wires everywhere and ruin our ozone and open her up to our deaths and, who knows, her life, still knowing sacred is knowing that nothing is as fearsome as a planet in a ritual way. Ritual means transformation, and that's what Old Lady Earth, that weird sister, the Great Sorceress is up to. She's done it before, you know. She took Old Man Winter to her breast, and she hung in there with him for eons. Summer came and went. Her sometimes sweetheart. But she's got this thing for extremes, a consequence of menopause and gestation and puberty. Those change-states of being, those dangerous ritual processes that are sacred and that wreck your life, changing you forever, moving you away from all you know, all you hold dear, they are the nature of the sacred, the sacred truth of nature. Ask the dinosaurs. They've been there, done that, and left some stony bones around to testify. But she survived. She changed—thrashed, flashed, mashed, bulged, spewed, dried, lifted, threw, grew great bumps and withered great forests. She survived, and emerged laughing and exhilarated decked in fine new clothes, new life-forms crawling all over her, decking her, amusing her, vexing her, loving her, reviling her, adoring her, plotting against her. She's the One Who Knows, and, as our cousins the Brits have it, She is THE ONE WHO MUST BE OBEYED. As one who's been there, I gotta admit that menopause is one long bout of PMS, and when you're The Earth, our dear Ma, the biggest baddest most awesome beauty-full aging woman around, WOW! The mind boggles and the smart body tries to stay out of her way.

Given all that, we would do well to follow her imperious commands graciously, respectfully, beautifully, sacredly. We might as well go like the corn grows and goes into soup and bread and cowfeed. Burning with delight. Dancing in the dry, flaming wind. Praying for rain and dancing for the awesome rage of beauty all around. Dying of grief, with a smile of gratitude and a dirty joke your final words.

Growing up sacred is understanding at last that no ceremony

is sacred without the sacred Clowns, and the role of humans under this sun

is Clown. Let us then, please, Clown sacred-ly.

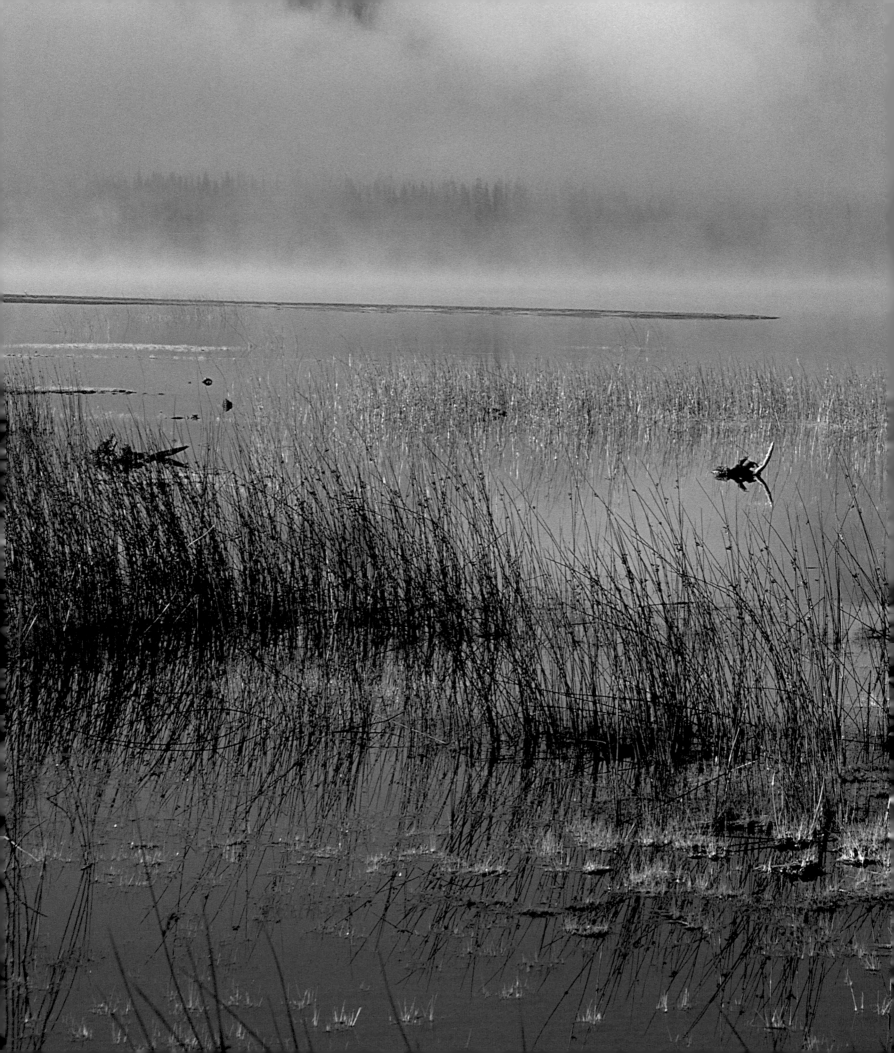

In Medicine Lake in northern California, the Creator and his son swam, thereby establishing a sacred pattern still followed by the Ahjumawi band, but the lake and its surround are threatened by geothermal development.

KEEPING A PLACE FOR PRAYER

Ahjumawi (Pit River)

When the Creator, from atop Mount Shasta, had made all the *things* of the world—the animals, trees, people—he took his son to Medicine Lake to impart his *spirit* to the world. He and his son came to the lake to bathe in the water, and afterward the Creator sent his son out into the surrounding mountains to pray. The Creator would not stay at Medicine Lake, for the world had become evil and he could not abide the evil. So he went back into the sky with his son.

But he left his spirit in the water for healing, and it remains in the lake. And ever since then, the people have come here to bathe and be healed by the spirit, and like the son, they go up into the surrounding mountains to pray in order to give their lives power and meaning.

This is the creation story, greatly abridged, of the Pit River people of northern California, as told by Floyd Buckskin, headman of the Ahjumawi Band. Like other Indian creation stories, it is tied to an actual place—in this case two places, Mount Shasta and Medicine Lake with its surrounding highlands, which lies thirty-two miles to the east. When the Creator and his son swam in Medicine Lake, Buckskin explains, this established a spiritual pattern for the people to follow. And in the Medicine Lake Highlands, he says, the Creator and his son would "do some act, speak some word, which set the sacred laws."

Were the people unable to have access to Medicine Lake and its highlands, or if the quality of the place were destroyed, Headman Floyd Buckskin continues in his quiet way, "we would be totally overcome by the evil."

Now, at the turn of the millennium, the evil

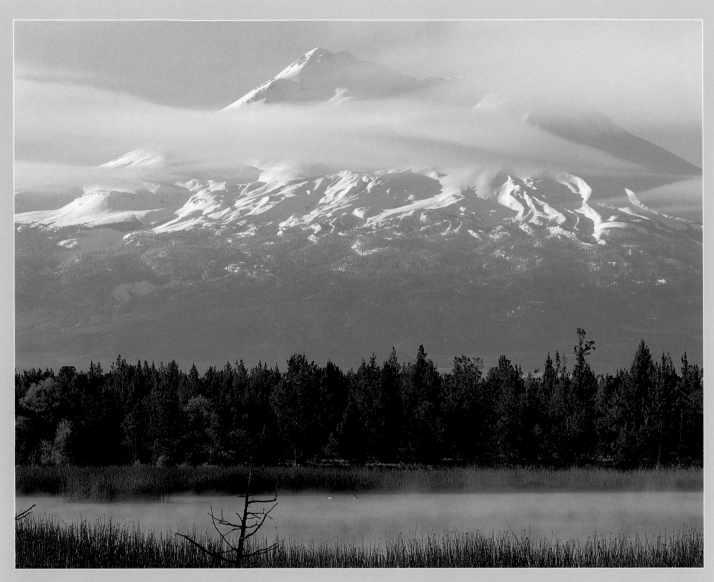

Mount Shasta, shown here with Medicine Lake super-imposed by means of an in-camera double exposure, is widely considered to be one of the major sacred mountains on earth. In ceremonial use for generations by Indians in northern California and southern Oregon, Shasta's sacred status is even mentioned in Tibetan texts, and indigenous people from as far away as Peru consider it part of their spiritual tradition.

Yet since 1978 the 14,000-foot mountain has been eyed by recreational developers as a good place to build ski runs and condos. According to representatives of the Shasta Indians, "to build a ski area in the chair of the Creator… is the ultimate insult." (For a similar problem with a slightly different standard, see page 89.)

After a protracted battle, environmental groups and Indian tribes managed to convince the managers of the Shasta-Trinity National Forest to reverse a long-standing Forest Service decision to allow development. Revocation of the previously issued permits was based largely on a finding that the area from the 8,000-foot elevation to the summit and an area called Panther Meadows were eligible to be listed on the National Register of Historic Places as significant Indian cultural areas.

Pressure for recreational development will doubtless continue for Mount Shasta, but the protection possible under the National Historic Preservation Act is heartening to Indians and their allies throughout the country. And now the Shasta Indians and others, with cooperation from environmental groups, are seeking to have the entire mountain designated a traditional cultural district. CEL

hovers over the Medicine Lake Highlands, a vast area within which fifty-five thousand acres have been leased to geothermal corporations that would draw power from a sacred place not for spiritual cleansing and vision, but for electrical energy. Medicine Lake itself is, in fact, a caldera now fed by springs.

Developing the geothermal plants would be a massive and disruptive undertaking, requiring that up to eighty wells be sunk nine thousand feet below the surface in order to tap into a pressure cooker of magma-heated rock that keeps prehistoric deposits of brine at a superheated boil. The water, which can have a temperature of from four hundred to seven hundred degrees Fahrenheit, turns to steam when pressure is reduced, and the steam can then be used to drive electrical generators.

In the mid-1980s the federal Bureau of Land Management sold leases in the highlands for this kind of geothermal development to three major energy corporations for $10.6 million. The sale took place without so much as a by-your-leave from Indian tribes.

The corporations delayed development, however, finding greater riches elsewhere, and by 1998 all but one of the leases had expired. Two years earlier, in 1996, President Clinton issued a quite explicit executive order on Indian sacred sites that might have seemed, to some, to settle the matter. "Each executive branch agency," the order states, with "responsibility for the management of Federal lands shall (1) accommodate access to and ceremonial use of Indian sacred sites by Indian religious practitioners and (2) avoid adversely affecting the physical integrity of such sacred sites." Despite these instructions, however, and ignoring a draft environmental impact statement showing that geothermal development in the Medicine Lake Highlands would have "adverse impacts," the Bureau of Land Management renewed the expired geothermal leases for forty years.

The problem lay in the executive order's fine print. Section 3 states that agencies should not use the order to "impair rights to the use of Federal lands that have been granted to third parties." And Section 4 states that the order is merely an internal administrative guideline and not "enforceable at law or equity by any party." Effectively, then, the executive order was just a scrap of paper. The Indians

could (and did) appeal the government decision in league with environmental groups—under the aegis of the Native Coalition for Medicine Lake Highlands Defense (of which Floyd Buckskin is chair)—but on the grounds of environmental impact and procedural impropriety, rather than on the constitutional guarantees of freedom of religion that the Clinton executive order intended.

Still, the environmental impacts are dire enough: geothermal development can cause a major change in groundwater levels and reduce the flow of springs, such as those feeding Medicine Lake. The extraction of hot water can also cause subsidence in the drilling areas, with collapses on the surface of the ground that damage religious sites, roads, utility corridors, and much else. The steam and water brought to the surface include a variety of extremely toxic salts, heavy metals, and in some cases radioactivity. An experimental well site in the highlands is, in fact, surrounded by a sturdy chain-link fence with large red signs warning that the foul-looking puddle it encloses is poisonous. Air quality is also affected. A common constituent of geothermic steam is hydrogen sulfide gas. Finally, geothermal plants are exceptionally noisy, driving away wildlife, outdoor recreationists, and the worshipers.

On such grounds, the permit for one of the power plants to be built a half mile from Medicine Lake, has been denied. The other plant, to be two and a half miles away, still threatens, and partial victories are no solace to the preservationists. According to one estimate, at least six huge plants shattering the stillness and fouling the air and water and

land could be accommodated by the proposed three-hundred-megawatt transmission corridor.

Clearly, the Medicine Lake Highlands should not be sacrificed to the state's errant energy policies. Should geothermal development come to pass, the spiritual value of the lake for cleansing and of surrounding holy places for healing power and vision would be greatly diminished, and thus the people would, in the Ahjumawi view, be overcome by evil. "We must make a place for the sacred," Floyd Buckskin says.

At length, in the summer of 1999, in response to such Native sentiments, the Keeper of the National Register of Historic Places declared the Medicine Lake caldera within the highlands "an interrelated series of locations and natural features" eligible for designation as a Traditional Cultural District. The Keeper, Carol Shull, based her decision on the importance of the area in maintaining Native American cultural identity.

What is often forgotten in disputes of this kind is that the land does not belong to this or that agency of government, but to the *public*. And on this *public* land the Ahjumawi, Shasta, Modoc, and

Mount Shasta presides over an ancient volcanic landscape where obsidian abounds in the lava flows of Glass Mountain and others.

other Indian tribes and bands have a claim and a right to its use related to the free practice of religion, as provided in the First Amendment of the Constitution and specifically in the American Indian Freedom of Religion Act. But explicit legislation is called for that gives sacred lands at least a fighting chance. (For more on this topic, see Postscript.)

At the edge of Medicine Lake itself, Floyd Buckskin speaks of his hope that this sacred geography will be protected. When he has finished speaking, he walks out to a sandbar, a traditional place of prayer, and, turning to the east, asks the spirit for healing and understanding. After the prayer, which is in his language, Palaihnihan, he walks slowly into the water—he is fully dressed—until it reaches his waist. He leans forward with cupped hands to bring the cleansing water to his face. He turns again to the east and prays.

Later he says, "This is the place for quiet. Once you go to the lake to say a prayer, that's when good things begin to happen. Maybe not all at once. But they will happen." 🖌 CEL

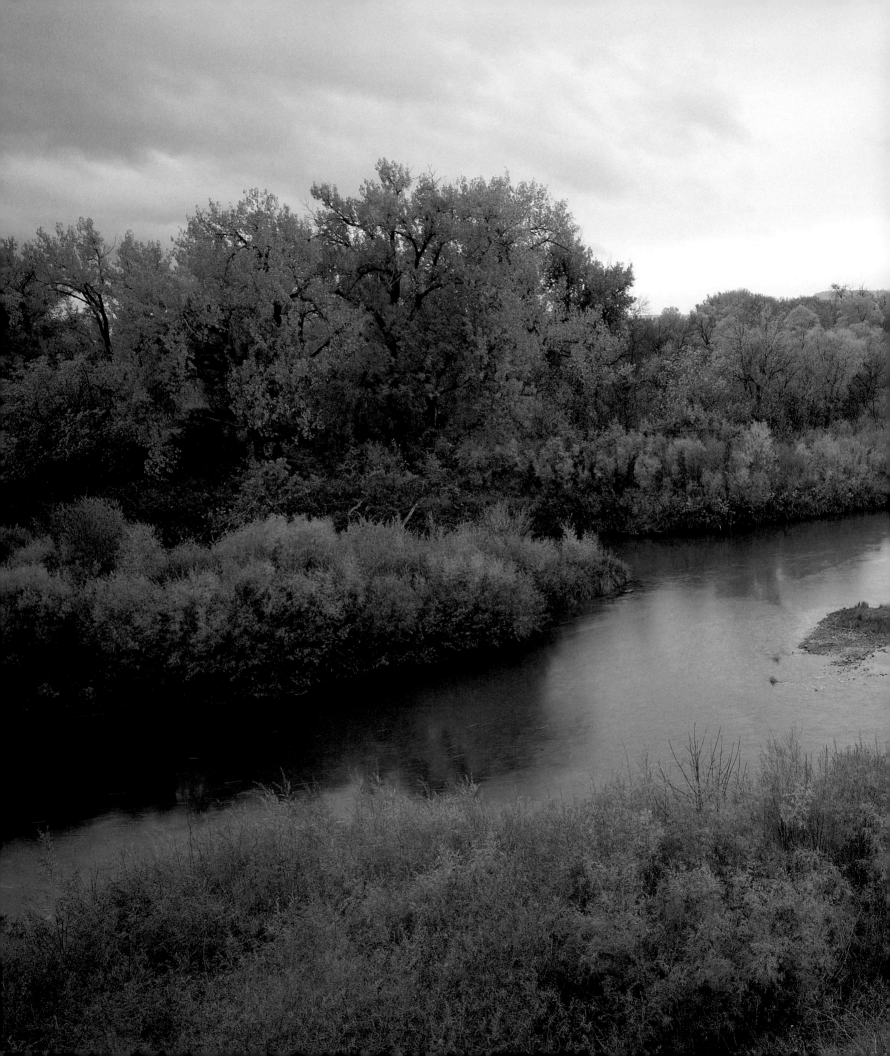

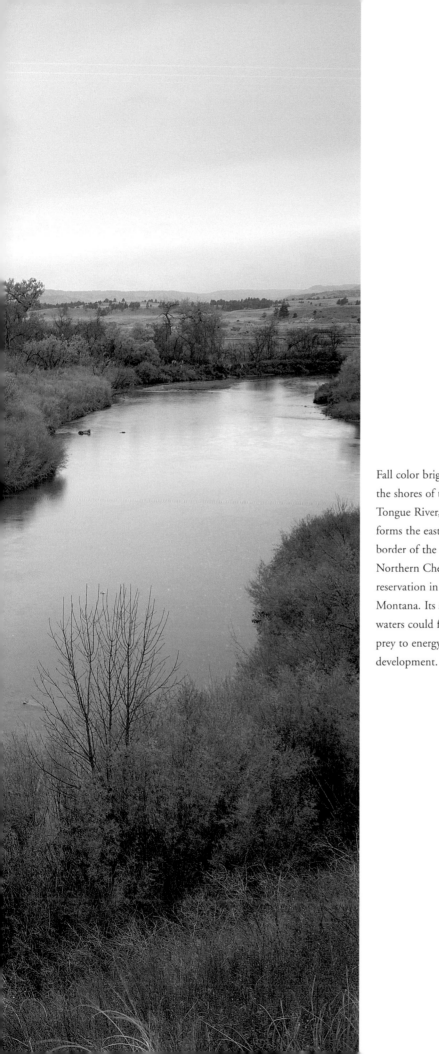

Fall color brightens the shores of the Tongue River, which forms the eastern border of the Northern Cheyenne reservation in Montana. Its sacred waters could fall prey to energy development.

RIVER OF LIFE

Northern Cheyenne

A golden afternoon, hot in autumn sun, and the horses wind uphill, down, across plowed land, across the paved road, across gold grass to the edge of the Tongue River. The trees at the edge of the Tongue are golden. The horses enter the river to drink, the stream riffling about their legs. On the far side there are woods. On this side, there is an endless time, as if what is now is forever.

Rock cairns along the Tongue mark places where something happened, something important, something to be honored, protected forever. The river moves past the cairns, past the autumn trees, past the centuries.

About a mile and a half west of the river, Zane and Sandra Spang operate Cheyenne Trailriders, a horse operation that takes guests on trips of hours or days. Family land runs to the river's edge. The Spangs are both Northern Cheyenne, born and reared on the reservation, and they offer guests an opportunity to enter Cheyenne country in a way appropriate to the land. Zane Spang has just returned from a ride along the river. He holds a grandchild on his lap as he talks about how Cheyenne elders view the Tongue. "They say the water is sacred," he says. "Water is life."

The sacred water on the reservation is currently threatened by coal bed methane gas development. Methane is a benign, clean-burning fuel, but for the Northern Cheyenne it is another matter altogether. Coal bed methane is extracted by drilling wells that, at first, produce mostly water because fractures in the coal beds are usually filled with water and water pressure holds the methane in the coal bed. To release the gas, huge amounts of water are pumped out of the coal bed acquifers. In southeastern Montana, the country of the Northern Cheyenne

Reservation, many communities and ranches draw their water from coal bed aquifers. Even though the communities depend on the aquifers, the gas companies do not need to acquire water rights to pump the water out because this water is legally considered—of all things—a waste product.

Apart from the possibility of depleting the aquifers, there is further potential danger. If the water is relatively unpolluted, the companies propose simply to discharge it on the ground. But much of the water is highly saline and rich in sodium, unsuitable for irrigation or livestock without diluting it with water from other sources. So these water discharges could flood ranch land, cause erosion, and harm fish and other aquatic wildlife in streams flowing into the Tongue River and Rosebud Creek.

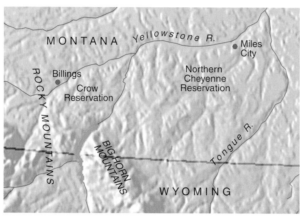

The Tongue forms the eastern border of the 444,000-acre reservation. Rosebud Creek crosses its western side. In addition to polluting these watercourses, the methane gas wells may produce carbon dioxide and hydrogen sulfide that could be vented directly into the air. Gas-powered compressor stations and motor vehicles used to maintain the coal bed methane development will produce yet other pollutants. The likelihood of underground fires in coal beds increases when water is removed.

These are serious consequences for the reservation, which has a class I air rating, a pristine status, both prized and protected. A few miles north of the reservation, the Colstrip power plants provide much of the energy for the state of Montana. Years ago, the tribe successfully demanded that they agree to clean the smokestack emissions. Cheyenne stations on the reservation's north side monitor those emissions continually.

In other words, the Cheyenne are tough. They have so far spent twenty-seven years fighting a proposed railroad along the Tongue River's edge. The railroad would bring noise and fuel pollution, besides literally running over sacred sites along the riverbanks. It was originally intended for the reservation side of the river, but the tribe was able to get plans for it to be moved to the opposite bank, which is off the reservation. While there is a certain victory in this, it actually isn't much better. There are burial sites and other ritual sites on the east side of the river as well and medicinal plant areas where the Cheyenne go because none of those plants grow on the reservation side. The problems caused by the railroad will not stay on one side of the river or the other. The desecration is the same, wherever the tracks are placed. The project is on hold for the moment—current economics of transporting coal from Colstrip does not warrant the expense of building the railroad—but it has not been abandoned.

Clifford Long Sioux, a ceremonial leader of the Northern Cheyenne, has worked years to protect the Tongue River. He has dedicated his life to saving what the Northern Cheyenne have—their land and their culture—for the generations to come. He fought against (and continues to fight) the railroad. He is fighting against coal bed methane development. He has lived his whole life on the reservation and was recently elected to the board of the Northern Plains Resource Council, the organization devoted to protecting the land and resources of the Northern Plains. In other words, he makes use of every possible approach to protect this river and this land, entering into both the political activism of a white environmental organization and maintaining Cheyenne spiritual practices such as praying for the health and safety of the Tongue River by organizing a series of sweat lodge ceremonies.

"I want to help protect this land," he says. "I want to help protect our way of life. I'm concerned about our future generations. I want them to live in a good place, in a good environment. I want to leave something for them so that they can live peacefully here, on this little piece of land we have. I vote against any development because this is our way of life. This is the way we practice our Indian religion."

Speaking about the connection of people to air, Clifford refers to his experience with the Colstrip power plants: "If it [methane gas development] does go through, who's going to benefit from it?"

he asks. "Naturally, the gas companies, but what about the people that live here? What about the people that have to live here for the next hundred years? They're going to be affected if all the water is taken out of the ground. Then where's our water going to come from?"

He knows there are coal bed methane wells currently operating at Decker, just south of the Tongue River Reservoir, a few miles southwest of the reservation. He has seen videos of things happening in Wyoming, where a rancher lost eight of his nine wells.

"All his water was gone," Clifford says. "Is that going to happen here?"

Northern Cheyenne elders here have always opposed development. In the early 1970s, ceremonies against coal development were held. "The elders say if you go against the Arrows, then these Arrows can harm you," Clifford says. "That's the belief that we have here." The Sacred Arrows are one of two Cheyenne spiritual icons. Received at Bear Butte (see page 39), they are held by the Southern Cheyenne in Oklahoma. The other, the Sacred Hat, is kept by the Northern Cheyenne.

"Are they going to dig up our people who are buried across the river?" he asks.

After the tribe won a year-long battle for the right to cancel the leases of companies wanting to exploit the coal resources lying under the reservation, ARCO arrived in the late 1970s, drilled exploratory oil wells, then moved out in 1984. "They ran right over these grave sites," Clifford says,

"and they were not considerate until some of the people, especially the elders and ceremonial people, made an issue of it and said, 'This has got to stop. We can't do this to our people.'"

According to a U.S. Department of Agriculture memo written in March 2000, gas production increases steadily for a few years, then gradually declines. While the companies hold out the possibilities coal bed methane offers for employment on the reservation, the jobs are no more permanent than those in any other boom-and-bust resource-based industry. Because the tribe retains mineral rights to its land, it would, at least, receive payment for anything found eighteen inches below the surface. But even this is temporary, only for as long as the methane holds out. It is also, perhaps, no compensation for the problems caused in watercourses and wells, or for the potential air pollution, or for the visual degradation from wells that are set up on a grid pattern every twenty to forty acres and then connected by pipelines, power lines, compressor stations, and roads.

"The elders say, if you start digging the black rock [coal], then you'll lose sight of your way of life, the covenants that we have," Clifford Long Sioux says. "There's consequences that come with that. The elders have always said that. That's one of their teachings."

Coal bed methane is one more black rock. While they have yet another fight on their hands, it seems the Northern Cheyenne elders will never let it cost them their way of life. 🔥 RR

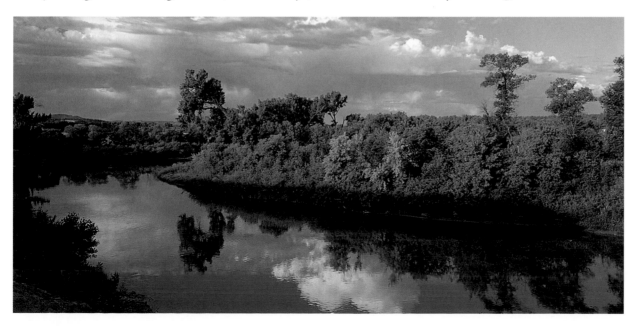

Cheyenne ancestors lie buried under the shores of the Tongue River.

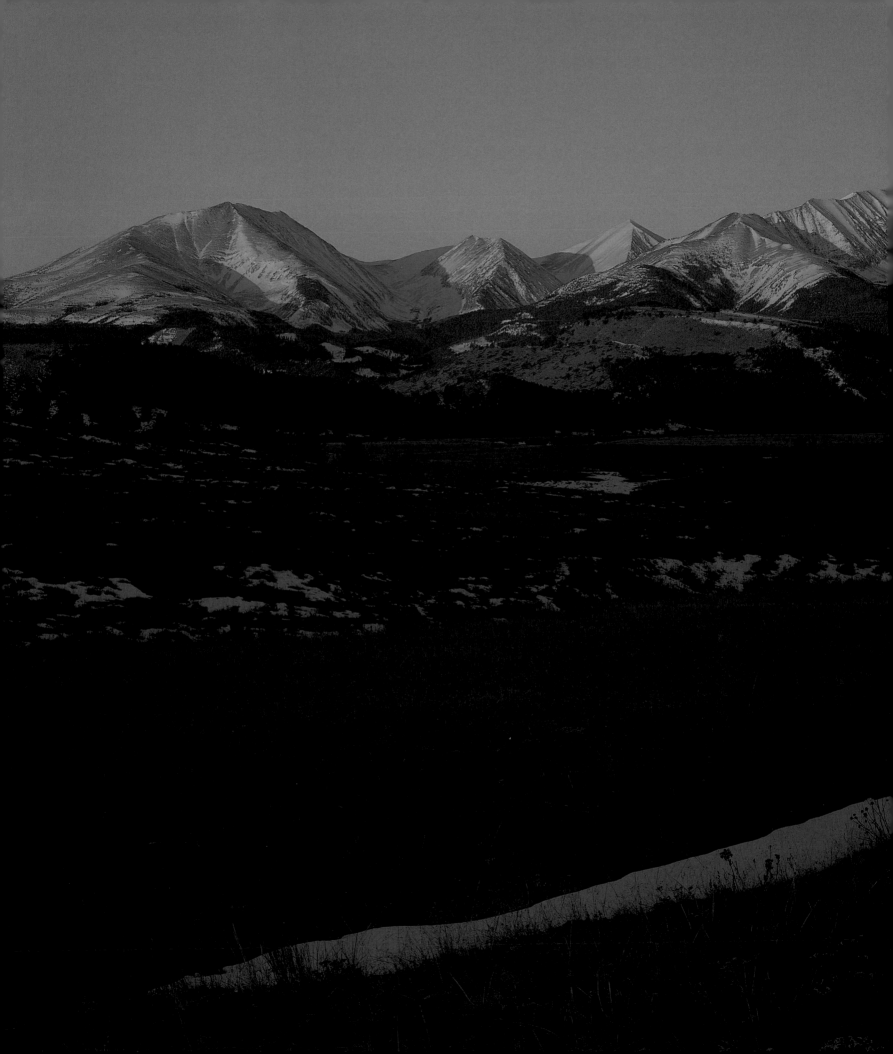

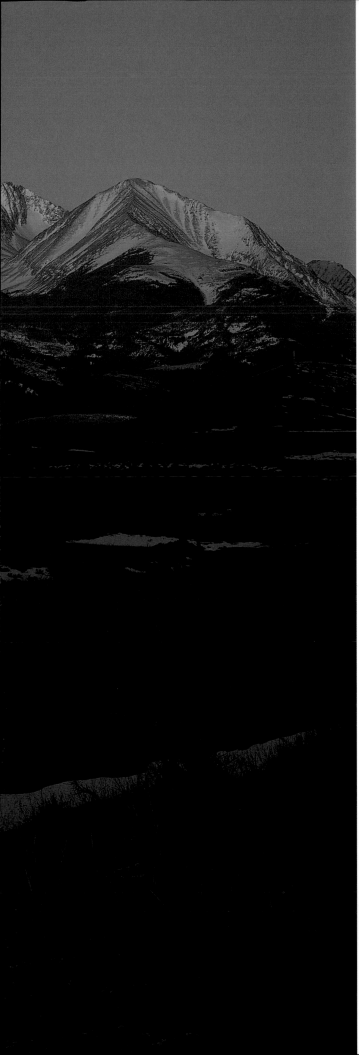

First light sets Montana's Crazy Mountains ablaze. The range has long been part of Crow Country, where the people still go to seek visions in the mountains' treacherous crags and extreme weather.

TREACHEROUS MOUNTAINS

Crow

"The Crow Country is a good country," the great Crow war chief Arapooish said in 1833. "The Great Spirit has put it exactly in the right place.... Everything good is to be found there."

The Crows entered their good country in the late seventeenth or early eighteenth century, a hundred years after Chief No Vitals had a vision in which he received sacred tobacco seeds he was told to plant in the mountains. Their migration lasted a hundred years, but they knew they were home when they reached the mountains of north-central Wyoming and south-central Montana.

North of Yellowstone, east of the Rockies, they came upon an island range standing alone on the edge of the prairie—the Crazy Mountains, Awa xa ipia. Conceived by volcanoes, sculpted by glaciers, knife-edged and sharp-angled, the mountains soar six thousand feet up from the floor of the prairie on the east and just as abruptly from broad river valleys in every other direction. High cirques carved by ancient glaciers hold green, cold lakes. Water bounds down from the heights, glittering in rushes and waterfalls to lie easy in the summer meadows. Parks edge into subalpine forests. Meadows are vibrant with paintbrush and lupine, shooting stars, arnica, and larkspur. Views from passes and peaks encompass the world.

The Crazies were included in the Crow Reservation by the treaty of 1851, when over thirty-five million acres were reserved to the tribe. Twenty-seven million acres of that were taken away by the treaty of 1868, when the reservation was cut down to eight million acres. Chief Sits in the Middle of the Land, representing the Crow in this second treaty conference, was asked the boundaries of his land.

"The Crow Country is where I set my tipi," he said. "When I set my tipi, I use four poles. One pole rests at the western slopes of the Black Hills, another pole rests at the banks of the Big Lake in the Mountains [Yellowstone Lake], the third pole rests near the Big Falls of the Big River [Great Falls], and the fourth pole at the junction of the Yellowstone and Missouri. That's my land."

"We practically got all that in '51," Joe Medicine Crow, the Crow tribal historian, says. Descended from a long line of Crow war chiefs, this vigorous eighty-seven-year-old man was the first Crow to graduate from college and the first to earn a master's degree (in anthropology). "It's been sliced away ever since," he adds.

There are many white stories about how the Crazies got their name (most of them having to do with a woman going crazy in them), but the name is actually a mistranslation of the Crow name, Awa xa ipia—which means treacherous or mean mountains. According to Joe Medicine Crow, the translators were non-Indians who spoke a little Crow and got it mixed up. The sign language for sacred is the hand spiraling upward. The sign for crazy is also an upwardly spiraling movement of the hand, but in the opposite direction.

"The reason the Crows call it Treacherous Mountains," Joe Medicine Crow says, "was that when people go up there, pretty high up there in the main part of the mountains to fast, hunt, or whatever, sudden storms come up. High winds. And in the fall, snow. Or rain in summer. So weatherwise, it's not a pleasant place. They seemed to get hit by adverse weather conditions. Also, when people go up there to fast, they would be approached by an evil spirit who would harass them, try to scare 'em

The silence of the Crazies' forbidding peaks is threatened by today's fad in extreme (and extremely noisy) motor sports.

off. And some Bigfoot up there would come in and harass people. So, altogether it is a kind of treacherous, mean place. And we kind of stay away from it. It's so sacred, it's like that, you just better not go in there too often.

"My grandfather, Chief Medicine Crow, went up there when he was a young man," he continues. "He and several others. Went up there, way up on top, the highest part. A snowstorm came, covered them, so cold and windy, miserable. They all took off except him and another one. They stayed through. Got covered with snow, but they stayed through, received some power."

Chief Medicine Crow and Chief Plenty Coups were contemporaries, both growing up in prereservation days, both living out most of their lives on the reservation. Plenty Coups also went into the Crazies on a vision quest. It was 1858, and he was a young boy. When he came out, he told his people that the buffalo would disappear from the plains, that a race of white men was coming. This vision influenced the Crows to ally themselves with whites rather than war against them. It is the reason Crow scouts aided Custer at the Battle of the Little Bighorn.

The Crows continue to climb to the high peaks of the range to fast. "Recently several of our young men did that," Joe Medicine Crow says. "And they had frightening experiences with an evil power that comes around there. But they also received some good, powerful, beneficial blessings by beings up there. At first, one of them reported that he almost decided to run off. But he stayed, persisted, and that thing finally left. So I don't know...."

The Crazy Mountains are a checkerboard of private and public ownership. Public land, managed by two national forests (the Gallatin and the Lewis & Clark) and split into three ranger districts, is interspersed with private land. Most private landowners in the range are protective of the land, but some, seeing themselves sitting on a gold mine, are waiting to see how well a landowner in the Absaroka Range, south of the Crazies, does with the sale of a tract of controversial top land. The game being played is for the landowner to claim his land will be developed, raising outrage among environmentalists, who will ultimately force the Forest Service to buy the land—for a huge sum of money.

For years, environmentalists have worked to consolidate ownership and get wilderness designation for the Crazies, but the state of Montana has been unable to get a wilderness bill passed in Congress. Nor does this seem likely in the near future. Meanwhile, logging and roading continue. The use of ATVs grows, abetted by ads promoting the Crazies as a snowmobiler's paradise. In the village of Wilsall, on the west side of the range, the Crazy Mountain Extreme Motor Sports shop installs extra-powerful engines in snowmobiles of various manufacturers. These retrofitted machines can reach extreme speeds, blast through unbroken powder, and easily travel off trail and up to the high peaks. Although some trails in the southern part of the Crazies are off-limits to motorized vehicles, the forest travel plan in essence shows you can drive snowmobiles and ATVs anywhere *off* trail in the

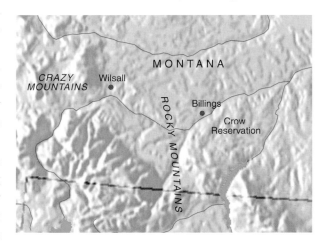

range. Snowmobiles disturb the peace of what was, not terribly long ago, a place of wild and profound silence. ATVs, motorcycles, and Jeeps tear up the ground as well. In places, trails have been so torn up by these vehicles that they have all but disappeared.

"The Crazy Mountains has always been the holiest of all the Mountains used by our people for fasting and vision quests," Burton Pretty on Top, Sr., wrote to the Livingston district ranger in 1997. Pretty on Top wrote as a representative of the Crow Cultural Commission, objecting to snowmobile routes that would open the roadless areas in the range to motorized use. "The Spiritual significance that the Crows had with this Holy Mountain was known to the other Plains tribes," he continued. "In times of attacks from other tribes that outnumbered us, we would run back to Awa xa ipia for protection. Once we entered into those canyons, the enemy would retreat and leave because they knew

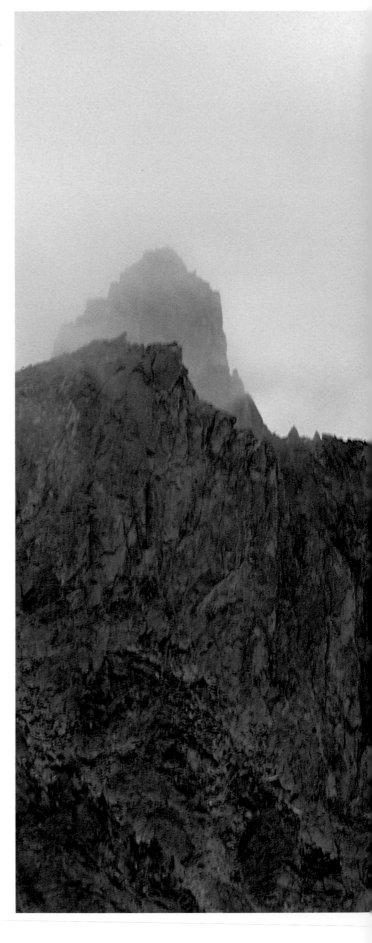

this Mountain was our sacred protector."

In accommodating ATVs, the Forest Service has overridden its own regulations. At the instigation of off-road vehicle manufacturers, the traditional "forty-inch rule" was changed in 1990 to allow the local forester to increase the width of a trail to fifty inches on the ground. Forty inches is the legal width of a trail in all national forests, specifically designed to cut out motorized vehicles. Fifty inches accommodates them nicely. This change was made without any official environmental review. A suit brought by the Montana Wilderness Association in the late 1990s challenging the introduction of ATVs in areas covered by the Montana Wilderness Study Act has still to be resolved. While the suit was not about the Crazy Mountains, the ruling will have an effect on how land is managed there. If the judge finds the Forest Service violated the rule, he can reverse the Forest Service change and close the trails to wheeled vehicles.

Whatever the legal finding, the Gallatin Forest has already violated its own agreement to consult the Crow Tribe before making any decisions involving the Crazies. In a settlement agreement signed in June 1992 the Forest Service agreed to "insure that the Crow people are informed and involved in Forest Service decisions that could have an effect on traditional cultural properties in the Crazy Mountains." It agreed to "have a formal process which would allow the Crow Tribe to comment on proposals in the Crazy Mountains which may affect them." No such thing happened.

"The peace and quiet, the beauty and the sacredness of the whole mountain should not be disturbed by motorized vehicles," Burton Pretty on Top wrote.

The sanctuary Awa xa ipia has provided the Crow for three hundred years is a sacred trust in a place where the U.S. Forest Service is the newcomer. Here, once again, we have feds versus Indians. It is an old story, with the same federal agency (the Forest Service) unsympathetic here while sympathetic and cooperative elsewhere in similar situations (see page 29).

Although these mountains were snatched away from the reservation, they continue to provide the Crow with the possibility of silence and of wildness, a place to fast, to seek a vision, a blessing. What is left to the Crow is what Awa xa ipia has provided them for three hundred years. 🔥 RR

Mist shrouds the precipitous cliffs of the Crazies in the Gallatin National Forest, a place for frightening visions and lasting blessings.

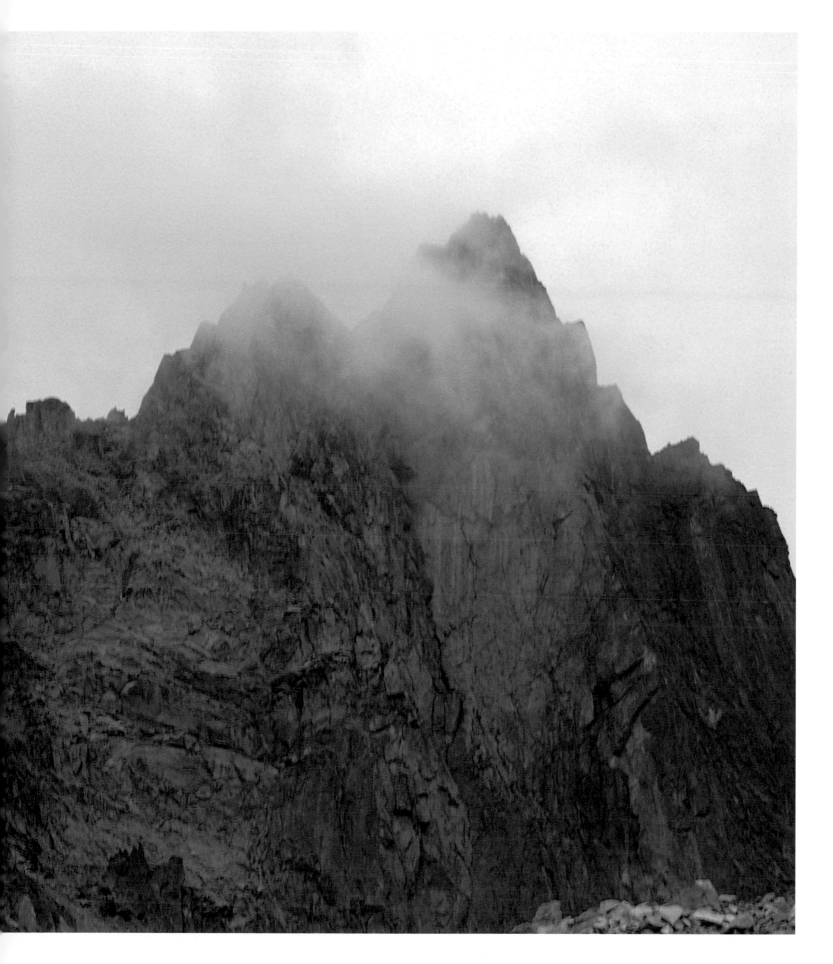

In California's San Marcos Pass, cave walls bear the sophisticated rock art of the village-dwelling Chumash Indians, a coastal culture dating back nine thousand years.

A HERITAGE IMPOUNDED

Chumash

In 1912, Smithsonian ethologist John P. Harrington recorded a teaching about Humqaq by Maria Solares Qilikutayiwi, an old Chumash woman. Humqaq, known as Point Conception to non-Indians and as the Western Gate to the Chumash, is on the southern California coast north of Santa Barbara. After death, Maria Solares Qilikutayiwi said, the people of her town could see a soul passing on the way to Humqaq, thence to depart from the world. And then they would hear a loud noise. It was, she told Harrington, "the sound of the closing of the gate of Similaqsa [the afterworld] as the soul entered." This is her teaching:

> The soul goes first to Point Conception, which is a wild and stormy place. It was called Humqaq, and there was no village there. In ancient times no one ever went near Humqaq. They only went near there to make sacrifices at a great *sawil* [a shrine]. There is a place at Humqaq below the cliff that can only be reached by rope, and there is a pool of water there like a basin into which fresh water constantly drips. And there in the stone can be seen the footprints of women and children. There the spirit of the dead bathes itself. Then it sees a light to the westward and goes toward it through the air, and thus reaches the land of Similaqsa.

This is one of the primary beliefs of a people who, before the Spanish came, were the largest, most permanent, and most sophisticated indigenous culture in the West, with indications of settlement dating to nine thousand years ago. At their pre-Columbian peak, some fifteen thousand Chumash lived in permanent "towns" in a benign and beautiful two-hun-

dred-mile-long coastal region (plus some inland areas) running from the lower end of the Santa Lucia Range (Big Sur) down to the beginnings of the Santa Monica Mountains (near Malibu). Legend has it that the first people had come to the mainland from the Channel Islands, some thirty miles offshore from Santa Barbara. The word *Chumash* is, in fact, a Spanish corruption of a term referring to an islander.

A few of the aboriginal towns had populations of a thousand, but more typically there were one or two hundred people in a village. Some settlements even had streets; all of them contained *temescals* (sweat houses), a field for games, a fenced cemetery, and a shrine for offering food and money in the form of carved shells (these were among the earliest Indians to have currency), where religious ceremonies were held. The *tomols,* the superbly designed plank canoes used for fishing and trading, were pulled up on the beach. Because of the climate and the abundance of food and materials for shelter and tools, the Chumash had the leisure to develop a highly organized social structure, far-flung trade routes, a rich oral literature, and an extraordinarily complex theology.

Today some three thousand Chumash live scattered about their original homeland, but few Americans outside of southern California know anything about these people. The main reason is that these Indians were enslaved, even hunted down and murdered, their beliefs expunged courtesy of the Spanish missionary system, utterly dispossessed. "The treatment shown to the [Mission] Indians is the most cruel I have ever read in history," wrote Spanish priest Antonio de la Concepción Horra in 1799.

Despite this lamentable history, however, the Chumash are alive and well and desperately trying to save what is left of their once vivid heritage— including their heritage of sacred lands.

Of special importance are three sizable tracts of historic coastal land that remain in large ownerships and so far, at least, are relatively intact: Point Conception, now a gated community of large estates near Santa Barbara; Vandenberg Air Force Base, a heavily guarded ICBM installation whose main access is via Lompoc, a prison town; and a stretch of high-security oceanfront containing a nuclear power plant near San Luis Obispo. Ironically, while these ownerships have kept the sacred lands relatively free of the high-density residential and commercial development that has destroyed so much of this part of the California coast (and the heart of the Chumash homeland along with it), the sites are nevertheless impoundments. They are off-limits except by special arrangement to any Chumash who might wish to travel to them for spiritual or ceremonial purposes or just to understand a heritage.

For example, Paul Pommier, a historian, cultural consultant, and founder of the Mission Barbareño Chumash Committee, recently tried to visit Point Conception, only to be turned back at a guard post athwart what had once been a public highway. The guard was suitably apologetic but firm. No entry,

From a cave anciently inscribed by Chumash ancestors, the highlands stretch toward the ocean.

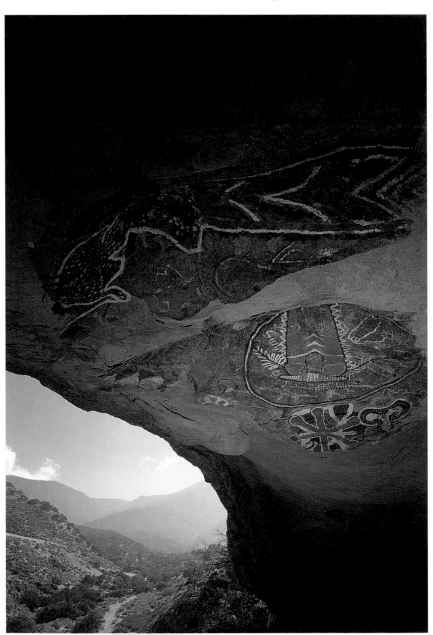

A Heritage Impounded

even for a Chumash official on an official visit.

For Paul Pommier and a colleague who accompanied him, Marcus Lopez, a traditional *tomol* builder and Indian activist, being turned back at a guardhouse was an insult. Yet both agreed that the land in the hands of wealthy estate owners was probably safer than if public access were easier. The owners have, in fact, created a conservancy district to protect the site. "We are still allowed to go to Point Conception for ceremonies if special arrangements are made," Pommier says. "And we are glad it is recognized, preserved at least for a while. But sooner or later, private ownership will destroy the land."

In fact, as Marcus Lopez points out, Point Conception was very nearly lost in the 1970s when an industrial consortium proposed a natural gas terminal on this pristine coastline. The Chumash and their allies occupied a part of the point for nine months, protesting the development. "It was designated a spiritual encampment," writes Michael Khus, a leader of the Coastal Chumash Council, "and time was taken up with sunrise ceremonies, sweat lodge purifications twice a day, communal meals, camping chores, around-the-clock security, hunting and fishing expeditions, and singing and storytelling at night." In the end, confronted by this spiritual power, the consortium that was to build the liquid natural gas (LNG) facility fell apart and the scheme collapsed.

Adjacent to the Point Conception estate country is another guard-posted, fenced-off shoreline area, Vandenberg Air Force Base. This supersecret ICBM installation is also the location of the ancient Chumash towns of Xoqto and Saspili plus some thirty miles of sacred coastline. Recently entrepreneurs have sought to convert the southern section of Vandenberg into a private, profit-making launch pad—the California Commercial Spaceport. The development of the spaceport will burden Point Conception with fallout from spent rocket fuel as well as destroy a number of religious shrines, including Rattlesnake Shelter, where quartz banding reflects the sunlight in a seemingly mystical way and where major examples of ancient rock art are to be found.

The northernmost stretch of impounded Chumash coastline consists of some fourteen linear miles totaling fourteen thousand acres, owned (an odd concept considering the thousands of years that

Indians lived here) by the Pacific Gas and Electric Company (PG&E). The company purchased the land in 1985 to provide a security buffer for the controversial Diablo Canyon nuclear power plant. The

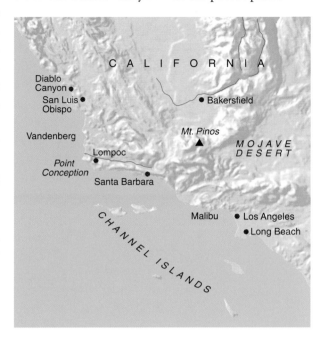

plant itself is situated in a centrally located 585-acre compound.

To gain access to the site, visitors must call in advance and state their purposes, provide a social security number so that it can be checked by authorities, and be escorted at all times. The entryway consists of a guardhouse and a forbidding, twelve-foot chain-link gate, but once the visitor is around a couple of curves, the magnificent sea-pounded coastline comes into view. The landscape is rolling, with flattish fields sloping to cliffs that rise fifty feet or so above the crashing surf. Where creeks enter the sea, there are narrow beaches that once gave access to the water for the *tomols* and where the people gathered shellfish from the intertidal zone. Then suddenly, as the visitor drives along, the nuclear plant looms surrealistically into view. But just as suddenly, after one drives through the reactor site, the plant disappears from view around several more curves, and the unruined coastline is intact again—a kind of miracle that suggests when this power plant is obsolete and nonfunctional in fifty years or less, the domes and stacks can be dismantled and destroyed and the beautiful primeval coastline will become whole.

For Mark Vigil, chief of the Obispeño Chumash and a cultural consultant, the ownership of the land

The Canyon Diablo power plant now squats over the Chumash past.

by PG&E is both maddening and beneficial. On the one hand, he wonders why he, of all people, with his hereditary responsibility for protecting the Chumash culture, should be vetted and then escorted by those who have intruded without a by-your-leave on sacred Chumash land.

On the other hand, the alternative to PG&E ownership would be for the land to be cut up into estate properties for the wealthy, grossly disturbing burial and other sites. "We Chumash," says Vigil, "think it is better to have PG&E rather than developers. We hope it remains as a natural landscape." In fact, PG&E has already agreed to provide a conservation easement on an estimated two thousand acres in the northern part of the tract as part of a settlement with the state of California for discharging warm water from the nuclear plant into the ocean. Meanwhile, according to Tarren Collins, pro bono attorney for the Obispeño Chumash, state, county, and private organizations such as The Nature Conservancy hope to establish some sort of preservation scheme before the presumed closing of the plant in 2025, although the federal license to operate the plant might be renewed.

For the Chumash the protection of the impounded lands along the coast as well as other sacred sites on the Channel Islands and inland, such as at Mount Pinos (Iwihinmu—a sacred peak), is a never ending challenge. It is made even more difficult by the historic separations of the different Chumash communities scattered throughout their southern California homeland. Altogether the Chumash are divided into eight major groups, based on original language, and because there are no native speakers of any kind now alive, this has tended to make difficult any pan-Chumash efforts to assert their right to a heritage. A further division is created by the existence of a small Chumash reservation at Santa Ynez. The Ynezeños are a federally recognized Indian tribe, with all the benefits that confers, but their reservation land amounts to 128 acres and is home to only a hundred members of the Santa Ynez Mission Band. But because the Ynezeños have an official government (and a casino), some believe they speak for all Chumash, when in fact they represent only a tiny fraction of the Chumash population. The remaining Chumash are "landless," federally unrecognized, and therefore powerless except in their assertion of moral rights.

To remedy the power imbalance and political disconnection, a continuing effort is being made by many to unite the Chumash. In the view of John Anderson, a scholar who has studied Chumash social organization and religion for twenty years, a cultural consolidation is essential if the Chumash are to recapture their heritage, which in substantial part is a matter of reasserting their moral right to have a voice in the management and use of traditionally sacred lands.

For many Chumash, especially those who have family recollections of the villages along the coast, a return of the ancestral lands would help ease the

great spiritual void that many feel so keenly. One of these is Mary Trejo, a pleasant-faced, soft-spoken Chumash elder born in 1917, who tells of the village where her great-grandmother—Rosario Cooper— was raised, situated along the San Luis Obispo coast near the present town of Avila Beach.

Mary Trejo's grandmother, Rosario's daughter, would show her grandchild the various places along the fertile shelf above the sea where the villages were and where her family had lived in thatched huts before the Spanish came. She taught Mary where the good plants for medicine and food could be found, how to catch fish and to gather abalone and clams along the sacred shoreline. And she told the stories of the people. Now Mary Trejo does the same for her own grandchildren, in a transference of a culture and a spirituality of the land that, when her grandchildren themselves become grandparents, can continue unbroken down the generations.

But of course, it all depends on the land, and whether the land will be saved or, like so much of the southern California shore, will be buried beneath an impenetrable layer of condos and shopping malls. "If we lose the sacred land," says Mary Trejo quietly, "we lose the culture, and then we lose everything we stand for." 🪶 CEL

The Chumash occupied Point Conception for nine months in the 1970s to head off a liquified natural gas terminal. A nearby gated community of large estates blocks access to the point and the Chumash need permission to go there.

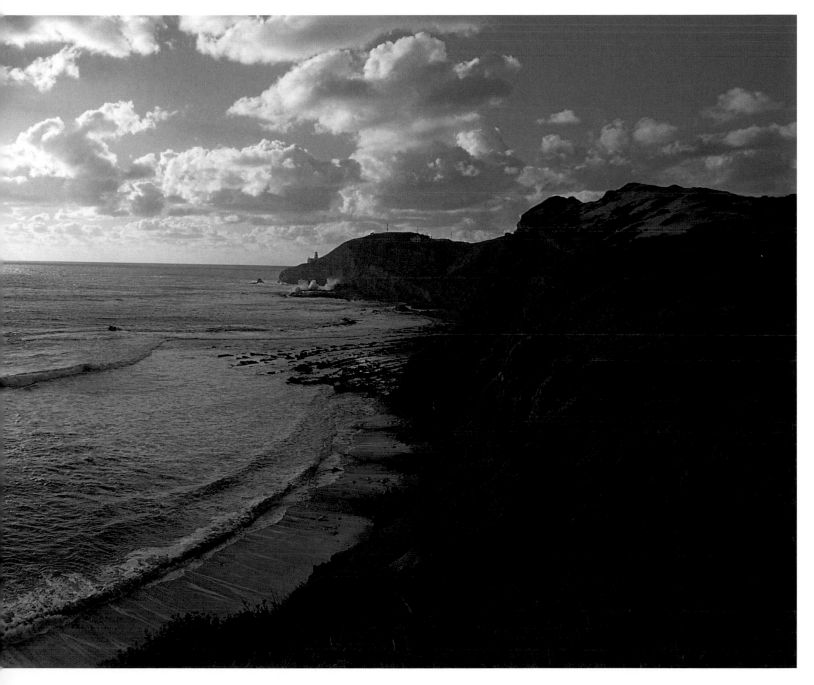

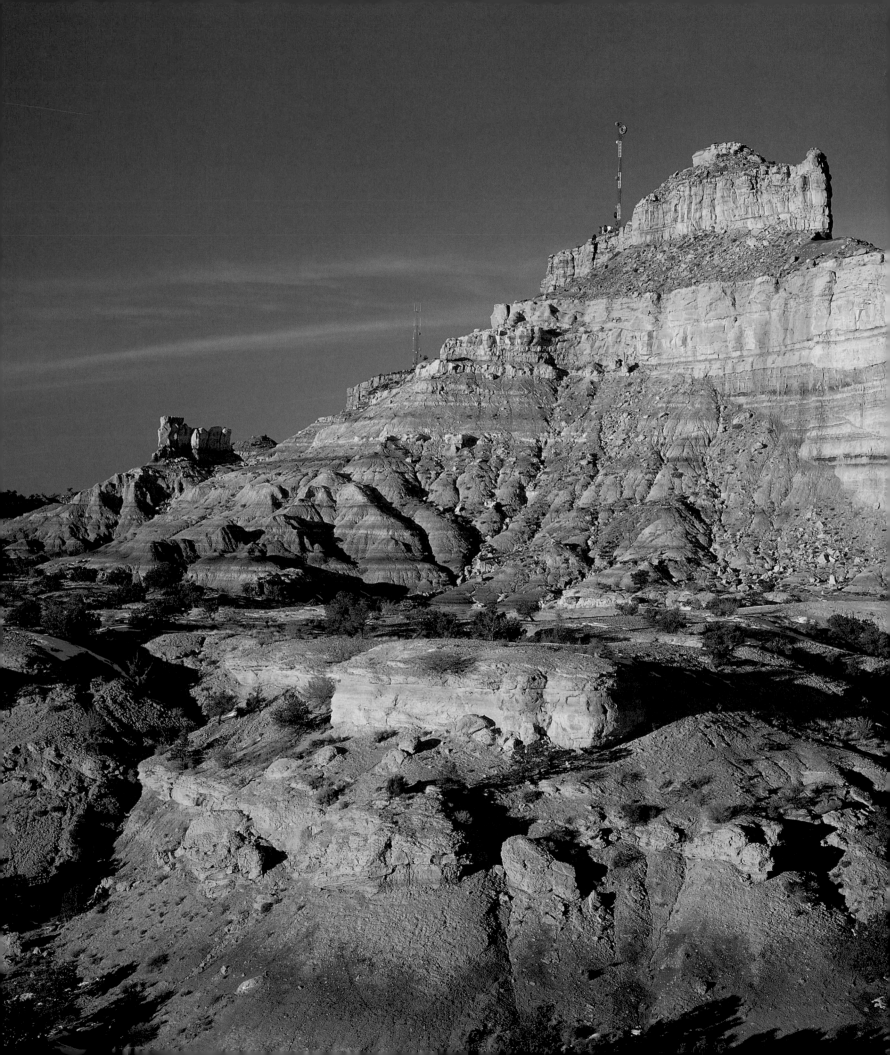

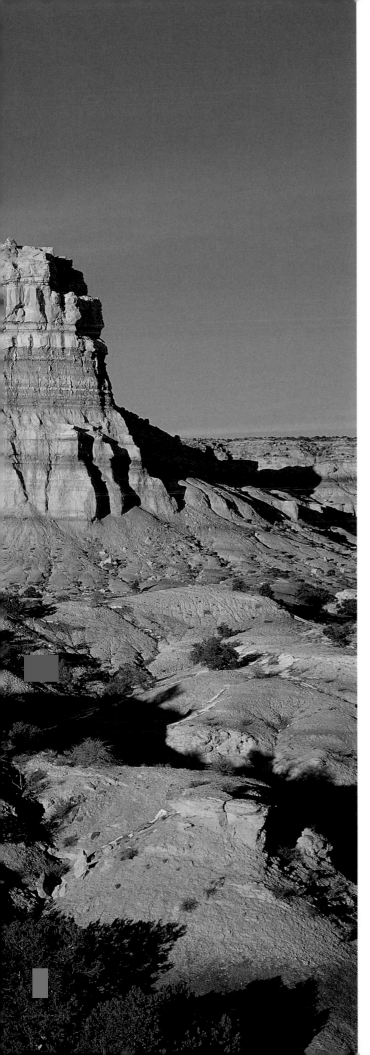

A TALE OF TWO MOUNTAINS

Navajo

Huerfano Mountain, just off New Mexico Route 44, is where the Hero Twins lived before they went forth and made the world safe for the Navajo people, the Dineh.

On most maps, it is called Huerfano Mountain, Spanish for "orphan", or "defenseless." Visible for miles as one speeds along New Mexico state route 44, Huerfano is a fairly modest body of sandstone and shale rising from a surrounding prairie of sagebrush and snakeweed. Its craggy top hosts a snaggle-toothed tiara of broadcast antennae, and around the base are the unmistakable signs of natural gas development.

This is a lonely place. A few Navajo camps can be seen far off the highway, a couple of remote schools, an Indian health center. Automobiles and trucks surge by, but nothing else seems to move much. Navajo medicine men make successful pilgrimages to Huerfano Mountain still, despite the antennae, the natural gas, the highway. For them, and all the 250,000 or so Navajos, the mountain is known as Dzilth-Na-O-Dith-Hle, which means Moving Around Mountain or Changing Mountain. The medicine men come to Dzilth-Na-O-Dith-Hle because it is where one of the most important and beloved of all Navajo deities, Changing Woman, gave birth to twin sons a long time ago before the world was completely formed, before the People had come to be.

Even earlier, fifty miles northeast on a rise called Gobernador's Knob, Changing Woman herself came into being from a piece of turquoise, growing into womanhood there and being impregnated by the Sun. And here in the arroyos and canyons of Moving Around Mountain, her twin sons grew up, bathed, ate, and prayed, and learned some of the skills they would need to make the world safe for the Navajo people, the Dineh. For in those days so long ago the world

was an especially perilous place, full of monsters.

In 1990, the monsters were long gone but different sorts of perils were loose in the land. A Farmington, New Mexico, company called ICU Inc. had its eye on the land near Huerfano Mountain. It entered into an agreement with the owner of a 160-acre plot about four miles from the mountain to use it as a dumping ground for asbestos. The state environmental department was willing to grant the company the needed permits so long as any archeological sites were fenced off and various emergency safety precautions were taken. The archeologists fanned out and soon found nothing there of archeological or historical importance.

To Navajos, the planned asbestos dump was just too much. The antennae were one thing, the natural gas machinery another: yet they did not mortally insult the sacredness of the mountain. But by 1990 everybody knew that asbestos was an active, lethal poison, linked to cancer and respiratory diseases. The idea of a toxic dump where Changing Woman's twins grew up was as offensive to Navajos as piping a slurry of chemical wastes through Westminster Abbey would be to Anglicans.

The tribe officially protested, the state environmental officer reconsidered the five-year permit, the company sued, saying the state had no jurisdiction over archeological sites on private land, and a state supreme court justice threw the suit out. Happily, to the enlightened judge and state environmental official, it made no difference that Changing Woman and her young sons had left no discernible archeological evidence of their sojourn at Moving Around Mountain. Deities typically leave few recognizable material traces to be dug up.

On the other hand, one *can* see the handiwork of Changing Woman's twin sons elsewhere in New Mexico.

The twins' names were Monster Slayer and Child Born of Water, two heros in one of the world's greatest epics, the Navajo creation story. Called *Dine Bahane,* it is recited in part or in whole at the Navajos' healing ceremonies and has been recited year-in and year-out for longer than anyone can remember. Like *The Odyssey,* the story of Gilgamesh, or the Old Testament, it is what the world tends to call myth, which is simply another word for someone else's religion. Like all such stories, it explains the origins of things, the nature of things,

Mount Taylor, one of the most prominent landmarks in northern New Mexico, is the southernmost of the four sacred peaks that mark the land of the Navajos, who call the mountain Tzoodzil. To the west is Dook'o'oosiid, or San Francisco Peaks, near Flagstaff, Arizona (see page 89). To the east is Sis Naajini, Blanca Peak, in Colorado's San Juan Mountains, and northernmost is Dibe Nitsaa, Hesperus Peak, also in Colorado. Within these four mountains, two *yei-be-ches,* or holy spirits, lie curled up, and it is within their sacred forms that the Navajo people are supposed to live and where they will be safe.

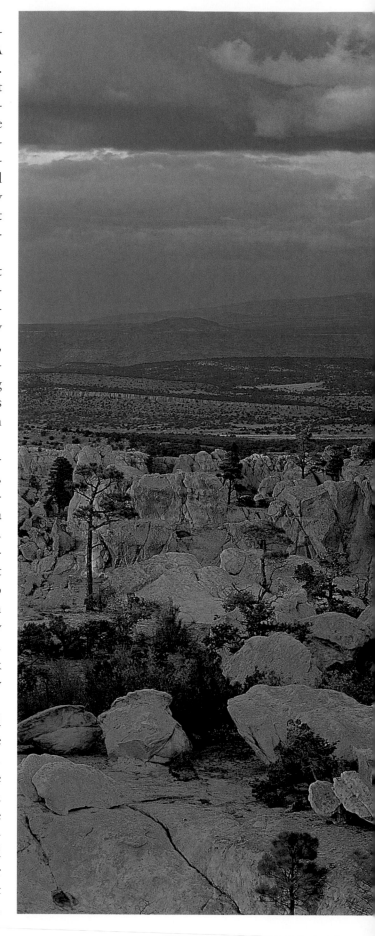

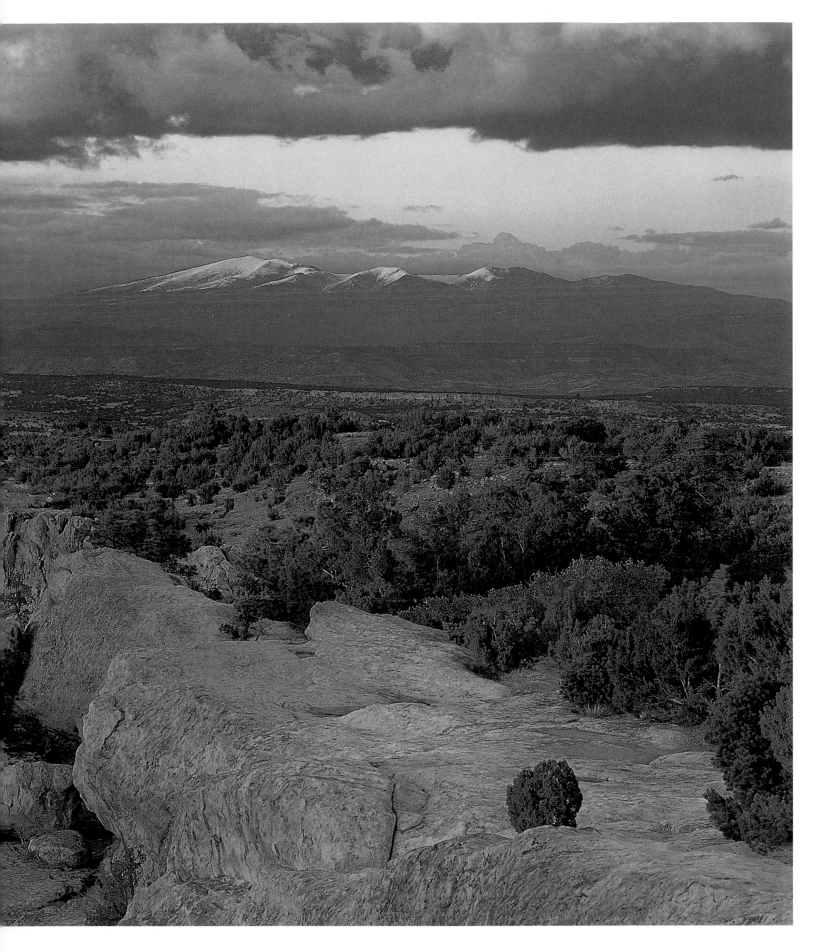

At Mount Taylor, the Hero Twins slew a great monster and his blood gushed forth, congealing here and there around the landscape into the ragged black rock some people call lava.

and the proper way to live. It explains the Navajo concept of *hozho,* loosely translated as beauty and meaning more than that—harmony as well, and moral excellence. There is no word in English that denotes both aesthetic and moral beauty.

But in those old days of myth time there was little harmony in a world so full of monsters, the worst of which was Big Giant, Ye'iitsoh, who lived at the Blue Bead Mountain, Tzoodzil. Big Giant would test the twins' courage and skill once they had made

an arduous journey to meet their father, the Sun, who armed them with flint armor and lightning arrows—even though, he admitted, the Big Giant was also his son, something of an early mistake.

On their way to the Blue Bead Mountain, which is called Mount Taylor on maps and is the remains of a gigantic volcano, the twins were informed that Ye'iitsoh came down from the mountain each afternoon to drink from a lake formed by Warm Spring. So there they waited for him and

eventually he came, his footsteps "as loud as the thunder that shakes the canyon walls and rattles among the peaks." He came bearing a basket full of prey, and had knelt down to drink at the water's edge when he spied the twins' reflection in the water.

"How delicious you look," he roared, and the twins taunted him, saying he was weak and they had great power.

"What?" he roared. "You dare to speak that way to someone who is about to feast on your flesh?" But the Twins threw his words back at him.

"Beware," warned the Wind, and suddenly the twin boys found themselves standing on a rainbow arc that moved quickly this way and that, letting four lightning bolts thrown by Big Giant sizzle past them harmlessly. As he was readying a fifth, a huge bolt came out of the sky from where the Sun stood and struck the monster on his head, and the heavens shook with thunder. Stunned, Big Giant reeled, and the twins hurled their own lightning bolts at him till he finally lay inert on the ground.

Approaching, the twins cut off the monster's head and threw it into the hills to the east of Tsoodzil's summit, where it can be seen today.

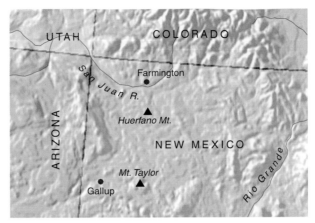

When the gigantic head landed, blood began to flow in a great torrent that swept away the rocks that blocked the waters of the lake. Monster Slayer cut a line in the earth with his stone knife and the onrushing blood built up behind the line, then flowed in another direction. The monster's hot blood foamed and flowed until it covered twenty-five square miles of land. Then it began to darken as it grew hard in the arid air.

Whoever cares to can go and see the dark cliffs that the white man thinks of as lava and, even at seventy miles an hour on Route 40 as it curves past Mount Taylor, you can see the chunks of congealed monster blood that filled the valley long ago.

So it was here at Mount Taylor that the heros began to make the world safe as a dwelling place for the People, the Dineh, the Navajos. Long afterward, in the 1950s, the world clamored for the substance called uranium to be used to make electricity that was too cheap to meter. It didn't quite work out that way, but in the meantime a great deal of uranium was found below the skirts of Mount Taylor, and it was Navajos who were talked into doing most of the mining. This became a monster that the Hero Twins could not have foreseen, a secret, invisible monster that poisoned people's lungs without their knowing it. In recent years, many Navajos have reaped that sorry harvest, and the families of a few of them have received payment in dollars for their loss from a reluctant federal government whose duty is to look after the interests and happiness of the American Indians. The mines have been silent now for a couple of decades, the boomtown of Grants on the southern edge of the mountain suffering the pangs of economic withdrawal ever since.

But with global warming, there is a need for carbon-dioxide-free energy production.... 🦅 JP

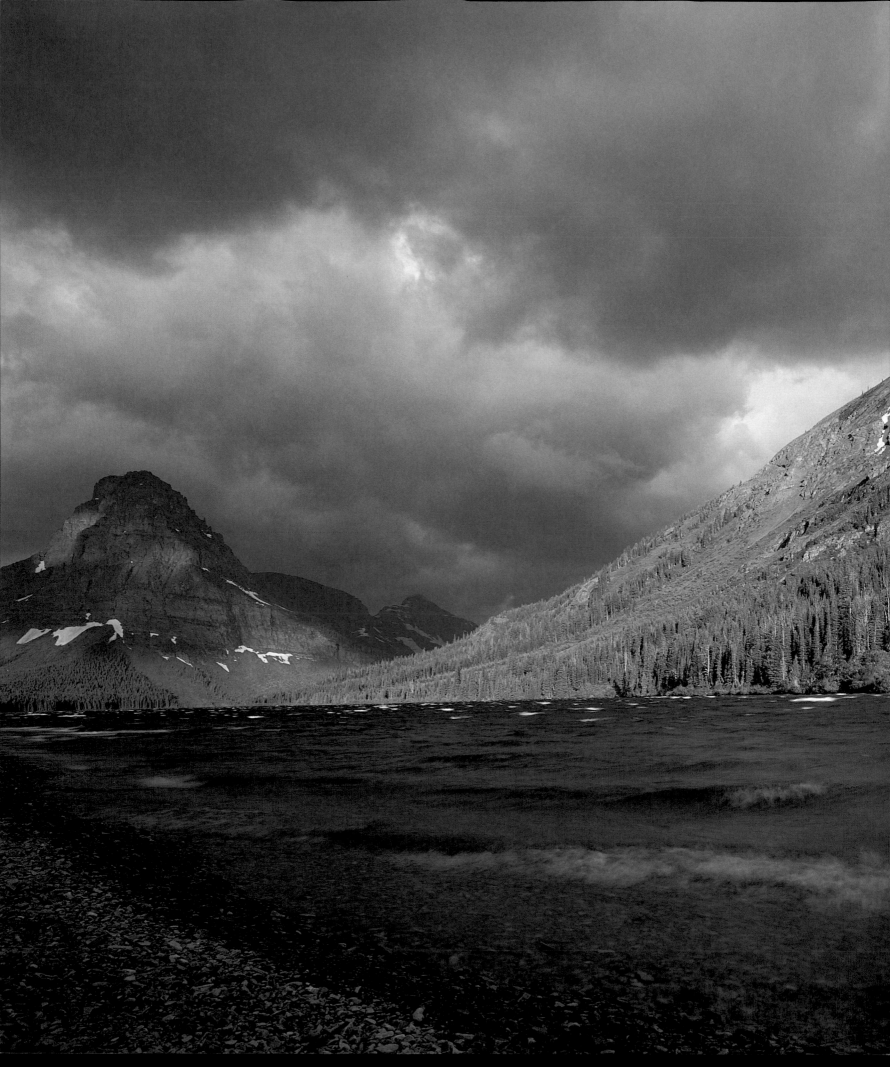

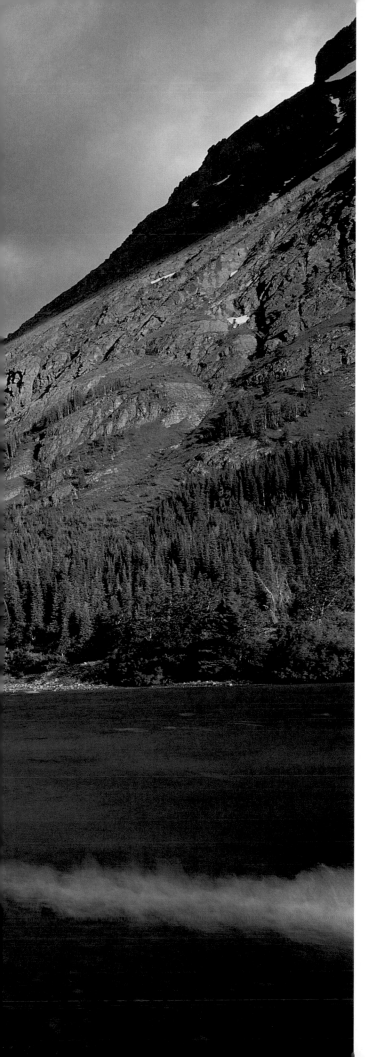

Part of the Rocky Mountain Front, a vast rampart between the plains and the mountains in Montana, Badger-Two Medicine is where the heroic history of the Blackfeet Indians began.

BADGER-TWO MEDICINE

Blackfeet

In ancient times, when the Blackfeet still used dogs as beasts of burden, Scarface was looking for the path to the Sun and crossed Badger-Two Medicine. Born in the sky as Star Boy, Scarface had come down to earth to live in poverty among the Blackfeet. Mercilessly teased by the young men of the tribe because of his poverty and his scar, he nonetheless sought the hand of the chief's beautiful daughter. She would marry him, she said, if he got permission from the Sun.

Finding the path to the Sun was a long and arduous journey. Following it was no easy matter, either. Along the way, he was presented with tests of his integrity—a beautiful garment lying in the path to tempt him to take it, the appearance of terrifying birds who had killed three sons of the Moon and whom Scarface killed to save yet another son of the Moon. When at last he stood face-to-face with the Sun, it was a triumph of the will.

Pleased with the honesty and courage Scarface had shown on his journey, the Sun removed the scar from his face—making him exceedingly handsome—and told him he could marry the chief's daughter. In return for the Sun's gifts, Scarface brought the Sun Dance to the Blackfeet people. When he returned to his tribe, Scarface was once again called Star Boy or Young Morning Star. He is present every morning, rising with the Morning Star just before the Sun.

Even before the time of Scarface, Badger-Two Medicine was a part of Blackfeet country, the whole of it a sacred place to them—a place to fast, to pick roots and plants, to engage in sacred ritual. At the edge of the Great Plains, where grassland rolls into hills and ridges and rocky promontories, the land itself draws you farther and farther back into a pow-

erful world of high peaks—with names like Scarface and Morning Star—and snowfields sending clear streams to run through broad valleys. Sky and wind embrace a walker in this place. Forest stands offer shelter (and relief, at last) from the boundless prairies to the east.

South of Glacier National Park, north of the Bob Marshall Wilderness, east of the Great Bear Wilderness, Badger-Two Medicine is a part of the Rocky Mountain Front, the great limestone rampart separating the plains from the mountains. It is a key biological piece in the mosaic of the huge Bob Marshall Wilderness ecosystem—a gorgeous, wild place that is home to grizzly bears and wolves, elk, moose, and mountain goats. Named for two streams, Badger Creek and Two Medicine River, that begin in the snowfields of the Continental

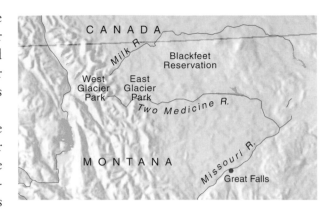

Curley Bear Wagner, Blackfeet cultural spokesman: "There's no damn way I'm letting them drill for oil in there..."

Divide, this area is fundamental to Blackfeet culture, the source of stories integral to Blackfeet life.

Once part of tribal lands, it was ceded to the U.S. government in 1896. Some Blackfeet say it was merely *leased* to the government. Today it borders the Blackfeet Reservation but is not included in it, although the 1896 treaty gives tribal members the right to hunt and fish anywhere in the area in accordance with state law and to cut firewood for domestic use. The treaty also acknowledges spiritual and cultural uses of Badger-Two Medicine.

When Fina and Chevron USA decided to drill for oil on thousands of acres they had leased in Badger-Two, the Blackfeet wanted to defend their sacred land but had no legal right to it. Outraged at the thought of this pristine wilderness being desecrated, non-Indian environmental groups across the state and the nation joined with the Blackfeet to fight against its exploitation. Mindful the tribe

would have objections to drilling for oil, the oil companies early on presented to the Blackfeet the idea that wells in their country were a good thing.

"We don't want no oil wells up in our country," Curly Bear Wagner, a tribal cultural spokesperson, said, expressing his concern that wells leak and could pollute the water system. "The water system is very important, the giver of life. When oil gets into it, it poisons the water and this is where the water starts from. The Badger drainage goes down into the Two Medicine. The Two Medicine goes into the Marias and the Marias goes into the Missouri. We don't want anyone fooling with our water."

The Fina site is about two and a half miles south of U.S. Highway 2 and the southern boundary of Glacier Park on a ridge between Hall Creek and one of its tributaries. The old Chevron site is about nine miles southeast of Fina's, on Goat Mountain between the north and south forks of Badger Creek. Chevron's lease was issued in 1981, Fina's in 1982. Other prospectors have sought to drill for oil and gas in Badger-Two for decades.

In the early 1980s the Lewis & Clark National Forest wanted to conduct a controlled burn in the Hall Creek Basin. The Blackfeet elders told Curly Bear not to let them burn there. "If I give in to them and let them burn," Curly Bear said, "next thing I'll be letting them drill for oil in there and there's no damn way I'm letting them drill for oil in there because of the habitats of our four-legged ones and the winged ones and the berries. Our people use this."

Curly Bear went to the Historic Preservation Office in Helena, Montana, looking for *something* that could be used to stop the burn. What he found was record of a war lodge on Hall Creek. Although the Forest Service soon abandoned the idea of the burn in the face of opposition to the building of

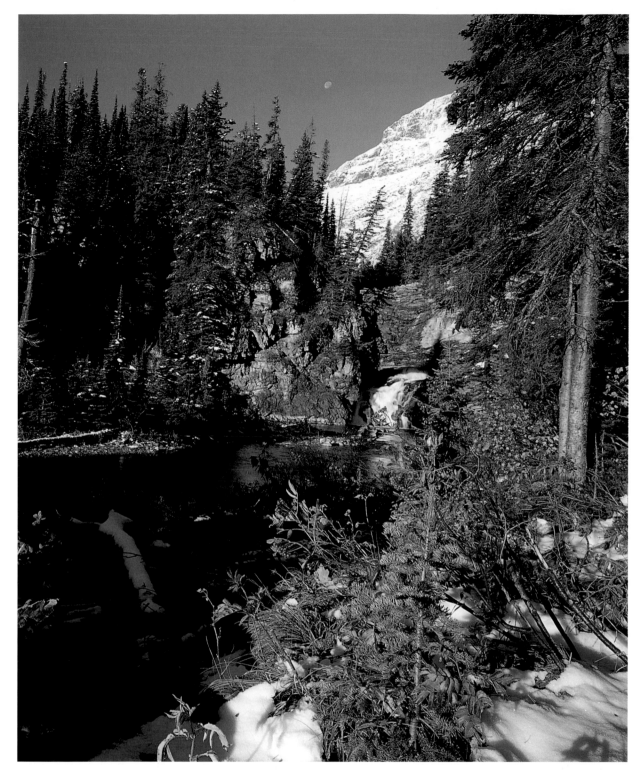

The region's snowfields, lakes, clear streams, pungent evergreen forests, pure air, and fresh winds all could be sacrificed to development if the Blackfeet and friends do not prevail.

roads required to get the necessary equipment into the site, the discovery of the war lodge did help put a stop to a Fina well. The war lodge was one of many built throughout the area known as Marias Pass, to protect the pass from other Indian tribes coming into Blackfeet territory to hunt buffalo.

Finding the war lodge is one fragment in the historic property review being conducted under the National Historic Preservation Act. Sixty-seven sites have been identified in Badger-Two and the information about them submitted to the Historic Preservation Office by the Lewis & Clark Forest. The forest (and everybody else) is now waiting to hear from the Keeper of the National Register whether or not the Preservation Office agrees with the Forest Service determination. If they do, these

sites will be listed on the National Register, which will offer the specific sites a certain amount of protection. For instance, the Forest Service must then determine whether any proposed management actions will have an effect on that site.

In 1993 federal legislation was introduced mandating a review of Badger-Two in accordance with the Wilderness Act. (Portions of Badger-Two Medicine were first proposed for Wilderness designation in 1976.) To allow consideration of the bill, Interior Secretary Bruce Babbitt issued a temporary moratorium on drilling that was renewed annually through 1996. It has since been replaced by a suspension issued by the Bureau of Land Management (the agency issuing leases for subsurface minerals on federal land), in essence stopping the clock on the leases. (Lessees don't pay annual fees. The lease does not run out.) The suspension will remain in force until the historic register process is completed.

The concerted effort on the part of environmental organizations and Blackfeet activists caused headaches for Fina and Chevron, and both companies soon wanted to trade their leases to the public for bidding credits elsewhere, most likely in the Gulf of Mexico. This trade requires an act of Congress. Montana's Democratic senator, Max Baucus, introduced a bill to do so in May 1998, but the state's Republican senator, Conrad Burns, kept it from having a hearing. Burns's contention was that the

Energy companies still hold leases in this land of streams and snow and, until recently, a silence unbroken by the sound of all-terrain vehicles.

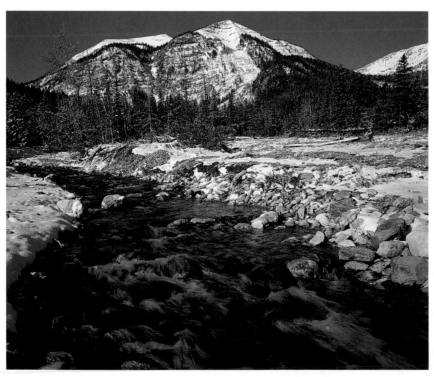

bill should be more Montana friendly, meaning the bidding credits should be applied to Montana alone, which would keep the oil companies' money in the state.

Impatient with the endless finagling, Chevron eventually sold its leases to Ocean Energy Resources, Inc., a Houston-based company, and several individuals. When the suspension is lifted, Ocean Energy intends to develop its lease. But given the long and complex legal history surrounding Badger-Two Medicine, doing so may not be simple. Among other things, the federal agencies *could* say they cannot approve drilling applications. Next move—Ocean Energy.

A second, more recent assault on Badger-Two Medicine is, in some ways, more insidious: ATVs. Invading the silence of wildness, they destroy the peace of the sacred. In Badger-Two, signs stating that vehicles over forty inches wide are not allowed are simply ignored. And because they have not been stopped, ATV riders have expanded their use of the area. They will continue to do so, as they do in the Crazy Mountains and elsewhere, until they *are* stopped. Because it has the potential for Wilderness designation, Badger-Two Medicine is on a delicate line. Roads, built or de facto, can make it ineligible as Wilderness. Until a final decision one way or another on Montana Wilderness is made (since 1983 Montana has been unable to get new Wilderness designated in the state), motorized vehicles are supposed to stay out. The National Forests, short of backcountry rangers, have limited enforcement power.

Blackfeet elders know there are myriad ways to destroy a region. They believe you cannot mitigate the destruction of the sacred. It can only be kept alive by honoring and protecting it with the integrity of Scarface. Greed for oil or backing away in the face of destroyers of the land cannot pass the Sun's tests. Can Badger-Two Medicine remain a proper route for Scarface to find the path to the Sun? How many who walk across this land are on that path? Because it is an area virtually surrounded by wilderness (either designated Wilderness or Glacier Park), Badger-Two becomes the only place in the region that seems exploitable. Does it then become a sacrifice area in a world of wilderness? Are today's temptations and dangers too great to transcend in the name of the earth's sacred beauty? 🪶 RR

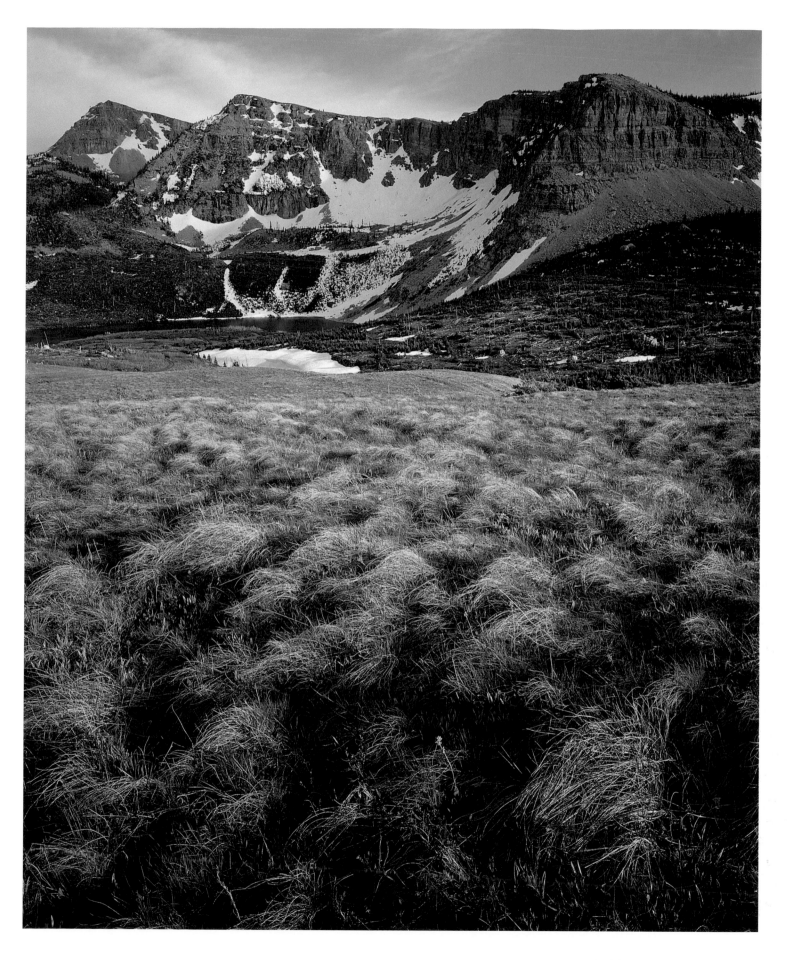

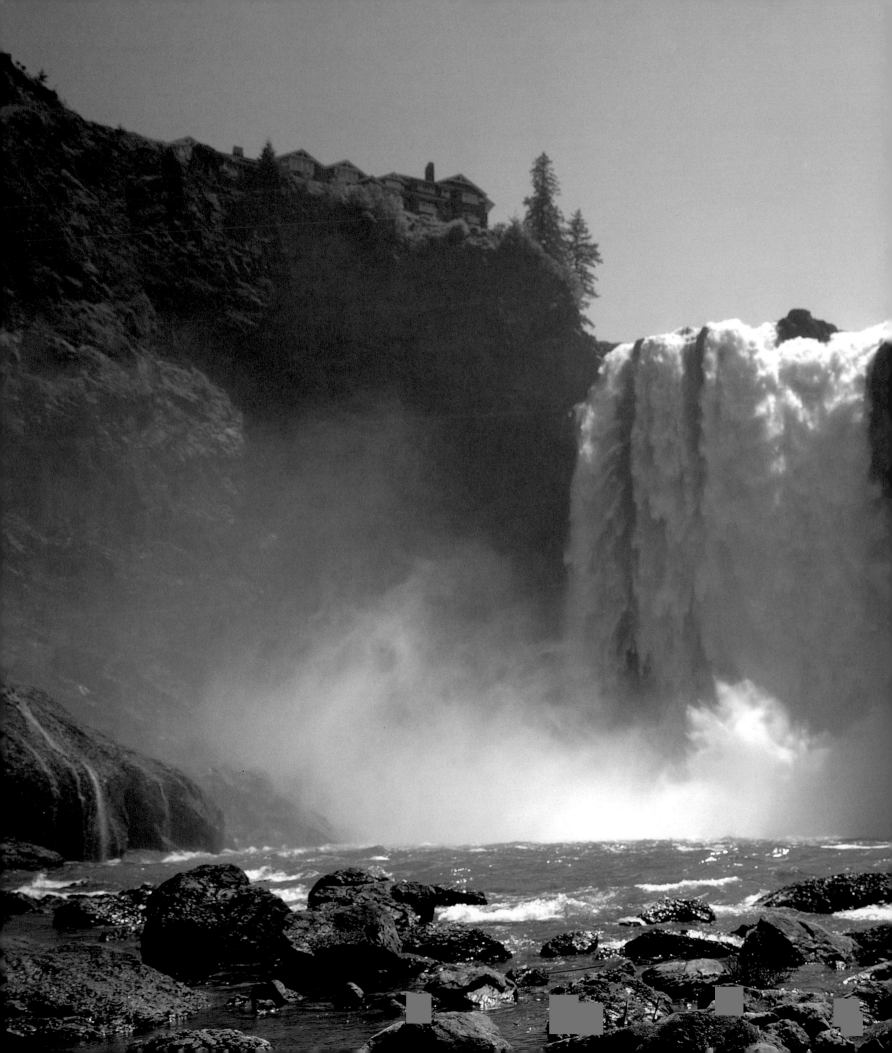

LET THE SPIRIT FLOW

Snoqualmie

A river called Snoqualmie tumbles out of the Cascades on its journey to the waters of Puget Sound, coursing down the steep mountainsides, gathering power from meltwater, springs, mountain brooks. Just before the land begins to gentle out into lower hills, the river meets a sheer cliff, 270 feet high, higher by far than Niagara. Then the water *falls* in a roaring curtain of white set off by the dark basaltic rock of the cliff into a sixty-five-foot-deep pool. As the falling water strikes the waters below, a great mist rises up the sides of the gorge, enveloping the rock, the river, and the surrounding forest. In the time before time, it was out of this meeting of water with water, the essence of life, that the first woman and the first man emerged.

Such is the meaning of these falls to the people of the river, who are also called Snoqualmie. Their legends say…

> Long ago when animals were people, the child of a star and an Indian woman was born. He was known as Moon, the Transformer, and he reshaped the world into a home for the people. During his travels, Moon came upon a huge fish weir that was built by Raven. So he turned the huge weir to stone, and the water spilling over the weir became the place called Snoqualmie Falls. And there, Moon created the first woman and man, and then he climbed into the sky.

Moon still looks down upon the falls. But they are not the same. Only rarely, these days, do the great mists rise from the gorge. The waters are diminished because in the 1890s a civil engineer named Charles

From the mists of Snoqualmie Falls, the Moon created first man and first woman, and from its fast-flowing water a Washington State utility still creates electricity.

H. Baker visited the falls, and while the people of the river saw this place as their Eden, he saw it as an ideal site for a hydroelectric power plant. Rising from the mist was not the lovely story of creation, but the unlovely pursuit of "progress." The Transformer had, in a bitterly ironic linguistic transference, become machinery housed in a masonry building at the edge of the river to convert the power of the water into kilowatts of electricity.

To the Snoqualmies, the desecration of the falls has been emblematic of a series of betrayals at the hands of white American businessmen, soldiers, preachers, and politicians throughout much of the nineteenth and twentieth centuries. Among the betrayals was the abrogation of the 1855 Point Elliott Treaty, which promised that the Snoqualmies would be given land. In the end, they were not. Another was the incessant hounding of Indians practicing their indigenous religion by those who beat and killed and imprisoned those who would not accept the peace of Christ.

Lois Sweet Dorman is a young mother who speaks for the falls on behalf of the Snoqualmie Tribe. Her eyes fill as she relates this tragic history and tells of her mother, the late Emma Sweet, a spiritual leader in the long effort to attain a measure of sovereignty. "In 1995, just before she died, she said the Spirit had spoken. She said it would happen because it is time."

And the time came. The Snoqualmie Tribe at last achieved federal recognition in 1999 and thus was entitled to insist on property rights, nation to nation, as was promised them when their chief, Pat Kanin, signed the Point Elliott Treaty in 1855, on the line just below that of Chief Seattle. "We have never been a conquered people," says Dorman. "We are a nation that has signed a treaty with another nation. We are still here. We are not going away."

Such a determined effort to insist on sovereign rights has been especially evident in regard to the restoration of Snoqualmie Falls. To restore the falls, desecrated for a century, the Snoqualmie Falls Preservation Project was formed, which calls upon the civic leadership of the Seattle region to preserve this "jewel of creation" as it once was.

The instigating event for the preservation effort was an application by Puget Sound Energy (then Puget Sound Power and Light Company) for a forty-year license from the federal government to continue using the falls for power generation and, in fact, to divert even more of the river flow for this purpose to drive the turbines of a third generating

Lois Sweet Dorman has carried on her late mother's struggle to gain sovereignty and to protect the Falls.

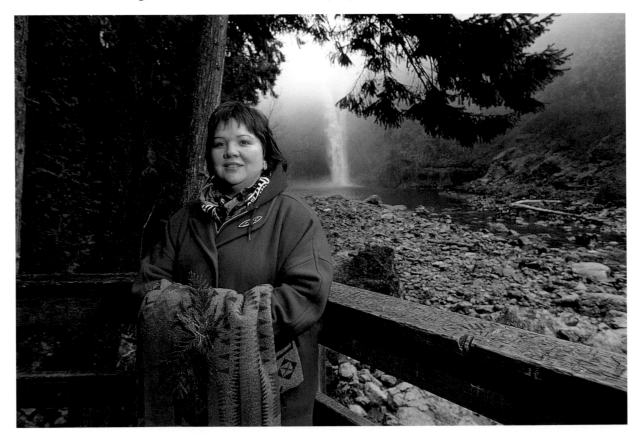

deck, or hike a trail down the gorge to a viewing platform at the base of the falls. Those who can afford it can dine or stay overnight (about $350) at the luxurious Salish Lodge, named after the language group to which the Snoqualmie tongue (Lushootseed) belongs. In the lodge is a gift shop and a library. Yet in neither location can one find a book, a pamphlet, or even so much as a folder about the meaning of the falls or the Snoqualmie people, whose name describes not only the falls, but the river, a mountain, a mountain pass, a national forest, and an incorporated municipality. The gardens of the lodge, which overlook the falls, are a favorite spot for outdoor weddings of the Seattle elite. Isn't it a shame that the young lovers aren't told that here the first woman and the first man were created?

plant. The first plant was completed in 1899, the second, at the foot of the falls, was a 1957 addition. The entire complex now produces forty-two kilowatts of electricity, less than 1 percent of the electricity produced by Puget Sound Energy as a whole.

As it turned out, many people were energized by the Snoqualmies' appeal for help. Only thirty-five miles east of Seattle and just off Interstate 90, the falls attract some 1.5 million visitors annually. They bring picnic lunches, view the diminished but still spectacular falling water from an observation

One of the most significant allies in the battle to save the falls has been the Washington Association of Churches. The association had earlier distinguished itself (in 1987) by adopting a "formal apology" to the tribal councils and traditional spiritual leaders of the indigenous peoples of the Northwest, asking forgiveness for a "long-standing participation in the destruction of traditional Native American spiritual practices." The apology was signed by the ecclesiastical leaders of the member constituencies

The unlovely presence on the river's edge of an outdated electric generating plant.

of the association, including the American Baptist Church, the United Church of Christ, the United Methodist Church, the Presbyterian Church (U.S.A.), the American Lutheran Church, and the Roman Catholic Archdiocese of Seattle. Ten years later, the apology was reaffirmed, stating among other things that "we embrace the spiritual power of the land and respect the ancient wisdom of your indigenous religions" and that the churches would help "secure access to and protection of sacred sites and public lands for ceremonial purposes."

When Puget Power proposed that as a "compromise" the full flow of the river could be restored on a handful of "Native American Allocation Days" (which in fact did not coincide with the Snoqualmies' ceremonial uses), the church association saw this PR ploy for what it was and fired off a stern letter to the Federal Energy Regulatory Commission, insisting that any limiting of religious expression was unacceptable. "The hydroelectric power of Snoqualmie Falls can be replaced by other sources," they wrote. "The spiritual power cannot be duplicated. Based on the pledge we made in 1987 to the tribes of the Pacific Northwest, we pray that the sacred flow of Snoqualmie Falls be restored, for all people, every day of the year."

By the end of the 1990s, which were as tumul-tuous as the falls themselves could be when in full flow, Puget Sound Energy and the Federal Regulatory Commission, which had to some extent supported the company, had been fought to a standstill. The forty-year renewal license was not granted and now is applied for only on a year-to-year basis. During that decade, the Snoqualmies' vision for the future of the falls gathered transformative power of its own, especially with the advent of federal recognition for the tribe. The vision of the Snoqualmie Falls Preservation Project is uncompromising. The falls must become free-flowing once again. The area around the falls must be protected from intrusive development. The falls park must be owned and operated by a public-interest organization set up for that purpose and be self-supporting. And religiously inclusive interpretive and educational programs are to be conducted that emphasize the sacredness of the falls and its natural and cultural history.

As the new century opened, it appeared that the power company was beginning to lose interest in a forty-year operating license and, in fact, was looking to sell off the facilities. According to Shelley Means, coordinator for Native American and environmental issues for the Washington Association of Churches, "Puget's now more inter-

One of the neighboring cedar tribes who joined the Snoqualmies sings at a potlatch held to celebrate federal recognition of the Snoqualmie tribe.

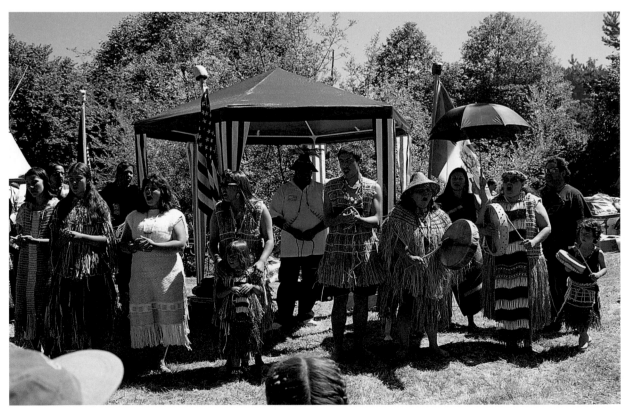

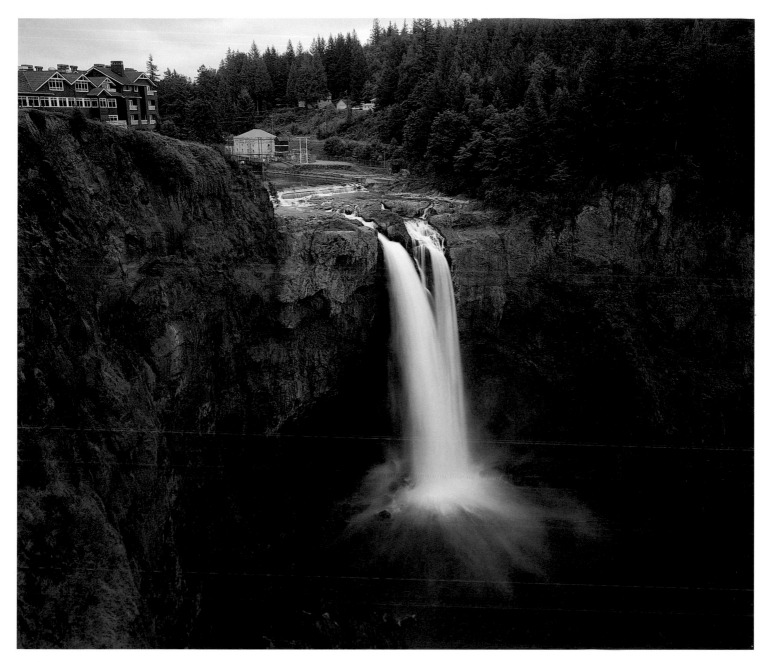

ested in gas, so it might be possible to purchase an option to buy. They're now operating at half capacity and making only about $6 million a year. The deal is dangling."

The deal may be dangling, but the Snoqualmies are resolute. "It'll happen," says Lois Sweet Dorman. "There's going to be a natural flow of water over the falls. This hydroelectric facility is going to be decommissioned, and the natural setting will be renewed. Cedars will be replanted. We will let the land heal, and the sacred cycle will be restored. I don't know when it will happen, but it will happen. It is by the Spirit."

The Salish Lodge would become an intercultur-al educational center where people from all backgrounds can learn of the spirit of the place. "We try to get people to understand that you cannot separate the people from the falls; the people and the falls are one. The cycle of water renews you, for it is the cycle of life. And after you can come to the falls, that wonderful spirit will travel with you. You will share it with the people you encounter, and they will be strengthened because you are strengthened."

As Lois Dorman says these words, the sound of the falls rises on the wind from the gorge where the waters meet the waters. She listens for a moment. "They are for all people, for all time," she says. "Let the spirit flow." 🔥 CEL

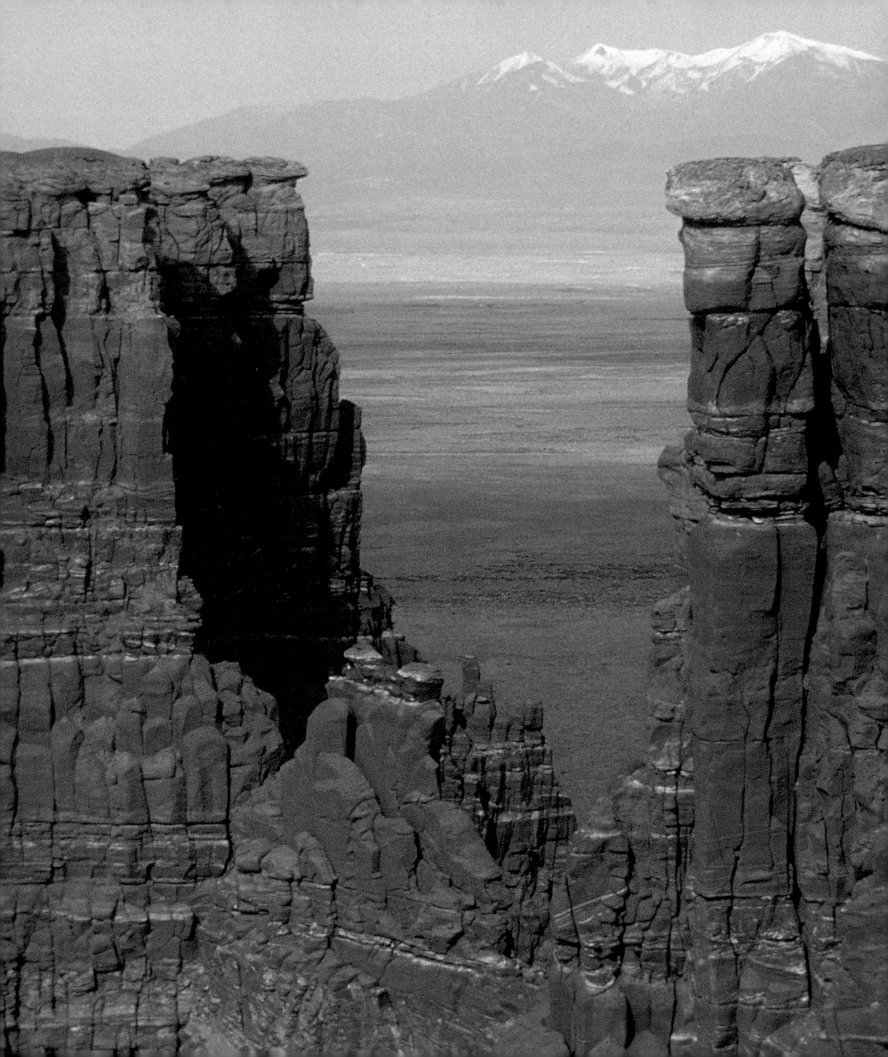

REHEARSALS FOR RAIN

Hopi, Navajo

From atop Katsina Bluffs, a Hopi eagle priest stares westward to the ghostly image of San Francisco Peaks near Flagstaff, Arizona, where the *katsina* spirits rehearse making the rain that has watered Hopi fields for a millennium.

The mountain is visible from every one of the twelve Hopi villages. One of the villages (Oraibi) along with Taos and another pueblo called Acoma are the oldest continuously inhabited places in North America. Hopis have been living in Oraibi since the eleventh century, in the high arid country of northeastern Arizona, some ninety miles from San Francisco Peaks, the 12,000-foot high remains of an old volcano that commands the western horizon and draws the attention of Hopis every day.

For the Hopis are, and always have been, agriculturalists, creating a plenitude of native crops—corn, beans, squash—out of dusty dry washes in the semi-desert lands below the mesas on which most of the villages perch. In such a situation, all moisture is sacred, every drop of rain a significant blessing, and every cloud that forms over the summit of San Francisco Peaks is to be applauded. For there, from July to December of every year, nature spirits called *katsinas* rehearse the making of rain and its delivery to the cornfields of the Hopis. Dry farming in such a hostile environment takes a lot of engineering, and most Hopi engineering is spiritual.

From just before winter solstice until late July, the *katsinas* appear in the villages, dancing at night in the underground chambers called *kivas* in late winter/early spring, then by day in the village plazas. The plaza ceremonies have been called by Yale art and architecture historian Vincent Scully "the most profound works of art in North America." For here people gather, women in shawls, children darting about like fish in an aquarium, young people on the flat roofs of the homes ranged around the dusty plaza. Overhead the sky opens out in all its enormity, San Francisco Peaks presiding to the west, and

the entire visible world is a Hopi cathedral.

Soon the plaza is filled with *katsinas*, beaked figures with eyes glittering through slits, necks ringed with pine boughs, fox skins hanging down behind native cotton kilts, moccasined feet pounding the dust to the rhythm of a drum, turtle shells and sleigh bells tied to lower legs clinking and plokking in counterpoint to the rattles clutched in hands, the line of spirits moving this way and then that, amid the myriad voices chanting songs that fill the plaza like an ancient wind. Throughout the day, and normally for two days, the spirits dance and sing, the wind picks up and creates little dust devils among the *katsinas,* and clouds begin to build up over San Francisco Peaks, break off, and drift eastward like ghostly white galleons, casting shadows on the Painted Desert, perhaps to tarry long enough over a Hopi cornfield to deliver a sprinkle of timely rain.

For these are prayers for rain, these dances, but more than that, too. They are prayers for the well being of all living things. They are not pleas, not a kind of begging. The Hopis know that the *katsinas* enjoy dancing in the Hopi plazas, and they enjoy being fed with cornmeal, which is spirit food. So the *katsinas* are enjoined to reciprocate, to bring rain, for example–providing that the ceremony has been done with a good heart, that everyone present has put forth only good thoughts. And so at the end of the day the *katsinas* are asked to return to go forth and explain to deities called the chiefs of the four directions that the Hopis have indeed lived up to their goals, and the rains should come.

Several times, in the course of such a ceremony, the *katsinas* leave off dancing and instead begin to hurl presents into the crowd—food mostly, bread, blue corn, fruit, soda pop—in a great melee of flying objects and laughter. Every so often a *katsina* splits off and walks into the crowd, bringing a special gift to someone—*a katsina* doll for a young girl, a colorful little bow and arrow set for a young boy. The *katsinas* may look fierce to some, and they carry out their duties with a high solemnity, but to all

On a pilgrimage to the summit, a Hopi priest sprinkles cornmeal, a food appreciated by the *katsinas* who live here for half of each year.

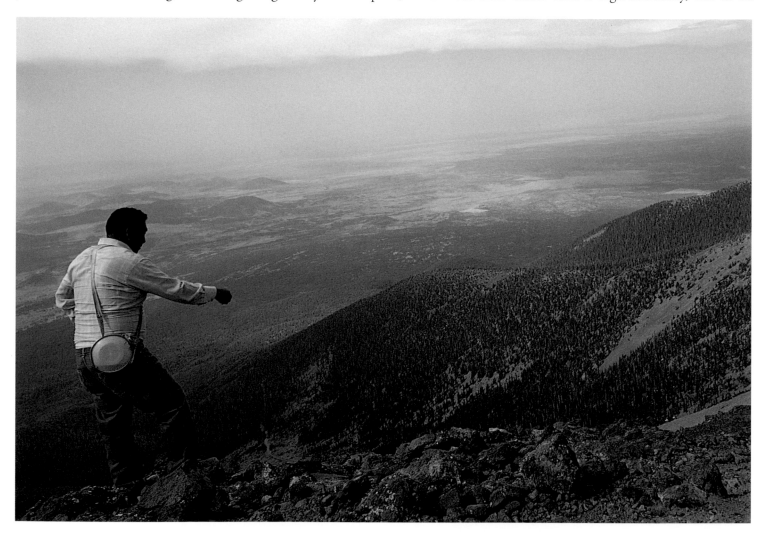

REHEARSALS FOR RAIN

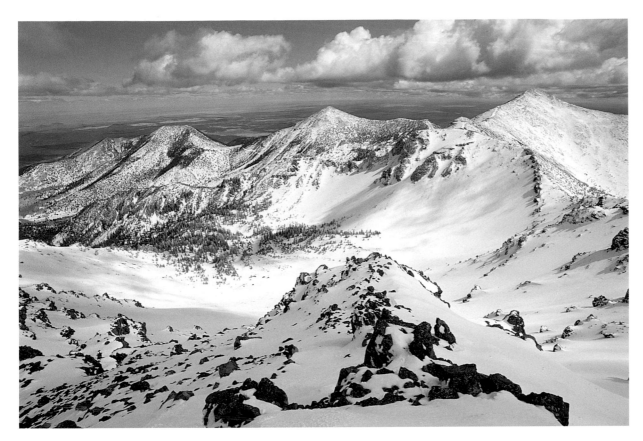

Snow caps the Peaks, Arizona's highest mountain.

who know them they are among the most blessed presences on earth. After a properly lived Hopi life, one will return from time to time in the form of a cloud—another embodiment of a *katsina*.

The Hopis have never seen a need to keep all this a secret (as most of the other pueblos do when it comes to their *katsinas*). Instead, outsiders are often welcomed at these ceremonies, for the prayers inherent in them are not exclusive but for the benefit of all people, and also, the Hopis will say, who knows whose prayers will be the most effective that day?

By early August, the plaza dances are over, the last one being called the Home Dance. The *katsinas* go home to San Francisco Peaks. They will remain there until it is time for them to reappear in the Hopi villages and help the people turn the Sun around so that it can return to its summer house, warming the earth again so that it can be bountiful—year in and year out since time immemorial.

In more recent times—a half a millennium ago—people who came to be called Navajos arrived in Hopi country and were equally awed by the great mountain to the west, San Francisco Peaks. They call it Dook'o'oosiid, while the Hopi name is Nuvatukya'ovi. For the Navajos it delineated the western extreme of their homeland, one of their four most sacred mountains. Navajo medicine men go to Dook'o'oosiid to collect herbs and other sacred materials; Hopi priests go to Nuvatukya'ovi to collect snow from the peaks for use in certain ceremonies and pine boughs for the *katsinas* to wear in the plazas.

All this was well known when the U.S. Forest Service, in the 1960s, granted permission to a private company to build a ski lift up the western side of San Francico Peaks, though not to the summit. In an unusual show of solidarity, medicine men from both tribes formed a unified group under the

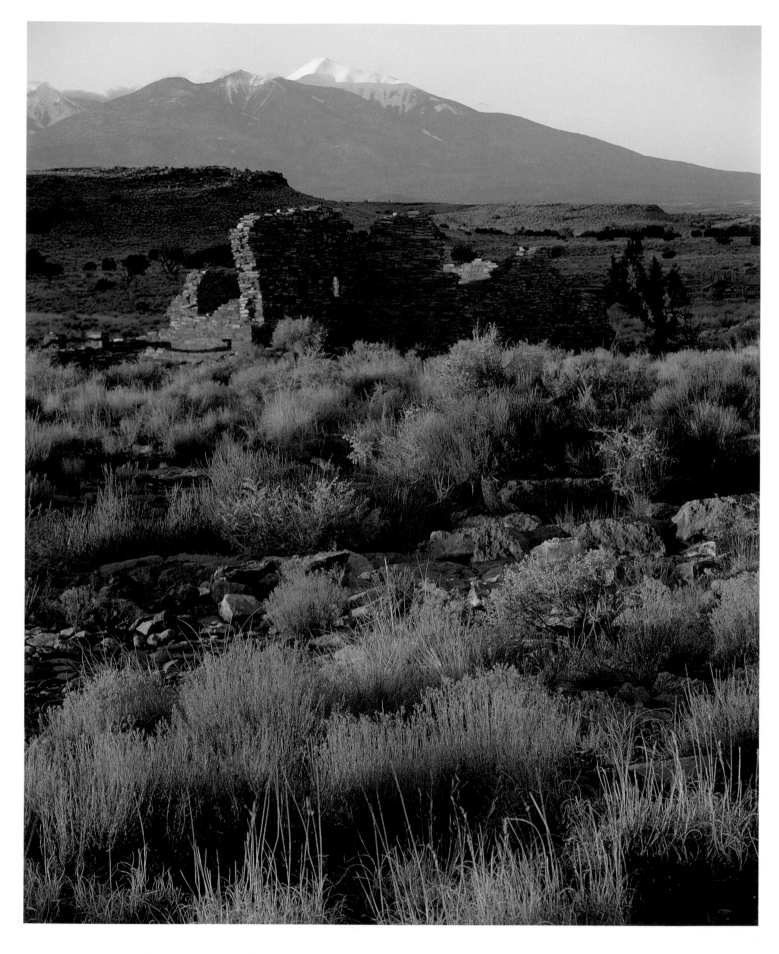

Rehearsals for Rain

A region-wide beacon sacred to Hopis, Navajos, and many other tribes, San Francisco Peaks rise behind a Hopi ruin at Wupatki National Monument *(far left)*. Clouds like these built up over the Peaks when a pumice mine on its flank recently agreed to close.

aegis of the Navajo Museum and protested this invasion of so holy a mountain. It didn't work; the ski lift was built. In the 1970s, another was planned, this one to extend farther up the peak. Its supporters found that some Hopi priests once used the ski lift to shorten a summer pilgrimage to the summit, and the Hopis, a bit embarrassed, saw to it that no Hopi used the lift again. The Hopis were not against other people using the mountain so much as they feared that people milling around among up there might interfere, however inadvertently, with the *katsinas'* rehearsals of rain that were so crucial to Hopi existence. Eventually, the ski resort was expanded, but not into the *katsinas'* realm at the top.

Meanwhile, fashion being what it is, the world invented stone-washed jeans. These are jeans that are beaten about with stones to create a look something like that of well-worn jeans. The stone used to stone-wash jeans is pumice, and pumice is a product of volcanoes. And so it was that a Phoenix-based company called Tufflite Corp. set out to expand an insignificant little mining operation called the White Vulcan mine that had been in use since the 1950s. In 1985, Tufflite began mining pumice in ninety-five acres on the eastern slopes of San

Francisco Peaks—a large area basically in the line of sight from the peaks to the Hopi villages. The Sierra Club, which does not always find itself on the same side as the Indians, added their voice to complaints that the mine desecrated a holy place. In their case, the mine was the set piece in their opposition to the mining law of 1878 that sells permits to mining companies on federal land for an amount so trivial as to be laughable.

Then in July 2000 the U.S. Forest Service, which administers most of the peaks as part of the Coconino National Forest, acknowledged recommending to the Interior Department that nearly seventy-five thousand acres of the mountain's eastern slope—including the Tufflite pumice mine—be withdrawn from mineral use. By summer's end, agreement was reached. Tufflite agreed with the Interior Department to cease further mining and to begin restoration of the land, in return for payment of a million dollars by the government as well as retaining the right to use the pumice already mined and on hand. On August 29, at a rainy ceremony near the mine, the deal was officially sealed. One of those present, Ferrell Secakuku, snake priest and former Hopi tribal chairman, called it "the best day of my life." 🐾 JP

Sacred Places of the Heart and Soul

When I was a young man studying law, I imagined myself as the next Louis Auchincloss—a brilliant lawyer who slaved by day in a great Wall Street firm and, by night, wrote incisive novels that told the story of "our people." In my case, the people were not New York bluebloods but Cherokees and Osages, intermarried with French and English and Scots (Tuckers and Reynards and Stricklands) who had come into Indian Country to barter and to trade and, eventually, to settle down.

I was studying law at the University of Virginia and, foolishly, I began a first novel while struggling to master the details of "A to B, remainder to C" and "proximate cause." It was the story of George Madison Lookout, a mixed-blood Osage-Cherokee lawyer who took leave from his Wall Street law firm and went back to Indian Country to find himself. In the romantic language of my adolescent novel, Lookout was "in search of the sacred places of heart and soul." Fortunately, the novel is long lost.

Ironically, now almost four decades after that first unpublished novel, I faced the challenge of writing about sacred places. I agreed to do what I had earlier imagined the fictional George Madison Lookout doing—discovering the meaning of sacred places in the lives of exiles from their native homelands. So here, in the manner of a modern legend, my fictional alter ego continues his search for "sacred places of the heart and soul." This story is in many respects autobiographical, but I have been an academic, not a practitioner. The issues raised here are faced by most native peoples living away from their homelands.

Approaching the summer of his sixtieth year, George Madison Lookout promised himself he would get out of his fancy fifth-floor corner office in Washington, D.C., and take that trip back to Indian Country. He would retrace the historic steps of his people over the Trail of Tears.

In many ways, Lookout envied Native American lawyers who had gone home, who spent their lives and careers working directly with their people, on the reser-

Rennard Strickland is a legal historian of Cherokee and Osage heritage. Dean and Knight Professor in the Law School of the University of Oregon, he served as editor-in-chief for the revision of Felix J. Cohen's Handbook of Federal Indian Law, *and president of the Association of American Law Schools. Among his numerous public service duties was serving as Chair and Arbiter of the Osage Constitutional Commission. He is author of several books including* Fire and Spirits: Cherokee Law from Clan to Court, *and* Tonto's Revenge, *a book of wide-ranging, witty and wise lectures on law, literature, history, art, film, and Indian identity and culture.*

vation and in the county seat towns and state capitals out in Indian Country. He had chosen another path. Early on, he decided that dealing with colonial power meant being in Washington, in the colonial capital amidst the colonizers themselves. He had never counted the price he paid for that decision, but he knew it was high. And yet he continued to believe that at least for him, it had been the right choice.

Lookout thought of himself as a warrior in exile. He was Osage and Cherokee with a strong dose of French and English. A little Pawnee was rumored to be on his mother's side, or so his paternal grandmother hinted when offended by the frankness of his Osage mother. And, of course, his father's Cherokees had been so long intermarried that nobody even speculated what strains of peddler blood blended with the Native. He was what the full-blood Cherokees called "a thin blood." Yet he thought of himself as Indian.

As with most exiles, place loomed large in Lookout's life. Despite forty years in Virginia and the District, he still thought of himself as an "Okie," an Oklahoma Osage-Cherokee. He still carried an Oklahoma driver's license with the address of his father's Cherokee allotment of 180 acres. As with so many contemporary Indian people, his ultimate personal place was land to which the federal government had driven the Cherokees on the Trail of Tears and later tore from the tribe and "allotted" to individual Cherokees to try to end Indian nationhood. To Lookout, this plot in Cherokee County seemed more his home than his town house on Capitol Hill.

Beautiful as Virginia could be, Lookout missed the sea of grass that was The Osage, the tall grass prairies on which his mother's people had been forced to settle. To him, there was no spot equal to the clean, cool, and swift waters of the Barren Fork and the Illinois Rivers as they cascaded through Cherokee Country, opening up to the hollows of the Cookson Hills.

During his law school days, the concept of the lawyer as "briefcase warrior" became clear to him. Lookout became a powerful warrior, fighting to preserve and protect the people and places that made up Indian Country.

Lookout's true sense of vocation came to him not in Virginia, nor on the tall grass prairie, nor even along the wooded stream of the Illinois. It came in the mountains of New Mexico; it came at a celebration of the victory at the Little Big Horn by young law students, tribal elders, and newly admitted Indian attorneys brought together by the American Indian Law Scholarship Program of the University of New Mexico. The celebrants included Indian lawyers Sam Deloria and Thelma Stiffarm, Duane Birdbear, and Sharon and Charles Blackwell, along with such elders as former Indian Affairs Commissioner Bob Bennett and Sam's father, the Reverend Vine Deloria, Sr.

That evening, Lookout listened as wise souls stood around the fire and talked about battles fought and battles ahead. For Lookout, it was a life-changing, life-affirming experience. He felt a sense of continuity, a joining of generations. He

understood how the legendary warriors who defeated the arrogant and cowardly Custer fought the same battle as modern Indian lawyers. Weapons changed, but equal cunning and courage were required; the stakes were as great and the enemy as arrogant and cowardly.

Such scenes flashed through Lookout's mind as he began his trip to the Cherokee homeland. His real journey would not begin until he reached the Trail of Tears, but as he started his car, he remembered the movie *Powwow Highway* and the old clunker of a car that was the Indian's faithful steed, and the scene in *Smoke Signals* where the girls on the Res could only drive the car in reverse, a sick but faithful pony. He had never understood the custom of naming cars, but he couldn't resist thinking of his Land Rover as Powerful Pony carrying him forth on a personal quest, if not a crusade.

As he headed south through the Virginia and Carolina countryside, the congestion and urban sprawl appalled him. He thought of what this land must have been before white contact. Lookout imagined a rich and fertile land that five hundred years ago had sustained southeastern tribes, many of which now slumber, extinct.

The old ones, his grandparents' generation, spoke of the beauty of the land when "the color of grass and trees and rivers blended together and there were no sharp edges" of roads and field lines. Driving toward Georgia, Lookout thought of the ancient places of Native worship, of precontact sacred sites and lost civilizations. As he thought about his own people—the Osages and Cherokees—he envied those tribes able to survive in their homelands, among the sacred places of their creation. His people had been, as one Cherokee recalled, "torn from the bosom of our Mother Earth."

Where did a people find new sacred places when driven from the homeland of their creation? From the graves of their ancestors? Lookout needed to understand the puzzle of re-creating a sense of place, of sustaining a sense of self. As he pondered this question, he remembered a Chickasaw family celebration he had shared more than twenty years before.

In the early summer of 1979, the Chickasaw family of Hughes and Cravatts have gathered on a Sunday afternoon at their home place, the family allotment along the Blue River, a few miles outside the old Chickasaw Nation's capital at Tishomingo, Oklahoma. Drawn together for a celebration, they honor the matriarchs of this large and scattered family. More than two hundred descendants have come home to Oklahoma in mobile vans and small, imported cars, in family station wagons and rusting trucks. They range in age from ninety years to less than nine weeks, from dark full-blood to light blond mixed bloods.

Fresh catfish from the Blue River is frying on portable butane burners in great black kettles while a full-blood cousin cooks the traditional *pah sofa* of corn and pork on a wood fire in the ancient kettle some say came with the Chickasaws from Mississippi over their own Trail of Tears. Row upon row of dishes of home-cooked foods line the tables.

A carload of Chickasaw men go back to town because someone forgot the cornmeal. A group of young girls whisper secrets while a gang of little boys runs up and down the riverbank, determined to find poison ivy. Almost everyone comes to the trailer to admire new twins, the latest addition to the generations of this Indian family.

Everything is in preparation for the coming feast. After the gift giving and the speech making, the crying and the laughing over shared memories, three Indian ministers say grace in two languages. Then there is the eating—and more eating!—followed by the singing of hymns in Chickasaw, in Choctaw, and in English. And then napping and more eating. And swimming in the river. And more gossip. And more tears. And finally, laughter and an agreement to return soon as a family to this Chickasaw home on the Blue River.

A sense of place and purpose, of permanence beyond mobile vans and foreign cars, permeates Indian celebrations such as this. In a statement delivered before the feast, Charles Blackwell, great-grandson of the Chickasaw woman who founded this dynasty, expressed not only the Chickasaw sentiment, but also the attitude of most Native Americans:

> It is fitting and natural that we return to this place—this Blue River—to celebrate as a family. These riverbanks have known the happiness of new babies, the suffering of passing generations, the excitement of thriving enterprise, and the laughter and love of a great family.
>
> From this place we have learned to love, to love the sweet smell of the air after a summer thunderstorm; we have learned to love the evening time call of the whippoorwill, to love the early morning smell of a wood fire.
>
> We are fortunate in these gifts. From this place we have been given a proud Indian heritage blended with the enthusiastic courage of the new pioneer. From allotted home places such as this, our tribes, our state, and our nation have grown strong.
>
> Wherever the circumstances of time and necessity may take us, this home place will always be ours. So, whether we return here in reality or only in our hearts and dreams, we will always gather strength from these tall cedars, these granite rocks, and this, our Blue River.

His own experiences had taught Lookout that Native peoples, whether Cherokee or Chickasaw, Pawnee or Osage, brought their old ways to the new lands. The Choctaws' ancient legend tells of an early migration in which they carried the

bones of all their ancestors. Cherokees on the Trail of Tears brought burning embers from the Sacred Fire so when they resettled, the people could worship as they had in their ancient homelands.

Lookout remembered with great pride how much of the traditional way had been preserved in the hearts and souls of his people. New sacred places for worship and celebration were created by the Native newcomers to this land. New grounds could not replace the tribe's ancient homeland nor the graves of their ancestors, but the new was, in time, sanctified by the keeping of the ancient ways.

Lookout drove straight through from Washington to Georgia, at last reaching a most sacred place for all Cherokee people. He stopped at the exact spot from which the Reverend Jesse Bushyhead had signaled the start of his people on the Trail of Tears. He intended to retrace the route his people followed in the dreadful winter of 1838–39, and bring it into his life. The journey stretched over six months, covering more than a thousand miles from Georgia to the Indian Territory, lasting from October 1838 until March 1839. The exiles died, in tens and twenties, every day. The very old and the very young could not stand the hardship of the brutal winter, and even the most able-bodied were soon weakened by relentless blizzards. Lookout prepared to follow the trail that got its name because white men and women and children were brought to tears by the brutality they witnessed.

Lookout knew that among the Cherokees this story had been told so often, so vividly and so dramatically, that a sense of the challenge of survival comes almost with one's mother's milk. The story of the crossing of the frozen Mississippi was forever etched in the minds of those, like Lookout's great-grandparents, who as children survived the Trail. All Cherokees knew the symbolism of crossing a river toward the west, for in Cherokee mythology, the west is the black direction—the way of death.

Retracing the Trail of Tears was Lookout's personal pilgrimage. To him, it was a holy trek, symbolizing both suffering and rebirth. It remains, to this day, the embodiment of genocidal banishment, the culmination of Andrew Jackson's removal policy. Cherokees were rounded up at the point of a gun and driven out of their homes, away from the graves of their fathers and mothers.

Leaving Georgia meant something uniquely personal to each Cherokee, but the loss of homeland, the abandonment of graves was a burden shared by all. The tragic deprivation and bitter humiliation of forced exile touched every tribal member. To the full-blood traditionalist whose religion was intimately tied to a particular place and to happenings remembered, the move was spiritual disaster; to the mixed-blood trader and

planter, the economic blow was devastating.

The beginning point of Lookout's journey was New Echota, the capital of the Cherokee Nation in Georgia, a tourist site today where the first tribal courthouse and newspaper office have been restored. At this site, Georgia troops began imprisoning the tribal members, events recalled for a *Smithsonian* chronicler:

> "Families at dinner were startled by the sudden gleam of bayonets in the doorway and rose to be driven with blows and oaths along the weary miles of trail that led to the stockade. Men were seized in their fields or going along the road; women were taken from their wheels and children from their play. In many cases, on turning for one last look as they crossed the ridge, they saw their homes in flames, fired by the lawless rabble that followed on the heels of the soldiers to loot and pillage."

Lookout, like the good lawyer, had done his research in preparation for his journey. He decided to retrace, as nearly as possible, the exact route of Reverend Jesse Bushyhead's removal detachment. Bushyhead had been chief justice of the Cherokee Nation as well as a religious leader. Lookout thought of Bushyhead as the kind of tribal leader he would like to follow, a fighter who always put his people first.

Bushyhead led the first wagons on a path that established the route of travel for most of the migrant nation. Lookout made a log of the route and followed it as closely as possible along the back roads across the South. More than a century and a half later, George Madison Lookout felt the powerful spiritual presence of Bushyhead and the other removed Cherokees.

The Bushyhead detachment departed for the west on October 5, 1838. They had limited funds to purchase supplies at inflated prices and suffered a delay when their oxen ate poison ivy. Bushyhead's report of October 31, 1838, declares: "We have a large number of sick and very many extremely aged and infirm persons in our detachment that must be conveyed in wagons. Our detachment now consists of 978 or 979 Cherokees and there are now forty-nine wagons."

In November, the rains made the roads almost impassable. December and January brought freezing rain and then blizzards. It was the worst winter in memory. The Bushyhead detachment spent a month stopped by the ice on the Mississippi River. By February 23, 1839, Bushyhead had brought his party to their final destination in the new Cherokee Nation. Only eighty-two of his company had died. Other parties did not arrive until late March, spending six months on the fearful Trail and suffering far greater casualties. In all more than sixteen thousand began the trek; fewer than twelve thousand finished it.

Jesse Bushyhead so managed the removal of his ragged detachment that he

arrived in the west as a man universally respected and beloved. And arriving with him was little Eliza Missouri Bushyhead, the daughter born on January 3, 1839, just after the Bushyheads crossed the frozen Mississippi into the state of Missouri. Destined to become Aunt Eliza Bushyhead West Alberty, beloved matriarch of the Cherokee tribe, this tiny girl symbolized the hoped-for new beginning.

After following—almost mile for mile—the trail of the Bushyhead detachment, Lookout came to the end of his own odyssey when he crossed the Arkansas border into eastern Oklahoma. The terminus of the Trail was marked by the church built in 1839 by Jesse Bushyhead, a church in which his little daughter Eliza Missouri would grow to womanhood.

At the end of the Trail, the surviving Cherokees settled. Gradually the wounds of removal began to heal. The Nation entered what historians call "the Golden Age of the Cherokee," destined to last until Oklahoma statehood at the beginning of the twentieth century. The tribe consolidated advances begun in Georgia. They revived their tribal newspaper, wrote new laws, issued books and broadsides in the syllabary of Sequoyah, established the Cherokee Seminary, which was to become Lookout's college, and maintained tribally funded public schools.

Pulling into a gas station just over the Oklahoma line, Lookout took out his wallet and handed his credit card to the attendant. He glanced at his driver's license displayed in the slot below. It pleased him to see there the address of the Cherokee allotment of his father, whose father's father had settled on this land after the Trail of Tears. Next summer, Lookout resolved, he would retrace the steps of his Osage forebears and see how they had come to be neighbors of his Cherokee family. For both tribes, Oklahoma was a land removed from the graves of their ancestors, from their ancient sacred places.

In the meantime, Lookout was needed back in Washington. He had a brief before the Supreme Court, a case he would argue next term that sought to protect surviving sacred places of Native peoples. Lookout hoped this time the Court would get it right. The justices always seemed to err in interpreting Indian ways. After this trip, he hoped he was better prepared to help them understand. It had been, for him, a journey of personal discovery and understanding.

George Madison Lookout turned the key in the ignition of his vehicle and headed east. Once again driving across Arkansas toward Virginia, he reviewed the Cherokee experience and wondered about other tribes and their sacred places. His mind focused not only on America's Natives, but also on tribesmen stacked in the belly of a slave ship, transported across vast oceans to America. He thought of those who exiled themselves from Europe and Asia because they were escaping concentration camps or starvation, or lacked economic opportunities or religious freedom. In his mind's eye, he saw them all as tribal brothers and sisters, descendants of Mother Eve, the common ancestor scientists say is the genetic mother of us all. Lookout believed that each of us carries a spirit, a place within the heart where our common humanity rests.

A rain squall moves in on the Little Rockies, an island range in Montana that the Gros Ventre people call the Fur Caps, where they go to collect sacred plants, to fast and seek visions. And there is gold in those hills....

THE PREFERENCE OF THE WHITE CLAY PEOPLE

Gros Ventre, Assiniboine

The Little Rockies are an island range in north-central Montana. Most of the range was included in the lands set aside for the Gros Ventre when an 1888 act of Congress carved the Fort Belknap Reservation out of the vastly larger 1855 treaty lands shared by the Gros Ventre and the Blackfeet. To the Gros Ventre, who call themselves the White Clay People (they were formed from the white clay found along the rivers after a great flood had covered the land), these mountains are the Fur Caps. Davy Belgard, who works with the tribal water quality program, says, "Our people used to call these mountains the Fur Cap Mountains because, from a distance, it looked like a fur cap. There was so much pines. It was just beautiful."

"To our people, one of the highest designations of a holy person was the wearing of the fur cap," says Preston Stiffarm, another tribal member. "We have four sacred mountains in our land," he continues. "The Fur Caps, the Judith Mountains, the Sweetgrass Hills, and the Bear's Paw. These ranges were the sentinels for our lands, where people went for spiritual reasons throughout the year. Any person who wanted spiritual gifts had to go out and fast. There were certain buttes named by First Man, who gave us our ways. These spirit places, they were sacred places."

From the town of Hays, through the high walls of Little People's Canyon, past a natural bridge, past the Sun Dance grounds, beyond the powwow grounds, where the steep and narrow road steepens and narrows more, it seems as if you have entered a secret place, oddly breached by the road. It is a place for ritual and tryst, for belief. For beginning. Years ago, the White Clay People did not have a wedding

ceremony. When a courting couple disappeared, everybody knew they had gone up to the mountains, where God married them. While they were away, the people made them a lodge and furnished it, then had a ceremony as the couple returned, their new life beginning as if the canyon had given birth to it.

The Fur Caps were taken from the people in 1895 when the heart of the Little Rockies was removed from the reservation. Gold had been illegally mined there since the 1860s, while the mountains were still Gros Ventre lands. To continue the mining—legally, if not ethically—George Bird Grinnell, a government agent, convinced a few Indians, most of whom were Assiniboine simply placed on the reservation by the U.S. Government (and some of whom did not even live on the reservation), to sell a piece of land seven miles long by four miles wide for $350,000. According to James Main, Sr., a Gros Ventre who sits on the board of commissioners of the International Indian Treaty Council of the United Nations, the Governing Council of the American Indian Movement, and the Indigenous Environmental Network, that money was stolen by a Bureau of Indian Affairs agent who later committed suicide. Many Gros Ventre, who never agreed to the sale of the mountains in the first place, remain angry at what they regard as trickery and theft.

"There used to be a butte up there called Goldbug," Davy Belgard says about one of the peaks dismantled by the mine. "I don't know how long the tribes fought them on that because they used to say—there's fasting beds up there. The old guys would go up there and fast on top of the mountains. There's burials up there, too, on some of those spots. You go to some of those old fasting places up there, and there's roads going right

through them now. There were cairns in a kind of horseshoe, with the opening toward the east. Those are our fasting sites. There were a lot of them in these mountains."

Today two mines—the Zortman on the east side of the range and the Landusky on the west—together form the largest open-pit, cyanide-heap leach gold-mining operation in the world. This kind of mining uses a cyanide solution to extract gold, and the gold-bearing solution collects at the bottom of containers called leach pads. Eventually the contaminated leach pads are left behind along with dikes, waste rock dumps, high walls, mine pits, the ugliness of mountains pared open, and the potential for poisoning surface and groundwater. In tearing apart the mountains, countless sacred cultural sites were destroyed—fasting sites where people went on vision quests and the sites of sacred plants. Ripped apart, the mountains are like the bodies of giant dead buffalo, skinned and left to rot.

This was their most holy, sacred land and they could not use it, Preston Stiffarm says. "Because of our sacred bundle, we were here. We had everything. Tipi poles, buffalo...It was a paradise. When you see that mountain gouged out, it makes you sick. Not only sick as a person at the destruction, but because the mountain is holy. It's our sacred place."

Raymond Chandler, Sr. is married to Ina Nez Perce the tribal Environmental Protection Manager. "There's only a few areas that have fireflies," he says. "But where are they now? You can't go fast on Mission Peak and drink from Bighorn Creek because the water's green! All of these things are spring-fed, but many of the springs have dried up."

The Gros Ventre and Assiniboine Tribes share the Fort Belknap Reservation. While there are many things on which they disagree, including mining, they are united in their opposition to the threats to the water supply and to wildlife and in their dismay at the destruction of the spiritual values of the mountains. In 1994 and 1995 the tribes took legal action against the mines when toxic water began seeping out of the mines in violation of the federal Clean Water Act. The litigation, joined by the state and federal governments, was settled in a consent decree requiring Pegasus Gold, the Canadian mining company, to do compliance monitoring, which they did.

The company was also to engage in three sup-

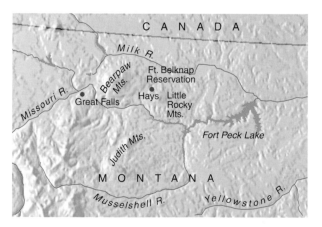

THE PREFERENCE OF THE WHITE CLAY PEOPLE

plemental environmental projects on the reservation. But mining ceased in 1998, by which time Pegasus Gold had already removed between one and one and a half million ounces of gold and about ten times that much silver. To do this, they dismantled twelve hundred acres of mountain so that the top of the range appears chiseled into a stone desert, open and vulnerable and without hope. In January 1999, in the face of a continual decline in gold prices, the company filed for Chapter 11 bankruptcy reorganization instead of carrying out the supplemental projects.

When rock containing sulfides is exposed to air and water during mining operations, it produces acid rock drainage. At both mines, the main sulfide mineral is pyrite—fool's gold. The longer it is exposed to air and water, the greater the acid-generating potential, so that rock that is relatively safe right now may be lethal in fifty or a hundred years. Water traveling through the rock becomes acidic, sometimes containing toxic heavy metals, which in turn poison aquatic plants, animals, fish, and people. A Canadian geochemical study said the mine water could well need to be treated until the next ice age.

The only alternative is a full restoration. Rock exposed in open pits and on high walls should be completely covered (and the technology exists to do this). In February 2000 a ruling by the Helena District Court in regard to a different Montana mine stated that mines had to be backfilled and the high walls taken care of to cut down on acid mine drainage. A reclamation plan developed by the tribes provides for this at a cost of $125 million. After this plan was developed, the Montana state legislature met in special session in spring 2000 and passed a bill stating that backfill of open pits is not required. The bill is retroactive to 1995, specifically to include the Zortman–Landusky mine.

The Montana Department of Environmental Quality and the U.S. Bureau of Land Management (the mines sit on BLM land) are responsible for reclaiming the Zortman and Landusky mines. Allocated funds are about $90 million short. The tribes are lobbying Congress to convince it to appropriate funds to get the job done, as well as suing the BLM for not taking care of their trust obligations to the tribes and the Bureau of Indian Affairs and the Indian Health Service for going along with the BLM and for their negligence in not looking out for human health and the environment.

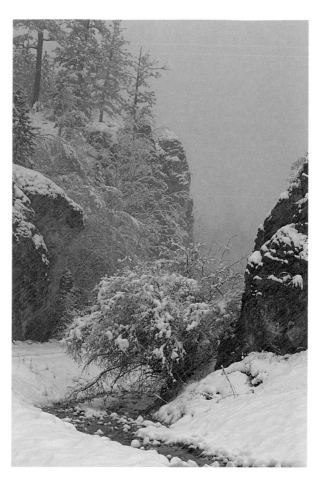

Long ago, a courting couple would enter Little People's Canyon, where God would marry them.

The suit doesn't ask for damages; just that the whole job be done.

"They won't be able to fix it the way the Creator fixed it," Fred Gone, a Gros Ventre elder and spiritual leader, says. "The whole area is affected by its [the mountains'] desecration. I don't know how the spirits are affected. We prayed to the mountain spirit. All of a sudden, they quit mining. I sure felt good about that.

"In my belief," he continues, "the mountain spirits are still in the mountain. Nobody here has died of the water. The mountain spirit keeps our water pure. Our people pray the spirit keeps the water pure. We have mountains all around us our people use for sacred ceremonies. The desecration is what I'm concerned about. The Fur Caps were the preference of the White Clay People. We're grateful we have what we have. That whole mountain is ours. Personally, I feel those spirits are still within those mountains. I can't see that the spirits would ever leave."

Would the spirits be happy if the mountain was restored? "I can't answer that," Fred Gone says. "But I'm happier." 🪶 RR

One of the greatest assemblages of rock art in the nation, the Petroglyph National Monument in Albuquerque is still a place of prayer for Pueblo people. It stands fragilely between the city and yet more uncontained urban sprawl.

A PLACE OF REVERENCE

Cochiti, Jemez, Santa Ana, Sandia, Zia Pueblos

Look west from nearly anyplace within the mindless sprawl of Albuquerque, New Mexico, and five worn-down knobs are visible on the horizon. The remains of five volcanoes all in a row that were active within the period of the ice ages but are now dormant, they sit on the highest of the terraces that form West Mesa here in the Rio Grande Valley. On an escarpment of dark lava below the old volcanoes is Petroglyph National Monument, established in 1990. On virtually all sides of the monument, developers are building, have built, or plan to build thousands of cheek-by-jowl residences, in order to perpetuate the city as one governed by centrifugal force. Within a stone's throw of the northern end of the monument is a large residential warren that calls itself, without the slightest sense of irony, Paradise Hills. A road curves along the edge of Paradise Hills, between it and the monument.

The monument was established for a number of purposes, not the least of which was to curb vandalism of what is the nation's largest array of Indian petroglyphs in one place. Some estimates say fifteen thousand images have been pecked into the lava rocks and boulders, starting as long ago, perhaps, as 1000 B.C. Thousands of images are in what archeologists call the Rio Grande style—kokapelli the flute player, various creatures from pronghorns to macaws, many spirals (generally taken as migration symbols). These were the work of the people known as the Anasazi, who once inhabited places like Mesa Verde and Chaco Canyon but later, beginning in about A.D. 1200, began migrating toward the Rio Grande. Here they established the villages now called pueblos and the cultures that greeted the Spanish conquistadors and Franciscans who were bent on enslaving

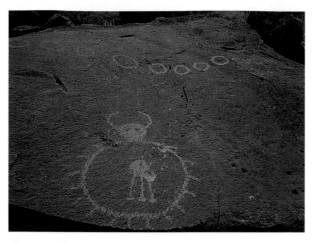

Some petroglyphs are three thousand years old, some as recent as yesterday.

to the Manzano Mountains to hunt big game and make offerings and sacrifices once those hunts ended. The petroglyph area is where messages to the spirit world are communicated. "It is here that our Pueblo ancestors 'wrote' down the visions and experiences they felt."

Weahkee went on to say that the area was in the approximate center of the great protective mountain ranges arrayed around the region and added that all the pottery shards, grinding stones, and prayer sticks in the ground among the petroglyphs confirm the sacredness of the area. "The real question should be…Where is the evidence that this site is not sacred?"

That question went unanswered in the political turmoil that raged around this new national monument over a plan to run a six-lane, high-speed highway straight through it. The private developers of Black Ranch and other properties west of the monument wanted the highway, as presumably did the thirty thousand people who would one day live there but who at the time had no names, didn't in fact yet exist as residents, and still don't. The very real people of Paradise Hills wanted the highway lest the twenty-five thousand or so vehicles a day predicted by the year 2010 drive right past their properties, emitting exhaust fumes and engine noise and, it was claimed darkly (and altogether falsely, it turned out), forcing a Methodist church to be bulldozed. The Albuquerque City Council, along with two of the state's three congressmen and one of its senators, wanted the highway, too. Virtually everyone else was against it.

The National Park Service (which runs national monuments) explained that they could not legally permit a highway to go through a national monument unless it served some park-oriented purpose. This one would not even have an exit into the monument. The politicians, led by Republican senator Peter Domenici, let it be known that his legislation in 1990 creating the monument included language permitting the highway (called the Paseo del Norte extension) to be built. This was in fact not true. The language of the bill said nothing about Paseo del Norte but did include it on a map of the area. Confronted with the laws about highways in national monuments, Senator Domenici, who got his political start as an Albuquerque city councilman, promptly and with breathtaking cynicism

them and abolishing their religions. The pueblos survived, however, and so did the mysterious records the people etched into the rocks.

In the autumn of 1996, a member of the Cochiti pueblo, Bill Weahkee, felt the need to explain to the world something about these petroglyphs—something that too many powerful people had forgotten. He wrote in the local paper on behalf of Cochiti, Jemez, Sandia, Santa Ana, and Zia Pueblos—all north of the city along the Rio Grande or one of its tributaries. To do so, to go public, he wrote, was "an unprecedented step," most Pueblo tribes choosing to remain mute about their religious observances ever since being hammered by the Spanish four centuries ago. But the five tribes felt the need "to inform the general public of pueblo views on this last remaining sacred site in the area."

Weahkee explained that his "ancient ancestors" regard the site of the petroglyphs as sacred because it "was born with Mother Earth's great labor and power." By which, of course, he meant the volcanoes, their once-open vents communicating with the world beneath and the lava that they sit on. For centuries the Pueblo people have used this area for hunting small game, for gathering seeds and medicinal plants, and as a stopping-off place on journeys

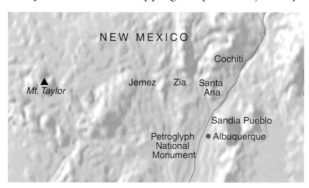

A PLACE OF REVERENCE

introduced legislation that exempted the Petroglyph National Monument from any such restriction by turning ownership of the exact corridor for the highway—no more, no less—back to Albuquerque, making it the city's exclusive business whether the extension was built or not. By then the city had a new mayor, Jim Baca, who had run on just such issues and was against the extension for a number of reasons, the main one that it was another inducement for wasteful urban sprawl.

Then the politics grew really ugly. It was pointed out that Senator Domenici and one of the city councilors were investors in a real estate partnership that owned land west of the monument that would obviously benefit from a big, fast, straight road into its neighborhood—although the senator's holding was fairly minor and at some remove. "I don't understand why anybody's fussing about this," said Domenici. Any alternative to the extension of Paseo del Norte would be far too expensive, the senator and others said, though this was never clear. It was said, as well, that a municipal golf course was at stake. A Methodist minister (the one who let on that his church would be bulldozed) and the morning newspaper smirked about what they implied were barbaric pagan rites being held at night in the monument by the Indians (they do go there quietly at night to pray so as not to be disturbed).

The New Mexico Conference of Churches, on the other hand, organized a multifaith pray-in at the monument—which the same Methodist minister later denounced as "hostile," rather than designed to create a spirit of reconciliation. Was it hostile?

The pray-in was held on April 16, 1998. After a daylong rain, the clouds began to part and by four o'clock, shafts of sunlight bathed the mesa. Indian prayers were spoken, as were brief homilies by Christian and Indian alike. A rabbi led everyone in a simplified hora, people singing "la-la la lai." Pouches were collected, Sonny Weahkee led the assembled—in all about 150 people—in a round dance, and a Navajo grandfather gave a final prayer, his voice cracking with emotion that everyone present understood through the barrier of language, which was no barrier at all. They came in peace, and went home in peace.

Bill Weahkee had written earlier that the Petroglyph National Monument was for everyone, for people of all races and religions, and that it

"should be a place of reverence and prayer." Perhaps it still can be. But surely the sound of traffic speeding by on a six-lane highway that chops the monument in two as cleanly as an ax shearing off a limb would be something of an impediment to a serene and reverential mood.

Some evidence indicates that those ancient spirits there—what non-Indians might think of as the genius of the place—have already begun to lose patience with what has been done to West Mesa in general and to the petroglyph site in particular. Paula Gunn Allen, a native of nearby Laguna Pueblo (see page 42), reports that on one occasion she was chased all the way along the length of West Mesa by a dust devil, the temporary embodiment of an angry spirit, and hasn't been back since.

At the moment, the angry spirits are waiting for the next part of the story to unfold. In the view of many political analysts, the developers and their allies are biding their time until Mayor Baca leaves office and the Indian activists of the SAGE Council get tired or run out of money to conduct their program. But meanwhile a major *national* movement to protect sacred lands is arising, and the moment a bulldozer blade is dropped, court battles will erupt that the spirits may find salutary. 🐾 JP

A major highway through the monument threatens, permitting yet more housing to crowd its edges.

THE GOD OF THE WATERS

Mendota

In Minneapolis's Minnehaha State Park, near where life began, water drips and icicles form in a spring that is the passageway into the world of a Dakota (Sioux) god, Unktehi.

The sacred spring pours out of a gash in dark limestone bedrock. A hidden, private place, it is a delicate rent in the earth, offering seventy gallons a minute, a hundred thousand gallons a day, of pure and healing water. Its sound carries across the pond into which it falls. By climbing the few feet down into it, you can stand on slippery dark rock and let the water run cold over your hands. Drink from it and it tastes cold and pure on your tongue. Through intense summer heat and deep Minnesota winters, where minus thirty-five degrees Fahrenheit is not uncommon, the springwater remains forty-seven degrees.

The spring is the dwelling place of Unktehi, God of the Waters. It is Unktehi's passageway into the world, part of the Dakota (Sioux) creation story, a sacred place for thousands of years. A quarter of a mile away, the spring's water enters the Mississippi not far above the confluence of the Minnesota and Mississippi Rivers. The confluence is the place where the Seven Fires (divisions) of the Dakota arrived on earth, descending from the belt of Orion. For the Mendota Mdewakantan, a Dakota people who have always lived in this place, this is where life began. Here, Ina Maka, the mother earth, gave birth to the ancestral grandmother and grandfather. This land, where western prairie meets eastern woodland, is sacred. The Reverend Gary Cavender, an Episcopal priest and a traditional spiritual leader from the Shakopee Dakota Community, says, "We came here as human beings, so that is our Eden."

Immediately to the north of the spring, on the last stretch of bur oak savanna along the Mississippi anywhere from its headwaters to the Gulf of Mexico, four sacred oak trees once grew. Oaks and

spring, Minnehaha Falls and much else of natural beauty form Minnehaha Park, the largest green space in the Twin Cities. The Mendota, other Dakotas, and many other Native Americans and whites fought sixteen months to save the trees, scheduled to fall prey to a plan to reroute Highway 55, with the old route turned over to the development of light-rail transit. The new route would shave three minutes off the drive time from downtown Minneapolis to the Mall of America, in the process cutting a four-lane swath across an edge of Minnehaha Park en route to the Twin Cities International Airport, about a mile away.

Spiritual leaders testified to the sacred nature of the oaks. In an October 1998 testimony, Gary Cavender said, "Among other reasons, the four oaks are sacred because of their age. Indians treat our elders with the greatest of respect because of their wisdom. Similarly, the oak trees are our wise elders. They are our kin."

Harry Charger, a Lakota Sun Dance leader from South Dakota, performed a sacred pipe ceremony at the four oaks. "It is a place where many, many cycles have been completed and are still to be completed," he wrote to the U.S. District Court in 1998. "Although this is not to be taken as a threat,"

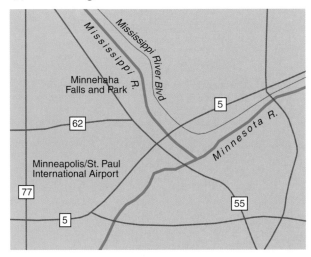

he continued, "when sites of this nature are disturbed or disrespected, there are always the consequences. All things, good or bad, have a way of coming back around."

In August 1998 protestors set up Camp Two Pines near the oak trees, establishing a communal village called the Minnehaha Free State. They vowed to stay until the road development was

stopped and the property returned to the Dakota Nation, whose land it always was.

At 4:30 A.M. on a bitter December morning in 1998, an army of more than six hundred policemen wielding guns and pepper spray brutally destroyed Camp Two Pines and bulldozed houses along the edge of the park that had been condemned to make way for the road. They tore down tipis and burned the lodge where the sacred fire burned, as well as a ceremonial tipi and other objects. (The state of Minnesota later reimbursed the owner of the ceremonial tipi.) More than thirty protesters were arrested. Some were injured. Protesters—both Indian and white—were back at the site the next day, announcing they would fight on. A year later, when the protesters were evicted from a second camp they had set up nearer the trees, the police changed their tactics. This time they waited quietly for an Indian ceremony to finish before moving in to arrest more than thirty people while state workers chopped down the four oaks.

Where the four oaks once stood, the Department of Transportation has erected a sign. Tree Protection Area, it says.

While the trees were still standing, Harry Charger told the Mendota the trees would be lost, but the Mendota would not be defeated because they would be educating people and the sacred spring would be preserved. Now the Mendota, and many others, have turned their energy and prayers to saving the spring, Unktehi's passageway, from the grasp of the Metropolitan Airport Commission (MAC).

The spring is on land owned by the U.S. Department of the Interior—in all, twenty-eight fenced acres that, until 1997, held a research facility for Interior's Bureau of Mines. When the facility was closed, the land was handed over to the Bureau of Land Management. At that point, the Minnesota congressional delegation decided they could get a good deal for the state if the land was sold—for $6 million—to the MAC, with the money staying in Minnesota. The MAC would get the flyover zone it desired, plus space for a seven-acre parking lot for employees and equipment.

The problem with selling the land to the MAC, according to Bob Brown, chairman of the Mendota Mdewakanton Dakota Community, is that it then

Unktehi's spring feeds an icy urban pond that is only minutes away from the Mall of America.

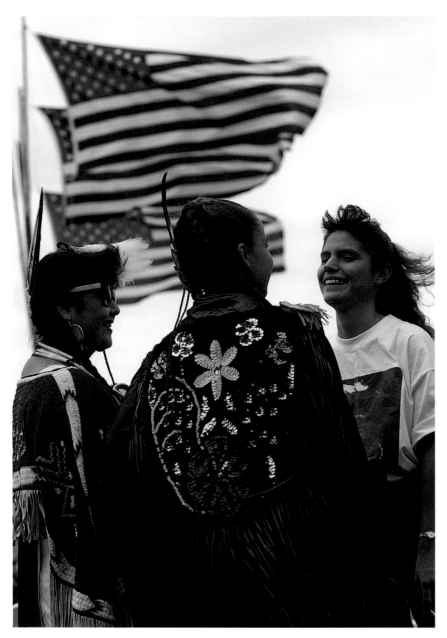

Indians from many tribes assemble at the annual Mankato powwow to honor warriors who fought and died for the tribes and for the United States in twentieth-century wars.

grass near the spring to pray. An interpretive sign near the spring calls it the birthplace of Minnesota. The sign does not mention the Dakota.

At the beginning of one Monday gathering not long ago, Jim Anderson, cultural chairman of the Mendota Mdewakanton Dakota Community, said, "Today we're here again, and it's one more day the spring is running." A blanket was placed on the ground and sage burned. Those gathered were smudged with sweet grass. Jim began his prayer. "Thanks to the Creator for the water and the day and you guys." He passed the pipe around. A uniformed security guard arrived before three and stood at the edge of the prayer circle (without joining in) to make sure the ceremony did not overstay its time.

During a February 1999 press conference held by Minnesota state representative Karen Clark, Gary Cavender said, "To block the sacred passage-way would be courting drought and things that have to do with water, because after all, this is the God of the Waters. When you hear a thunder-storm and it starts to rain, that is the underwater God having battle with the Sky God so that the rain may come down and replenish the earth, and the Sky God is throwing down thunderbolts to fertilize the land."

The Mendota, who are currently engaged in a struggle to win federal recognition, have had a hard time for a century and a half. In 1851 they and other Dakota tribes ceded twenty million acres to the federal government. Money and supplies promised in return never materialized. In 1862 a white trader whom they approached for food told a group of starving Dakota to eat grass. The next morning the trader was found with his throat cut, his mouth full of grass and his warehouses empty. The people who had killed the trader asked Little Crow, a great Dakota leader, to fight with them. Little Crow had visited Washington, D.C., and knew how the government worked. Further, he saw his role as that of peacemaker between Indians and whites. When he told the Indians he would fight with them but that they could not win, someone called him a coward. "I'm not a coward," Little Crow said. "I'll die with you, but we're going to lose everything we have here."

The ensuing conflict resulted in the deaths of

becomes subject to potential development. "It doesn't have to go to the MAC," he says. Under consideration is a fifty-year conservation easement on the land, administered by the National Park Service. While this would safeguard the spring for the time being, what happens at the end of fifty years?

A high, chain-link fence surrounds the abandoned Bureau of Mines buildings. Access to the site is granted only during weekday daylight hours from 7:00 A.M. to 3:00 P.M. In spite of the hardship this places on working people who wish to come to the spring, a gathering is held here every Monday. Parking a quarter mile away, people walk across land ripped apart by the road construction to reach green

about six hundred soldiers and settlers, precipitated the removal of those Dakota who did not flee to a concentration camp at Fort Snelling, and caused three hundred Indian men to be condemned to hang. President Lincoln stayed execution for most of them, but thirty-eight were hung at Mankato, the biggest mass execution in the history of the United States. Fort Snelling sat on a bluff above the confluence of the rivers. The camp was placed on the flats below, where many died of disease and starvation and the cold.

During the uprising, Mendota and other Dakota farmers who were friendly with white settlers saved more than three hundred women and children. In return, Henry Sibley, regional manager of the American Fur Company, wrote to the government on behalf of the Mendota, prompting the 1863 Congress to grant the people eighty acres and $50 apiece to start over. The money was not sent. Nor did the people get the land. Instead, they were told to go to the reservations.

Outraged, Sibley, a large landowner in the area, took the Mendota to a small lake in the region. Until his death in 1891, he continued trying to get for them the land and money appropriated by Congress. After his death, his family simply kicked them off the land.

Meanwhile, the Dakota who had either fled or been shipped out of the region began returning home. The government now appropriated land for them in Shakopee, Prairie Island, Granite Falls, and Morton, Minnesota. There were plans for land in Mendota, too, but because whites in the area did not want Indians that close to Minneapolis and St. Paul, no land was ever provided there. "They ended up more or less just assimilating us," Jim Anderson says.

In assimilation, the Mendota in essence lost everything. It was as Little Crow predicted. Landless, their fight for what is sacred is doubly hard. Lacking federal recognition as a tribe, they cannot fight for the trees or the spring on the basis of Indian religious rights but must instead base their case on violations of their civil rights, a less powerful vehicle. Without federal recognition, there is no chance the government will give the Mendota the federal land on which the old Bureau of Mines buildings sit. Jim Anderson hopes the area will be

made into a park that will allow the Mendota (and everyone else) access to the sacred spring. He would like to see at least one of the buildings turned over to the tribe to be used as a cultural center, a place where young people can learn their own history.

For the Mendota, the struggle to save the oak trees and the sacred spring is a struggle to exist as a people, to regain their history, their future.

About half a mile from the sacred spring, on the west side of Minnehaha Creek in high grass above Minnehaha Falls, there is a statue, a giant bronze mask held up on two poles. It is Little Crow. Through the open sockets of his eyes, you can see the sky. It is the mask of a man in great pain for his people, his world. There is no marker there to identify the mask. This work by an Indian artist was put there by Indian people, for Indian people, so they will remember. 🔥 RR

A bronze mask installed a half mile from the sacred spring is a sculpture of Little Crow, a leader who knew that his people, including the Mendota band, might lose everything. Their struggle continues.

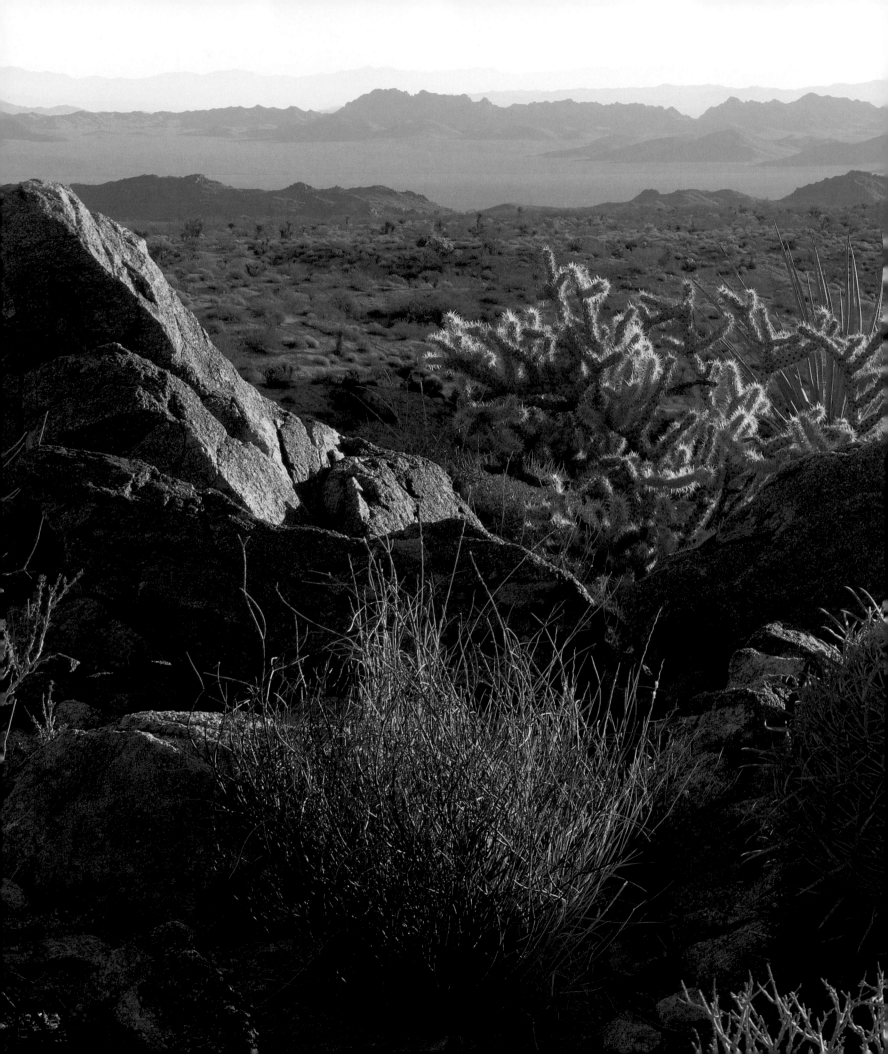

In the Old Woman Mountains of California's Mojave Desert, the ancestors of a Southern Paiute tribe gathered medicinal and food plants and slept under the stars. Today the tribe, called Chemehuevi, are finding their roots— and protecting them— in this ancient spot.

THE PRICE OF THE SACRED

Chemehuevi

Some fifty miles west of the Colorado River as the eagle flies and a similar distance east of the city of Twentynine Palms, California, a cave is hidden in a rounded outcrop at the base of the Old Woman Mountains. You reach the place only after a teeth-rattling thirty-five-mile trek along a rutted Jeep road with stretches of deep sand in a remote section of the Mojave Desert. Only a few know the way.

After a difficult scramble up and over granite boulders, the entrance to the cave appears, about the size of a cellar door. Inside, the cave is cramped, but through a triangular-shaped opening in the rock opposite the entrance, the great Mojave stretches out for miles, a vivid three-dimensional canvas of the homelands of the Chemehuevi Indians, one of the Southern Paiute tribes of the Mojave and adjacent desert lands of southern Nevada, southern California, and parts of Utah and Arizona.

This is a Chemehuevi shamans' cave, the floor worn smooth by generations of use. The walls are covered in red-ocher pictographs, representations of the visions received here by the medicine men, those lonely persons of power who were revered by the people, but also feared.

The rainfall here measures five inches a year or less—usually much less. And yet the desert seems like a garden: yucca, creosote bush, cholla cactus, burrobush, and sage spread across the desert floor, interspersed by native grasses, as if designed by a landscape architect. In the mountains and sandy flats live badgers, bighorn sheep, kit fox, mule deer, the poisonous Gila monster, the chuckwalla lizard, which swells up so that it cannot be dislodged from the crevice where it takes shelter, and notably the nearly extinct desert tortoise, unchanged for the last

sixty-five million years and considered a sacred teacher for the Chemehuevi people. Overhead, hawks, eagles, and falcons fly patrol by day and owls hunt by night. All this the shamans who occupied the cave saw and the people of a nearby village, (identified through archeological remnants) spoke about as they hunted and gathered plants for food and medicine and built fires and slept beneath the bright stars that cover the desert like a blanket.

The shamans' cave of Old Woman Mountains has been part of the Chemehuevi's oral history, but until recently its location was lost to the modern descendants, who no longer live in the desert but have been absorbed into the prosperous economies at its edges, mainly along the Colorado River and in various bands in the Coachella Valley, whose most famous city is Palm Springs. Then in 1997 a private landowner, Tom Askew, asked to meet with the Twentynine Palms Band of Mission Indians, one of the Coachella Valley Chemehuevi groups. His family's property consisted of some four sections of land (about 2,500 acres) on the eastern edge of the Old Woman range, and, he told the Indians, an ancient

cave was located there. It was, of course, the cave of legend, at the very epicenter of the Chemehuevi homeland.

As soon as the Twentynine Palms Indians and their neighbors, the Cabazon, Cahuilla, and other Chemehuevi bands, saw the shamans' cave with its visions of the surrounding landscape, they knew it must be treasured as the sacred place it was, a place for healing, for connecting with the spirit world, for recovering the cultural history of this desert tribe, and for preserving and teaching others about the natural history of a beautiful and unspoiled patch of Mojave Desert. Immediately the Chemehuevis had a vision of their own, a grand plan: the Old Woman Mountains property could become, once again, a *Suupaaru'wape*—a Gathering Place—for all the people. "A meeting place," Dean Mike, as headman of the Twentynine Palms Band describes it, "for Indians and non-Indians alike to establish a closer relationship with God's creation."

Under the leadership of Dean Mike and his wife, Theresa Mike, who spearheaded the project, plus Joseph Benitez of the Cabezon Band, Clifford Trafzer, a noted historian (of Wyandot heritage) at the University of California at Riverside, and a number of others, a nonprofit organization was quickly established—the Native American Land Conservancy (NALC)—to raise tax-free donations to acquire and manage the 2,500 acres in the public interest. As soon as the property was in hand, they would conduct environmental, biological, cultural, and historical surveys; build a visitor's center and associated facilities; and install utilities and water. It would become a "learning landscape" for all. Families, scout troops, school classes, religious groups—would learn of the desert, of the ancient ways, and of the Great Spirit who had made this place a cathedral.

But the grand plan stalled unexpectedly. The NALC had not reckoned that the very people they would soon turn to for help—a Presbyterian church—would have little interest in the preservation of this sacred site and would make it nearly impossible for the project to proceed.

The Old Woman Mountains property was jointly owned, with undivided interest in the land held by four entities. The original owner, the Foto family, to which Tom Askew belonged, held a 60 percent interest, with the remaining 40 percent donated for tax and estate-planning reasons to a hospital, the Boy Scouts and Girl Scouts, and a suburban Presbyterian church near Pomona, at the eastern edge of the Los Angeles metropolitan region. In early conversations with Tom Askew, the conservancy asked what a fair price might be. A price of $100 an acre would be fine, he thought, since the assessed value (usually half the market value) was $40 per acre. The conservancy then applied to a major foundation, which told the group that the foundation would probably be able to fund the purchase of the land if the $100-per-acre

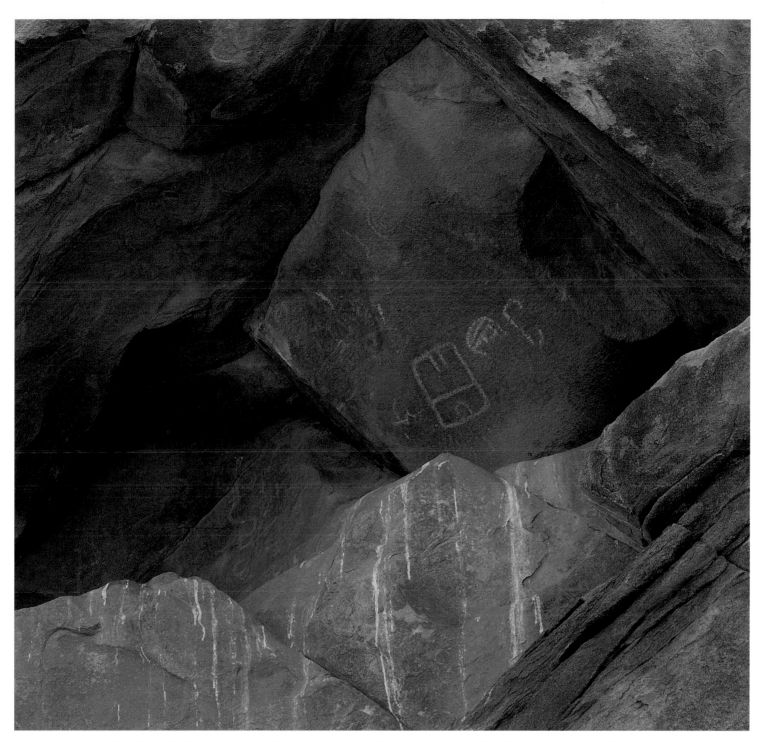

price were agreed to by all of the owners. Greatly heartened, the conservancy offered to pay this amount to the owners, and it was accepted by all of them save one—the suburban Presbyterian church that owned a thirty percent interest in the site, a recent gift of the Foto family.

Despite the family connections, at a meeting between church officials and the conservancy, the Presbyterians made it clear that they were not concerned with the spiritual and natural values of the land and that they wished only to maximize the income from the sale of the land that had been given to them. They said they wanted $200 per acre, a figure they derived from the price of land along Interstate 40, thirty miles and more than an hour's dirt-road drive to the north. This position, to which the church held firm, wasn't just a setback; it all but destroyed any prospect of acquiring the land since the foundation required agreement among the landowners at the $100, fair-market level.

Rock drawings mark a shamans' cave that was recently rediscovered with the help of a local rancher.

Theresa Mike leads a Chemehuevi project that raised money to buy the area and make it a "learning landscape."

"We could have no conversation with the church about the price since the representatives were interested only in money," wrote historian Trafzer bitterly in an unpublished account of the meeting. "The church had no interest in Indian people, the earth, animals, plants, and the sacred. All three representatives of the NALC are Christians, and we were appalled that we were treated like three primitives with pagan views of the earth and its meaning. To the church, the land was material, monetary, and nothing else. There was no room for discussion and compromise. We had our worldview and they had theirs. We could not meet in mind or spirit."

Trafzer is a highly regarded and widely published scholar and historian, and his account, forwarded on by Liveoak Editions, the creator of this book, was taken seriously by the national and regional officials of the Presbyterian Church. After a long and tense period of waiting, the church, under pressure from higher administrative levels, agreed to accept the $100 offer. In mid-November 2000, just hours before the beginning of a major conference on the preservation of sacred lands convened by the conservancy in Palm Springs, a letter announcing the decision arrived from the Presbyterian Synod of California and Hawaii, which held the land in trust for the local church. And while many faulted the Presbyterians for not publicly explaining their previous behavior and for the rather grudging spirit in which they made their "counteroffer," conservancy members nonetheless felt as if a healing rain had come to the desert at last.

Theresa Mike, the leader of the Old Woman Mountains project, believes that it was faith that made the project come together, even after most of her friends and colleagues had become tired of waiting, felt hopeless, and wanted to move on to other matters. For Mike, keeping the faith was especially important since the project will honor the Mikes' daughter, who died at age twenty-two in 1997, just as the project was beginning, and for whom a Salt Song was held.

The shamans' cave site lies along what is called the Salt Song Trail, a thousand-mile route created in the distant past by the Southern Paiutes. It starts at the lower Colorado River, moving up through Arizona and into Utah, and then loops back through the ranges of the Mojave, including the

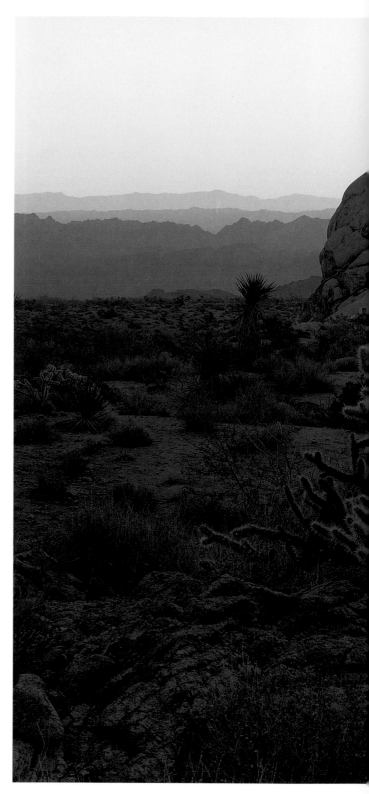

Old Woman Mountains, until the starting place along the river is reached again. Each of the Paiute tribes has its own songs, although many are lost or nearly so. It is a project of the NALC, working with others, to bring them back.

The songs, considered "salt" because of the tears of mourning, are normally sung when somebody

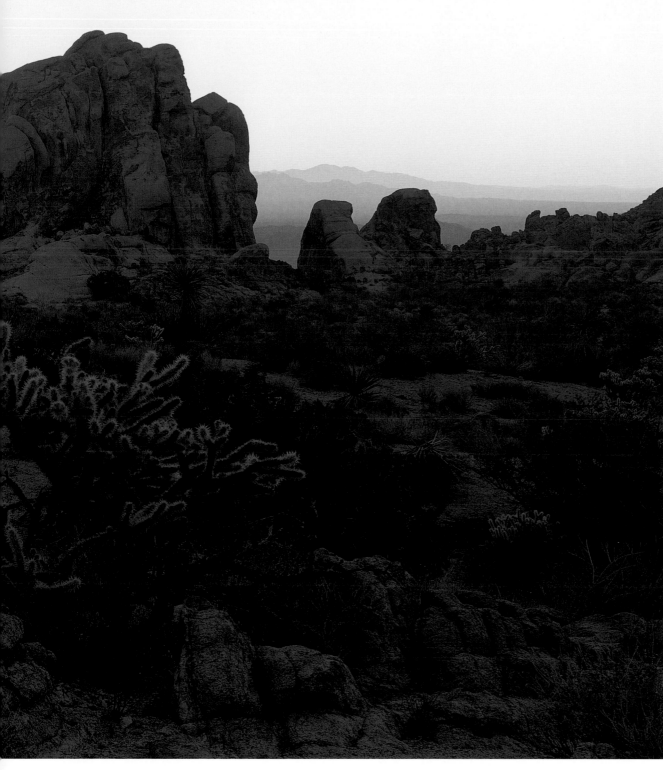

In the cave in this outcrop, shamans of old practiced at the epicenter of the Chemehuevi home-land. It will now be part of a new Gathering Place.

dies. "They are sung," Theresa Mike says, "from sunset to sunrise. When you are singing the song, the people are talking about the landscape. You are with the person's spirit when you are singing, and then just before sunrise, the story picks up speed. The spirit is getting ready to leave you. And at sunrise, you have to let the person go, to let her spirit go."

Out in the Mojave Desert, though the spirit of the beloved child has departed, her memorial will remain in the Old Woman Mountains as a place of teaching and of healing. At a timeless cathedral of stone, with its ancient shamans' cave, many will come to pray—and to learn, one hopes, that there is no price for the sacred. 🪶 CEL

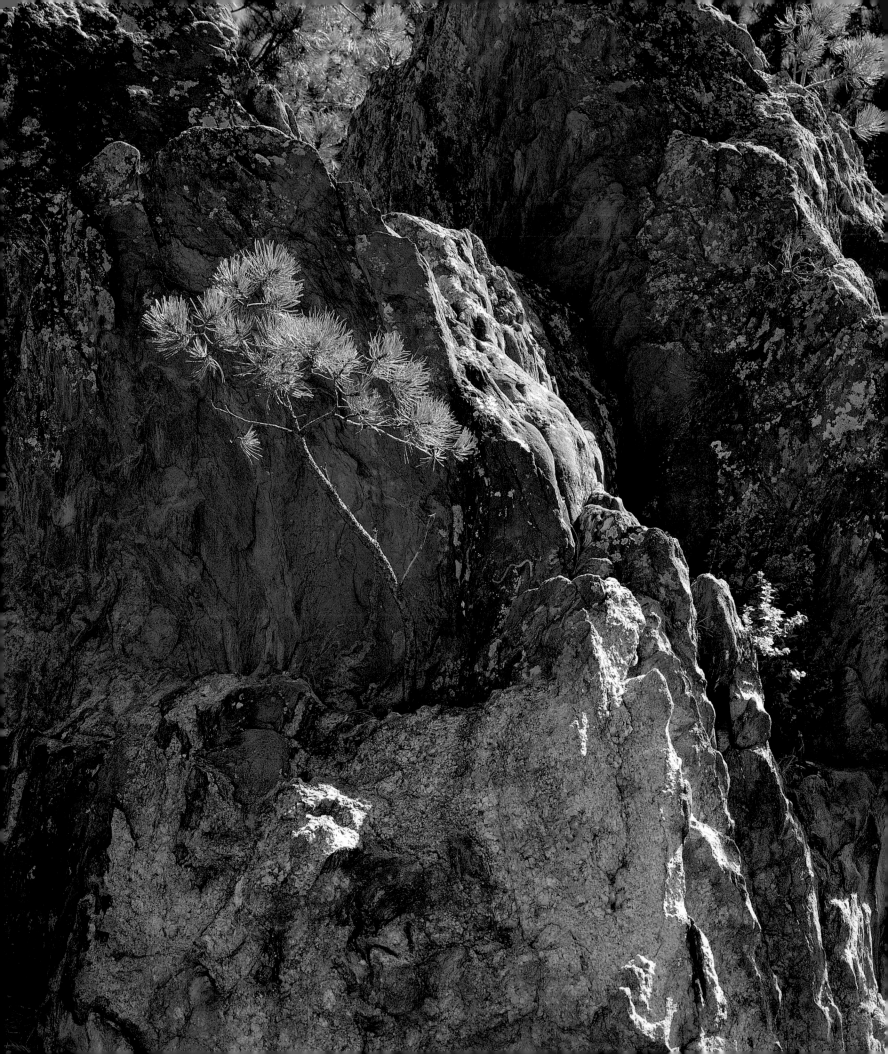

"From the beginning of creation,
We were placed here…we are
This holy land…."
from a Navajo prayer

"Where wast thou when I laid the foundations of the earth? . . .
Doth the hawk fly by thy wisdom, and stretch her wings toward the south?"
—Book of Job, 38:4; 39:26

Time Is Running Out. Many of creation's most extraordinary miracles and North America's primordial centers of worship are on the brink of destruction, forever.

We have but a moment to reverse our ignorance, arrogance, and greed—a moment to prevent spiritual obscenities equivalent to installing McDonald's at the Wailing Wall or a shopping mall in the open plaza of St. Peter's. But no, the desecration of indigenous sacred lands is worse, so much worse…. Human constructs, no matter how profoundly spiritual, can be reimagined, reraised. The sites sacred to the indigenous Americans are elements of the first dreaming, the cosmic stardust of all creation. Mankind is but a latecomer in this holy landscape where the great forces of the Creator can make a mountain.

How central this ancient recognition is to my own spiritual development as a man, as a priest, as a thinker and architect! And yet how unexpected, how new!

When I began my life's "professional" journey almost fifty years ago and chose a spiritual path, at the core of my vocation stood the example of the French worker priests, with their radical commitment to social justice. I sought to emulate their mission among the poor and disenfranchised, the victims of social, ethnic, and

The Very Reverend James Parks Morton is director of the Interfaith Council of Greater New York, an organization of volunteers committed to mobilizing the spiritual communities of New York in response to vital issues of the area and beyond. Before taking on this post, Reverend Morton was the dean of the Cathedral of St. John the Divine in New York City for twenty-three years, inaugurating there such innovations as the Earth Mass and a day for blessing the animals, which saw the likes of elephants promenading down the center aisle. He has also served as co-chair of the National Religious Partnership for the Environment.

racial discrimination. Thus, my life as an Episcopal priest began in the bowels of Jersey City, a place of desperate poverty, urban desolation, and racial despair. It continued in Chicago, as head of the Urban Training Center—a place for religious leaders of all stripes to experience firsthand the street life of the destitute and to develop skills to open up their own lives to the needs of all. When I was summoned in 1972 to be dean of the Cathedral of St. John the Divine in New York City, it was as an urban priest experienced in the specific problems of the inner city—and indeed in the twenty-five years of my service there, the cathedral became a great center of urban renewal and training, an innovator of programs that have served as models and pilot projects in many other troubled cities: housing for the poor, urban homesteading, sweat equity, creative apprenticeship, youth advocacy, and training for the homeless and disadvantaged.

But in terms of my own spiritual path, ironically, it was at St. John the Divine, in the heart of the world's most diverse metropolis and set on the heights that look down on Harlem, symbolic of the difficult road African Americans trod from slavery to freedom to entrenched poverty, that a new ecological understanding of the universe was awakened in me. Of course, it was the great medieval cathedrals, set at the crossroads of Europe's trade routes, that once were Europe's source of "good news." Inside the cathedral walls, built to mirror the laws of sacred geometry, arts and crafts were nurtured and the skills to produce them taught and practiced. The first universities grew beneath Gothic arches; stars and equations, the wisdom of Persia and Greece and Egypt and Arabia were joined with that of Rome. Theater unfolded its stories and teachings; architectural form and scientific discovery sprouted and flowered. It was in the cathedrals of Europe that West met East and South and North. There the first word of the great religions of the Orient reached the West, religions that looked to the balance of the universe—its physical laws and concrete manifestations—to find the meaning of life and the spirit.

So perhaps it is not surprising that soon after my arrival at St. John's, a series of master teachers appeared in the new university of my soul, remarkable scientists, artists, and philosophers: René Dubos, Thomas Berry, William Irwin Thompson, Mary Catherine Bateson, Paul Winter, John and Nancy Todd, Carl Sagan, Gregory Bateson, Lewis Thomas, James Lovelock, and Lynn Margulis. They came with the revelation that ecology is central not only to the health of the planet, but is at the heart of the theology of creation itself. The news sparked a veritable explosion at the heart of my faith—a man who had not even heard the word *ecology* before 1972, not as an undergraduate at Harvard College, nor as a graduate student at Cambridge University; not as a seminarian at the venerable General Theological Seminary in New York, and not afterward in my nineteen years as a priest in the inner city. I heard for the first time the news that if religion truly means *religare,* a binding together, an inclusion of everybody and everything, then religion must be an ancient synonym for ecology, the study of connections within all life systems,

and the acknowledgment that not one iota of creation can ever be left out. When every atom in the universe affects the whole configuration, then faith is meaningless without ecology at its foundation.

And yet on reflection I realized the message has always been there, in every religion, in the writings of some of the greatest minds and voices of theology, ethics, and poetry. In the Old Testament, when God spoke to Job from the whirlwind, it was not the accomplishments of man He extolled, but rather the universe, the stars, earth, and all the creatures therein with which He challenged his petitioner. Bernard of Clairvaux, twelfth-century Christian builder and visionary, found heaven "in the book of nature." Saints Francis of Assisi, Hildegard of Bingen, and Julian of Norwich found the most profound expressions of God in every living creature, in the grandeur of the lily and in the humble hazelnut. In Islam, Sufi master Rumi knew no separation of Allah from the star sapphire or the far constellations. And in the teachings of the Tao, of Confucius, Buddhism, and Shinto, the holiness of the natural forces of creation is central. Springs, storms, stones, trees, caves, and mountains are everywhere the expression of the convergent spirit of the holy.

And now we can no longer suppress our terrible failure: the environmental disasters of the post–industrial age, the vast deforestation of the globe, dead waterways, and ozone hole; the human degradation of holocaust, holy wars, and ethnic cleansing; and finally the potential, through weapons of mass destruction, of destroying the planet itself. We in the "developed" West have not only denied the sacred in all things animate and inanimate, we have been on a path to ravage the very basis of life. Earth cannot not long survive the onslaught of our waste and blind greed.

But in the last twenty-five years, bright hope has also dawned upon us—and maybe in the nick of time. From the ivory towers and measured laboratories of academe, most notably of science—physics, biology, and geology—came new evidence of the ancient interconnectedness of all life. James Lovelock and Lynn Margulis put forth the Gaia hypothesis that the earth is one living interrelated and interpenetrating reality. Theories of chaos and hyperspace revealed an intimacy binding the very movement of molecules across the continents, the biosphere, and outer space. Geneticists promised, and just in the year 2000 delivered, the mapping of the human genome—a prospect that through the unlocking of the secrets of DNA, humanity may be on the threshold of comprehending the structure of life itself.

And yet how like the *li* force of the Tao or the dharma of Buddhism these "discoveries" are! How reflective of the creation stories of indigenous peoples everywhere.

And so it should come as no surprise that many of our great thinkers have begun to look back to the wisdom of the first peoples, finding elements in their myths that mirror the discoveries only now being unpacked with the aid of modern computers.

James Parks Morton

Amazing! We have begun again to seek environmental, philosophic, and even scientific solutions from those who have lived successfully on this earth—those who have learned to dwell in a mutual harmony that nurtures and protects their surroundings. Finally we have awakened to the wisdom of our Native American brothers and sisters, to a respect for cultures we dare not call primitive as we assess how well and how long they have lived sustainably and honorably upon the earth. As dean of the cathedral I began to weave native voices, art, drums, and dance into the fabric of our worship, and ten years ago we began our annual service of giving thanks to the First Peoples just prior to our national holiday of Thanksgiving. Each year we push back the chairs and the cathedral becomes a vast longhouse in which we all encircle the four drummers in a dance of solidarity with all of creation, led by our native elders.

To say this was a turning point in my vocation is no exaggeration. My understanding of the universe and of my religion were turned upside down forever. The view of *Homo sapiens* as the apex of the pyramid of creation was replaced by a new vision of the human as one interdependent (though dangerously powerful) presence among the many presences in creation.

I began to examine, too, where we went so terribly wrong. Where in the past two millennia did humankind—earth's "thinking" species—not only lose its veneration of nature, but actively, if unknowingly, move to destroy it? What became of humanity's primordial spiritual practices that held all being as sacred? Why have religions north, south, east, and west so often become the silent partners of mass destruction for profit?

In this country, we can identify a basic component of this desecration: "Manifest Destiny," the virtual mandate for the young United States to expand and tame the continent. This conviction was based on a flawed reading of Judeo-Christian tradition, whose manifold texts about the "glory of creation" suddenly took second place to a catastrophic misunderstanding of the divine command about "dominion"—which means "stewardship," not "control" or "subjection" or "conquest." So our Western European pioneers marched across our vast open spaces, pushing both inhabitants and forests out of their way.

Also inherent was a profound North American racism: our forefathers regarded the native peoples and those transported from Africa either as fodder for religious conversion or subhuman obstacles to progress. The result has not only been the seizure of their land and near extermination of whole peoples, but also the dehumanizing treatment of those who survived, with a conscious attempt to eradicate their cultures. We have forced Native Americans to live in isolated reservations and have sent their children away to "Indian schools" where their clothes are confiscated, hair cut, language forbidden, and culture ridiculed. Only recently has the rampant physical and often sexual abuse of Indian children in these largely religious schools—

most often Roman Catholic, Anglican, and Lutheran—come to public awareness in both Canada and the United States.

We have also victimized our native and minority communities by shunting them into our least-desirable urban areas, denying them access to basic social services, and often using their neighborhoods as dumping grounds for hazardous and toxic materials. And yet our native brothers have maintained their reverence for nature's gifts, even those the majority would view as useless.

The American public has been slow to recognize the ecological devastation resulting from this disrespect of the land and blind to the concomitant exploitation of irreplaceable natural resources and venerated natural monuments for economic gain. Only in the past three decades have we begun to awaken to the environmental crisis. But as Americans, we have tended to look upon environmentalism as elitist, unlike parts of Europe such as Scandinavia and Germany, with their vigorous Green parties. It has been a consistently tough political stance for the environment's champions.

Further, unbelievably, organized religion has been among the last elements of our society to recognize the impending ecological crisis as disaster to God's sacred natural creation. How different from the civil rights movement, when the religious world early on committed moral voice and large human and economic resources to achieving justice for an overlooked part of God's sacred human creation.

In stark contrast to indigenous and Asian religions—Shinto and Taoism and, to a lesser extent, Buddhism—Judeo-Christian theology has tended to be anthropocentric, with the environment largely seen as a stage for humans. In Native American spirituality there is no such hard separation between Creator and creation, but rather a deep interpenetration of heaven and earth. "We were placed here.... We are this holy land."

Only too recently have we come to the obvious, if self-serving, realization that a robust environment is essential to human health, and with this long overdue recognition has also dawned a long overdue respect for indigenous peoples everywhere. For the first time we have begun to look to the so-called primitive cultures as sources of deep wisdom for everyone's survival. Our environmental blindness begins to be noted and the light of change dimly perceived.

But there is also the real danger that our awakening is too late. So many of our natural resources and monuments of sacred beauty have already been defaced or destroyed. And so many stand in imminent danger. We are therefore at a crucial moment as a species where the failure to act will be catastrophic:

The ice is melting in the north.

Indigenous nations and peoples believe in the spiritual powers of the universe.... We believe in the laws of creation and that all lives are bound by

these same natural laws. We call this essence the spirit of life....

As we speak, the ice is melting in the north....

The human species has become the most voracious and abusive consumer of earth's resources. We have tipped the balance of life against our children, and we imperil our future as a species....

There must be a reconciliation between peoples and the natural world; between nation states and the forests that sustain us; between corporations and the resources that they mine; the fish that they catch and the water that they use....

Leaders of the World:

There can be no peace as long as we wage war upon our mother, the earth. Responsible and courageous actions must be taken to realign ourselves with the great laws of nature. We must meet this crisis now, while we still have time. We offer these words as common peoples in support of peace, equity, justice, and reconciliation:

As we speak, the ice continues to melt in the north.

These are words of the great Faithkeeper of the Turtle Clan of the Onondaga Nation, Oren Lyons. They still ring in my ears as I write—they were spoken before the Traditional Circle of Indian Elders and Youth in Michigan, August 9 through 12, 2000, and again before the gathering in New York at the Millennium World Peace Summit of Spiritual and Religious Leaders, August 28 through 31, 2000, at the United Nations.

Indelible, urgent, necessary. Chief Lyons sounds the tocsin, the summons to immediate action. He has called upon us not only to respect the faith of the oldest inhabitants of this continent, their rituals and their divine spaces, but also to recognize the holiness in every aspect of our diverse and deeply interdependent world. We must relearn that mutual respect, appreciation, and support of all of creation is the heart of religion, the sacred core at the center of humanity's search for meaning.

As a man of faith, I believe that we must heed Chief Lyons's words to preserve all that is threatened. We must act to keep the wilderness wild, to preserve the plains and marshlands, the sacred mountains and trees. We must act to treat the waters on and within the earth, and the air above, as sacraments of life and creation. With the indigenous peoples of the earth everywhere, with the scientists and thinkers who would preserve life, and with the poet William Stafford,

I believe that we must hold sacred even the smallest vista of creation

 "…in case God comes back

 to see what we did with it."

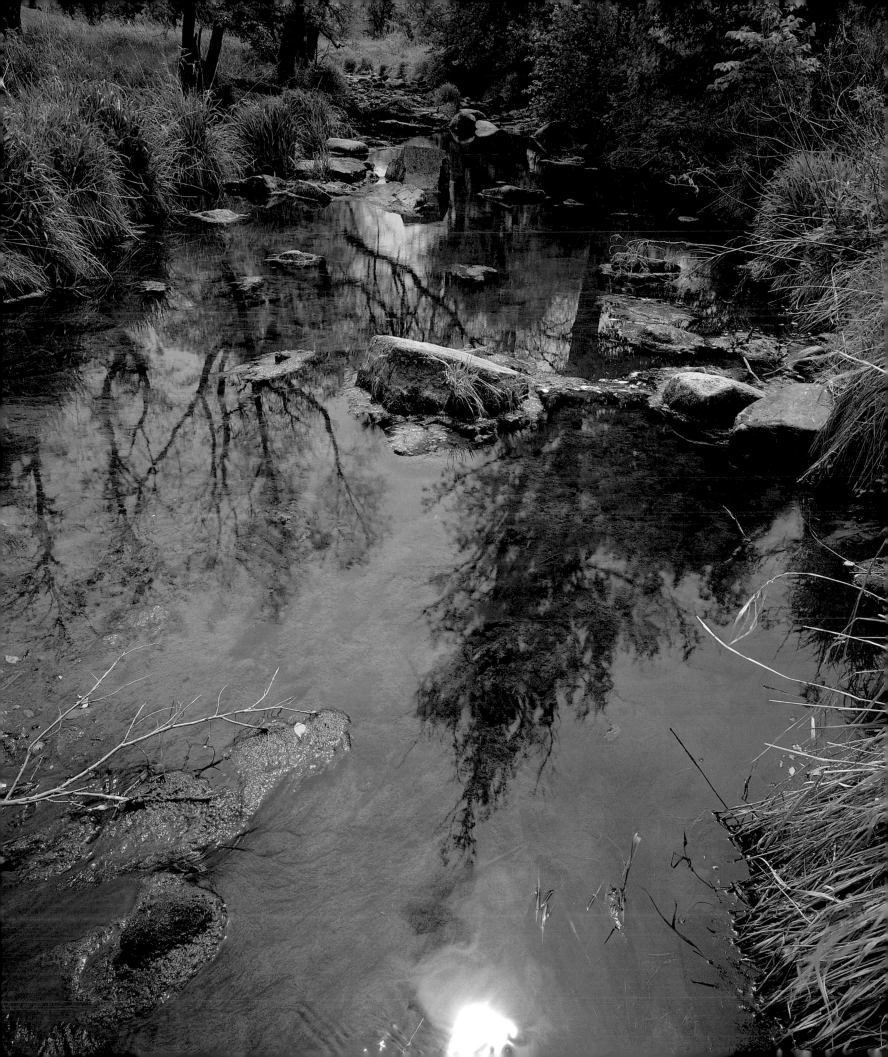

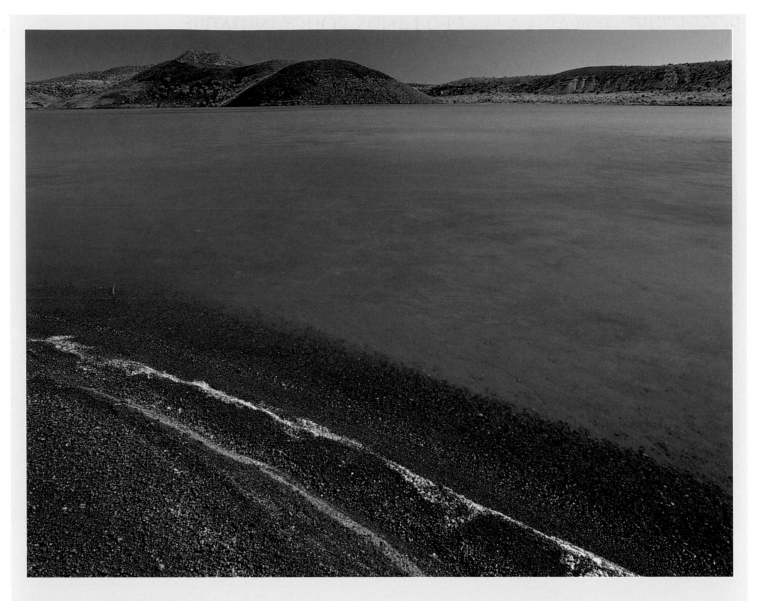

Home for Salt Woman

She resides here now, this greatly beloved deity of the Zuni Indians in western New Mexico who is admired as well by the neighboring tribes. Here Zuni boys are solemnly initiated into manhood. Here the salt is so pure all the nearby tribes know it is sacred, and all their paths to the lake are spoken of as umbilical cords. Whoever was on a path leading to the lake was in a state of asylum, of freedom from any form of interference from others no matter how hostile.

Salt Lake, once snatched from the Zuni by the federal government and eyed for commercial development, came back into their hands in 1978 after a protracted struggle. Salt Woman's home was finally safe.

Not quite, it turns out. Surrounding is state land and New Mexico issued a permit to the Salt River Project, an Arizona utility, to mine coal some twelve miles from the lake. This Fence Lake Coal Mine would obliterate parts of the ancient salt trails and intrude into the sanctuary of the lake's desert valley. The mega-utility has laid claim to more than twenty billion gallons of water underlying the area and one hydrological report suggests that the sacred home of Salt Woman could well be drained dry. And then where would Salt Woman go?

The Zuni governor, Malcolm Bowekaty, and the six-member tribal council have joined with tribal religious leaders and are summoning forth every legal means available to keep her where she belongs. And so for the Zunis, as for so many other native tribes of America, the price of preserving one's sacred places, one's own culture, one's world-view, one's identity is constant vigilance, an eternal-seeming struggle. Somehow, that seems inappropriate.

POSTSCRIPT: TOWARD A SACRED LANDS POLICY INITIATIVE

In the native belief system sacred places are not sacred because native people believe they are sacred. They have sacredness in and of themselves. Even if we all die off, they will continue to be sacred.

Christopher H. Peters
Seventh Generation Fund

Even the most casual reading of the stories in this book clearly reveals that the policy deck is stacked against the preservation of sacred land in the United States. In some cases the federal land-managing agencies—the Forest Service, National Park Service, and others—are sensitive to the cultural importance of sacred lands, and of the right of American Indians freely to conduct their religious observances. But more often they ignore the sacredness of traditional places of worship and ceremony, for the U.S. government has no clear policy requiring these agencies to be concerned with the use and disposition of sacred lands. As for private lands, while the Congress authorizes nearly a billion dollars a year to state and federal agencies for the purchase and development of recreational areas, virtually nothing is allocated to help Indian tribes and organizations protect sacred lands that are in private ownership.

We—the authors of this book—believe we have presented compelling evidence within these covers that the policy failure at the federal level (as well for states, tribal governments, and landowning corporations and institutions), must be addressed forthrightly, and soon. Accordingly, on January 26, 2001, Liveoak Editions convened a "policy workshop" in Albuquerque, New Mexico, to determine what might be done. Attending were representatives of the Native American organizations that have co-sponsored this book along with other experts.

The participants were Bineshi Albert, Alicia Maldonado, Sonny Weahkee, and Laurie Weahkee of the SAGE Council, host for the meeting; Christopher H. Peters of the Seventh Generation Fund; Tom Goldtooth of the Indigenous Environmental Network; Shelley Means of the Washington Association of Churches; Dean B. Suagee of the First Nations Environmental Law Program, Vermont Law School; Kurt Russo of the Native American Land Conservancy and consultant to the Lummi Nation; Jack Trope of Save the Children; Christopher (Toby) McLeod of the Sacred Land Film Project, Earth Island Institute; M. Lynne Corn of the Congressional Research Service, Library of Congress (speaking for herself, not CRS); and Charles E. Little of Liveoak Editions.

The following analysis draws on the comments of these participants as expressed in the meeting and in subsequent discussions as well as in published articles and papers supplied by them. Of necessity, our analysis tends to simplify what are quite complex legal matters and to leave out many collateral issues pertaining to religious rights, trust-land doctrine, and laws governing public land use and management. One participant suggested, in fact, that only a CD-ROM would be big enough to contain all the statutory, legal, and historical material pertaining to sacred lands preservation.

The Legal Setting

Certainly, it is not as though the destruction of sacred sites is a big surprise to members of Congress. In the early 1990s, a number of field hearings were held on a bill, introduced by Senator Inouye, the primary provision of which was to protect sacred sites. (Other provisions had to do with the religious use of peyote, eagle feathers, and similar matters.) The testimony was passionate and persuasive, and yet, while the secondary parts of the bill were enacted, sacred land was left in the dust, as it were, in substantial part the result of the 1994 change of leadership in the House of Representatives suddenly making the Congress a resolutely conservative body with an agenda that had little room for legislation that might interfere with the economic development of natural resources.

This was a pity, for the sacred sites provision of the Inouye bill was meant to correct an egregious 1988 Supreme Court decision that tended to vitiate the American Indian Freedom of Religion Act of 1978, a foundational piece of legislation, albeit not clearly enforceable, that establishes the importance of sacred sites as a Constitutional matter. The 1978 act reads, in part: "…henceforth it shall be the policy of the United States to protect and preserve for American Indians their inherent right of freedom to believe, express, and exercise the traditional religions…including but not limited to access to sites…."

In 1988, however, when Indian tribes sued the U.S. Forest Service to stop building a road (the so-called G-O road, connecting the towns of Gasquet and Orleans in northern California) that would obliterate traditional sacred sites, they found, once again, that the U.S. government didn't really mean what it said. While the Indians' suit was upheld in the federal district court and on appeal by the circuit court, the conservative majority of the Supreme Court, in a fit of judicial activism (by a court majority that claims an opposite inclination) rejected the lower courts' decision (*Lyng* v.

As Chris Peters of the Seventh Generation Fund describes the situation, "The Supreme Court contended that an infringement on native religion could only be invoked if natives were coerced to change their religious belief system in some manner. So if the Forest Service wants to let a contract to bulldoze a sacred area and totally destroy the religious significance of the area, it was not 'a violation of our belief system' because we were not coerced to act against our belief system. That type of logic is totally beyond me."

In the *Lyng* decision the Supreme Court obviated a generally accepted three-part test to determine whether a government action infringes on the free exercise of religion clause of the First Amendment. The test is, as Indian law expert Dean Suagee explains it: "If a government action imposes a burden on religion (1), then the action must be justified by a compelling governmental interest (2) that cannot be met through less restrictive means (3)." The court's majority opinion, says Suagee, found that the government had not placed a burden on religion in the strange, absolutist sense that they defined a burden—that it did not coerce the Indians to act against their belief system. Justice Brennan, in his dissent, called such reasoning "cruelly surreal."

Given this situation, which effectively stripped away constraints on federal agencies to protect sacred sites, the Inouye bill (Native American Free Exercise of Religion Act of 1993), explicitly referred to the *Lyng* decision as a matter to be corrected. Later, a Religious Freedom Restoration Act was introduced to affirm the primacy of the "three-part test," among other matters. And in 1994 Congressman Bill Richardson introduced amendments to the American Indian Religious Freedom Act that would also restore the three-part test as a cause of action (i.e., a lawsuit could be brought based on a violation). But none of these bills passed, with the result that sacred lands still have no direct statutory protection—in fact they have even less protection than they had before the Rehnquist Court reversed the circuit court decision on *Lyng*. At length, President William J. Clinton tried to make up for this failure by issuing an executive order in 1996 (No. 13,007) requiring federal agencies to take great care in managing sacred lands. But the order was hedged about with so many loopholes that it had little effect and in any case could not in itself provide a cause of action since lawsuits based on the order were expressly prohibited.

Existing Authorities and Programs

Unfortunately, there's not much to work with in terms of federal laws and programs to preserve sacred lands that are not already within Indian reservations (and even those are not immune to destruction). The most effective program thus far has been the National Historic Preservation Act (NHPA), signed into law in

1966. According to Dean Suagee, who has worked with the NHPA and written many articles about it, the act creates a decision-review requirement similar to that of the National Environmental Policy Act. As Suagee puts it, "When a federal agency takes an action that may have an effect on a property that is eligible for or listed on the National Register of Historic Places, Section 106 of the NHPA says that the agency must give the Advisory Council on Historic Preservation an opportunity to comment." In a key 1980 amendment, the Congress finally wrote Indian tribes into the NHPA in a minimal way by providing for the preservation of "cultural heritage."

Unlike Clinton's sacred sites executive order and the largely precatory American Indian Freedom of Religion Act, NHPA does provide a cause of action and was, in fact, part of the basis for the *Lyng* case (along with the American Indian Religious Freedom Act) since the entire area in question had been declared eligible as a historic site. In recent years, according to Suagee, Indian people have become increasingly involved in historic preservation and have helped a new preservation category emerge, which the National Park Service (administrators of the NHPA) calls *traditional cultural places*. "In the Park Service's view," Suagee explains, "this eligibility, being cultural, does not run afoul of the 'establishment of religion' clause of the First Amendment since it does not mean that you are supporting one religion over another."

Another means to protect sacred lands is for Indian tribes to have sacred lands in public ownership transferred to "trust status" as, in effect, a part of an Indian reservation. "If you really want to control the way land is used," says Suagee, "getting it into trust status is the preferable outcome." The process would be complicated since the agencies (such as the Park Service) transferring the land would want guarantees that the sites would be protected and not developed. And this, in turn, would tend to vitiate tribal sovereignty over their own land.

As for privately owned sacred land, acquisition is not just underfunded by the federal government, it is *un*funded. There is a major source of money for preserving recreational land, the Land and Water Conservation Fund. The fund has two "sides," one providing the wherewithal for acquiring, developing, and managing land by federal agencies, such as the National Park Service; the other providing grants to the states to implement comprehensive outdoor recreation plans. The LWCF derives its income from offshore oil lease revenues, which in recent years has brought fund authorizations to about $1 billion annually. There is no direct provision for grants to Indian tribes preserving sacred lands, although as natural resources policy analyst Lynne Corn points out, "There's nothing in the statute that would prohibit federal agencies or the states from acquiring sacred land." But it rarely happens.

A Policy Agenda for Sacred Lands

Given the inadequacy of federal authorities and programs, many policy experts favor the development of a big, comprehensive bill that would not only improve what programs there are but also create quite major new ones, and in the process help elevate the sacred lands issue in the Congress and among the general public. Others (especially those burned by the misbegotten *Lyng* decision and the failed Inouye bill, and bills that followed) believe that a more targeted approach to policy reform would be preferable. Jack Trope, a lawyer who worked on the Inouye bill and the subsequent Religious Freedom Restoration Act, points out that a comprehensive bill would require perhaps a five-year effort, but that "in the meantime there are specific things to be done."

Among the things to be done on an immediate basis would be to introduce the notion of American Indian sacred sites into pending legislation known as "CARA," the Conservation and Reinvestment Act, which would provide increased funding—an authorization of up to $3 billion annually— for a variety of resource protection programs. One possibility for a new CARA program could be to establish an "American Indian Sacred Lands Foundation" by congressional charter that could provide funding for the purchase of private lands by Indian organizations. In the view of Lynne Corn, such a foundation could be modeled after the National Fish and Wildlife Foundation, established by Congress in 1984, which now awards federal and private funds as challenge grants to "on-the-ground conservation projects." In 1999 the foundation supported 598 projects, committing $17 million in federal funds, matched with $50 million in nonfederal funds, for a total of $67 million.

Another prospect for immediate legislative action would be to shore up the "106 process" of the National Historic Preservation Act. According to Dean Suagee, 1992 amendments to the act provided that if a federal action affects a historic property to which an Indian tribe attaches religious and cultural significance, then the tribe has the right to be consulted, no matter where the property is. "This is a procedural right," says Suagee, "but it is a significant procedural right which gives federal agencies the discretional authority to deny permits, such as for mining, based on the 106 process." To improve the 106 process, Suagee believes a further amendment to the NHPA could be offered that would restore the "three-part test," famously obviated by the Rehnquist Court, and at the same time provide administrative mechanisms to create a structured dispute resolution process. One of the potential outcomes of a 106 consultation might well be, as Suagee puts it, "some kind of land transaction—to buy land or get conservation easements to protect the sanctity of the place."

In addition to improving NHPA, amendments to laws governing trust lands should be created to facilitate the transfer of sacred sites outside reservation boundaries to trust status, plus necessary policy changes to provide for "government-to-government" cooperative agreements for the management of sacred lands that are also places of rich biological diversity of interest to federal land management agencies.

Such remedies as these, significant as they are, still do not address the need for explicit legislation directing all agencies of the federal government to preserve sacred lands in the public-land holdings under their management, nor the need for a fairness in doling out federal grants for the purchase and management of privately owned sacred sites.

With regard to public land policies, one of the thorniest issues is determining where religious sites are located and why particular areas are especially important. As Jack Trope explains, "Here in the Southwest, I've heard stories about pueblo people being kicked out of religious activities just for revealing *any* information about sacred areas." At the same time, when the choice is between secrecy and the destruction of sacred areas, an accommodation can often be worked out. In fact, as Kurt Russo, consultant to the Lummi Nation of northwestern Washington, points out, some 14 tribes in Washington, realizing that their sacred sites were at risk, undertook a survey of the Mt. Baker-Snoqualmie National Forest, specifically identifying some 450,000 acres as sacred. One of the report volumes, says Russo, contains maps with very detailed information on "exactly where people go for spirit questing, for spiritual bathing, for gathering traditional materials, for depositing regalia, and for collecting traditional medicines. But the information is strictly confidential and cannot be accessed without permission of the tribes. Even so, there are people on the reservations in the Northwest that don't think these sacred places should have been talked about, especially with the U.S. Forest Service. But when they were given information to make informed decisions—that they needed to reveal the location of sacred sites so that they would not be clearcut—then consensus could form."

In view of such issues, a legislative proposal governing the procedures of federal land-managing agencies should specifically address the conduct (and funding) of surveys and pertinent issues of secrecy. Such provisions, if added for example to the earlier Richardson bill (The American Indian Religious Freedom Act Amendments of 1994, H.R. 4155), might, along with the sacred-sites title in the Inouye bill and its successors, provide a starting point for drafting a new legislative initiative. Significantly, all these earlier bills explicitly provide a "cause of action" if federal lands are managed in such a manner that undermines and frustrates a traditional Native American religion or religious practice.

For the other major policy failure, the lack of a fair share of federal grants for land acquisition, the most direct approach would be through an amendment to the Land and Water Conservation Fund Act (LWCF) to provide grants to tribes as well as states and federal agencies. Even a small percentage of the $1 billion authorized for the fund would fulfill the obligation of the U.S. government to assist tribal governments in protecting traditional sacred sites. The LWCF is traditionally seen as the source of grants for acquiring recreational land, but it would do no damage to this policy principle to include *re*-creational land in the formulation. Indeed, the fund is not just for heavily used parks, but also for the preservation of valued natural areas, which describes nearly all American Indian sacred sites.

Finally, as Dean Suagee proposes, any legislative package should include model statutes for states and tribal governments to support and perhaps expand on federal initiatives in sacred lands preservation.

The Legislative Elements

In summary, then, whether contained in a single comprehensive bill or introduced piece by piece, some of the salient opportunities are these:

■ A bill to create a congressionally chartered and federally funded "American Indian Sacred Lands Foundation," structured along the lines of the Fish and Wildlife Foundation, to make matching grants to non-profit organizations for preserving sites and to seek the donation of private land and money for this purpose. The foundation idea could be introduced as a title in the Conservation and Reinvestment Fund Act or as a freestanding bill.

■ An amendment to the National Historic Preservation Act to strengthen Section 106 by providing for the explicit application of the "three-part test" regarding management decisions on public lands, namely: "If a government action imposes a burden on religion, then the action must be justified by a compelling governmental interest that cannot be met through less restrictive means."

■ An amendment to the trust statutes administered by the Bureau of Indian Affairs allowing for the purchase and transfer of sacred lands outside reservation boundaries to trust land status with appropriate safeguards to insure their protection as places for religious observances.

■ An amendment to the American Indian Freedom of Religion Act for the management of federal lands so as not to undermine Native American religious practices. The amendment would specifically provide for the funding of sacred land surveys by tribes or Indian organizations, methods of embargoing (or not requiring)

confidential religious-practice information, the explicit establishment of the "three-part test" (as stated above), requirements for the co-management of designated sacred lands, and a specific cause-of-action provision for enforcement.

■ An amendment to the Land and Water Conservation Fund Act to provide for direct grants to Indian tribes for survey research and the purchase (in fee or less-than-fee title) of sacred sites on private lands, and their development and maintenance.

■ Model legislation for states and tribes supporting the foregoing, among other provisions.

Obviously, these are not the only initiatives that could be contemplated by tribal leaders and others concerned with sacred lands, and they might not be set forth in the manner that some might prefer (including some of those at the policy workshop). However, the six ideas listed can, we hope, provide something of a starting point for discussion.

Strategic Considerations

Whatever form a sacred lands legislative initiative may take, there are certain strategic "givens" that should be considered.

To begin with, while the earlier effort to enact sacred lands legislation failed, there is much to build on. Field hearings were held that filled some seven hefty Senate Committee Print volumes, a record that should be analyzed and the participants and their organizations identified. Certainly a powerful coalition is necessary and perhaps quite possible to develop for a sacred lands initiative, as Shelley Means of the Washington Association of Churches points out. The association has had good success over the past decade in creating coalitions of Indian, church, and environmental organizations.

The earlier bills, some of which contained provisions for the use of peyote, gathering eagle feathers, and the right of Indian prisoners to wear their hair in accordance with religious custom, attracted non-Indian organizations, especially churches, to support the legislation despite the diversity of concerns addressed. This time out, with a single, and quite universal, matter at issue—the preservation of sacred lands—it may be possible to expand the reach of a support coalition. Certainly, if churches and major environmental groups back an effort by Indian organizations in support of sacred land legislation, a powerful voice has been created representing a substantial fraction of the U.S. population.

The beginning point for coalition building, in the view of Tom Goldtooth, head of the Indigenous Environmental Network, must, however, be tribal leadership. "Tribal leaders must buy in to the concept first," says Goldtooth. "In this campaign, Indians must

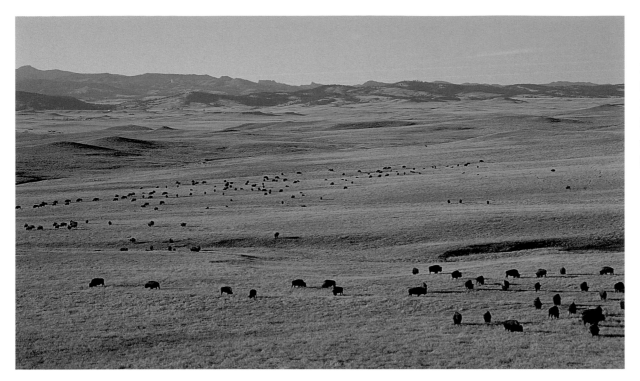

Bison ply the plains in sight of South Dakota's Black Hills, holy place for the many "fires" of the Sioux.

speak for Indians." As Laurie Weahkee of the SAGE Council puts it, "We're getting very cynical about alliances. We need people who know the subtleties of sacred site battles."

Another strategic element concerns the effective use of informational and educational materials. Chief among these at present is the film *In the Light of Reverence*, produced by Christopher McLeod, described elsewhere in the appendix, and this book, *Sacred Lands of Indian America*. The film, says McLeod, has several goals, among them "to win legislation that guarantees religious freedom and the protection of sacred sites on public land, and to facilitate access to and protection of sites on private land." Both McLeod and Liveoak Editions (the creators of this book) agree that book and film should be used together aggressively to influence decision makers and enlist local, grassroots organizations in sacred land preservation efforts.

Lastly, what is required is a "secretariat"—an administrative team—to coordinate efforts on behalf of a coalition in support of a legislative initiative. This was a purpose of the "Sacred Earth Conference" organized by the Seventh Generation Fund and held in Seattle in the spring of 2001. To be effective, the secretariat will need to represent Indian tribes and organizations as well as work with churches and environmental groups. And it will have to work effectively both at the local level and in Washington, D.C. An early item on the agenda for the coalition secretariat might well be to encourage the relevant committees of Congress to hold field hearings on sacred lands, preliminary to the introduction of specific legislation. This would not only provide a means for Indian leadership to make a direct contribu-

tion in shaping a legislative initiative, but also build interest nationally in sacred lands preservation.

A Final Word: What to Do

Usually, books that seek to raise public consciousness about a serious national problem prompt the reader to ask, "Yes, that's important, but what can I do?" Actually, there's quite a lot individuals can do about preserving sacred land. To begin with, they can ask their elected representatives to pay attention to sacred land issues in their district or state, and to address the issues on a national basis as well. This book, *Sacred Lands of Indian America,* is meant to be distributed to key members of Congress, so legislators should not be able to claim ignorance as an excuse.

In addition, individuals can send money, volunteer time, write letters on behalf of sacred-land battles, or take on a leadership role themselves by organizing study-and-action groups to discuss sacred land preservation, using the film and this book for background and perhaps inspiration. For information on this kind of activity, readers are encouraged to contact the Seventh Generation Fund or other organizations listed elsewhere in this appendix, or to visit the Liveoak Editions website, www.liveoak.org.

Clearly, the desecration of sacred sites is intolerable not just for Native Americans, but for non-natives too, for these places, as Chris Peters points out, have sacredness in and of themselves. "In talking about this land," adds Tom Goldtooth, "we are talking about sacredness for all of us. So let us cast our prayers widely to save the land, as a fisherman casts his nets. May the Creator continue to bless this work." CEL

ORGANIZATIONS CONCERNED WITH SACRED LANDS

The following list provides a starting point for those interested in becoming involved in sacred lands protection. The entries are divided into two parts: first, the five American Indian organizations that have worked with Liveoak Editions to bring this book into being and, second, other important national and regional organizations concerned with sacred land that were suggested by our cosponsors. Not included are the many local project groups such as those mentioned in the text of this book. Readers can learn about local efforts—and they number in the hundreds—by calling the organizations listed here or logging on to their websites.

Project Cosponsors

Indigenous Environmental Network

The Indigenous Environmental Network is a nonprofit national Native environmental organization working with some 200 local, national, and regional groups. IEN activities include youth programs, training, organizing, and advocacy on environmental justice, natural resource management and conservation, protection of sacred sites, biodiversity, treaty rights, and building sustainable communities.
Contact: Tom Goldtooth
P.O. Box 485
Bemidji, MN 56619
phone: (218) 751-4967
fax: (218) 751-0561
e-mail: ien@igc.org
website: www.ienearth.org

Indigenous Women's Network

The IWN was created in 1985 to support the self-determination of indigenous women, families, communities, and nations in the Americas and the Pacific Basin. The network supports public education and advocacy for the revitalization of our languages and culture, elimination of all forms of oppression, the attainment of self-sufficiency, the protection of ancestral lands, and the right to control the biological diversity of our Native territories.
Contact: Pamela Kingfisher
13621 FM 2769
Austin, TX 78726
phone: (512) 258-3880
fax: (512) 258-1858
website: www.almademujer.com

Native American Land Conservancy

The Native American Land Conservancy is a 501 (c)(3) grass-roots intertribal organization with central offices in Coachella, California. The NALC was established by tribal governments and communities to promote the preservation of sites of historic, biological, and cultural importance to tribes in the greater Mojave Basin. In addition to acquiring and preserving these landscapes, it also encourages both the preservation of traditional Native American culture and cross-cultural understanding through programs of environmental education and public conferences. Tax-deductible donations to the NALC can be directed to either land purchases or its educational programs.
Contact: Theresa Mike
46-200 Harrison Place
Coachella, CA 92236
phone: (760) 775-6866

SAGE Council

The SAGE Council is a community organization building self-determination and relationships through organizing, education, and leadership development. The council is committed to influencing the social, economic, and political decisions affecting indigenous peoples to prepare for the future generations. The SAGE Council promotes the spiritual and political values that respect Mother Earth, the Petroglyphs, and all People, with truth, honesty, respect, compassion, generosity, humility, and prayer.
Contact: Sonny Weahkee
P.O. Box 82086
Albuquerque, NM 87198
phone: (505) 260-4696
fax: (505) 260-1689
e-mail: sonny@SAGECouncil.org

Seventh Generation Fund

Founded in 1977, the Seventh Generation Fund is the only Native American intermediary foundation and advocacy organization dedicated to promoting and maintaining the uniqueness of native peoples and our nations. The foundation's work has grown in vision and direction over the decades to reach indigenous community-based projects with a dynamic integrated program of issue advocacy, small grants, technical assistance, management training, and leadership development.
Contact: Christopher H. Peters
P.O. Box 4569
Arcata, CA 95518
phone: (707) 825-7640
fax: (707) 825-7639
website: www.7genfund.org

Other National and Regional Organizations

American Indian Policy Center
749 Simpson Street
St. Paul, MN 55104
phone: (651) 644-1728
fax: (651) 644-0740
website: www.airpi.org

American Indian Ritual Object Repatriation
Foundation
463 East 57th Street
New York, NY 10022
phone: (212) 980-9441
fax: (212) 421-2746
website: www.repatriationfoundation.org

Apache Survival Coalition
P.O. Box 1237
San Carlos, AZ 85550
phone: (520) 475-2543

Association on American Indian Affairs
Box 268
Sisseton, SD 57262
phone: (605) 698-3998
fax: (605) 698-3316
website: www.indian-affairs.org

Cultural Conservancy
P.O. Box 72086
Davis, CA 95617
phone: (916) 759-2285
fax: (916) 759-2268
website:
www.rahunzi.com/costano/CulturalConservancy.html

First Nations Development Institute
11917 Main Street
Fredericksburg, VA 22408
phone: (540) 371-5615
fax: (540) 371-3505
website: www.firstnations.org

Honor the Earth
2801 21st Avenue South
Minneapolis, MN 55407
phone: (800) 327-8407
fax: (612) 278-7162
website: www.honorearth.com

Indian Law Resource Center
602 North Ewing Street
Helena, MT 59601
phone: (406) 449-2006
fax: (406) 449-2031
website: www.indianlaw.org

Montana Wilderness Association
P.O. Box 635
Helena, MT 59624
phone: (406) 443-7350
www.wildmontana.org=

National Congress of American Indians
1301 Connecticut Avenue NW, Suite 200
Washington, DC 20036
phone: (202) 466-7767
website: www.ncai.org

National Religious Partnership for the Environment
1047 Amsterdam Avenue
New York, NY 10025
phone: (212) 316-7441
fax: (212) 316-7547
website: www.nrpe.org

National Tribal Environmental Council
2221 Rio Grande Blvd. NW
Albuquerque, NM 87104
phone: (505) 242-2175
fax: (505) 242-2654
website: www.ntec.org

Native American Rights Fund
1506 Broadway
Boulder, CO 80302
phone: (303) 447-8760
fax: (303) 443-7776
website: www.narf.org

Northern Plains Resource Council
2401 Montana Avenue, Suite 200
Billings, MT 59101
phone: (406) 248-1154
fax: (406) 248-2110
website: www.nprcmt.org

CONTRIBUTORS

Charles E. Little, founder and director of Liveoak Editions, wrote the foreword to this volume and the chapters on the sacred lands of the West Coast. He is the author of many influential books on the natural environment, most recently *The Dying of the Trees,* a finalist for the *Los Angeles Times* Book Prize, and *Discover America: The Smithsonian Book of the National Parks.* He has served, over the years, as executive director of the Open Space Institute, senior associate at the Conservation Foundation, head of natural resources policy research at the Library of Congress, and president of the American Land Forum.

Jake Page covered the southwestern sites in this book. He is former editor of *Natural History,* science editor of *Smithsonian,* and start-up editor of *Smithsonian Air & Space,* as well as founder and director of Smithsonian Books, the institution's popular book publishing program, since deceased. With his wife, Susanne (picture editor for this volume), he has produced the books *Hopi, Navajo,* and *Field Guide to*

Southwestern Indian Arts and Crafts. He is an essayist, science writer, mystery writer, and among his forty books, several have dealt in detail with Indian history and mythology, including *Wild Justice* and *The Mythology of Native North America.*

David Muench served as principal photographer for this volume. Muench is the premier photographer of western landscapes and he has photographed more than forty books, among which are several on American Indian themes, including *Images in Stone* and *Ancient America.* Other volumes have illuminated the beauties of entire states, such as New Mexico and Arizona. His photographs have appeared in exhibitions in such venues as New York City and Los Angeles, and his one-man shows include the exhibit on the Lewis and Clark expedition at the Jefferson Expansion Memorial in St. Louis.

Ruth Rudner wrote the chapters on the sacred Indian sites of the plains and Northern Rockies, as well as Minneapolis. Her many books have focused chiefly on the celebration of place: they include the Sierra Club's *Bitteroot to Beartooth* as well as *Off and Walking, Greetings from Wisdom, Montana, Forgotten Pleasures,* and most recently, *A Chorus of Buffalo.* Her work has appeared in a number of magazines and newspapers ranging from *Wilderness* to *The Wall Street Journal.*

The essayists in this volume, Paula Gunn Allen, Rennard Strickland, and James Park Morton, are described on the first page of their respective essays.

The surging waters of Kootenai Falls in Montana are sacred to the Salish

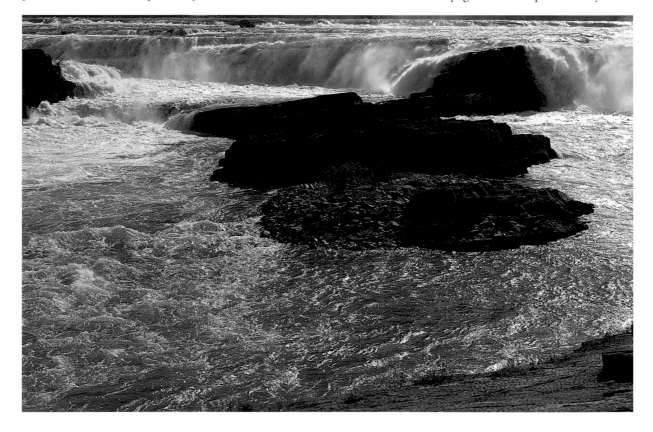

AN APPRECIATION

This book has been brought to publication through a generous grant to Liveoak Editions by the Pleasant T. Rowland Foundation; by donations to the project from Arnold and Katherine Sparnins, Rosewitha Augusta, Casey Coates Danson, David Muench, Sylvan and Mary Ann Dawson, Ila and Charles Little, Ted Danson, Jake and Susanne Page, Wallace H. Rowe III, and Tom and Virginia Suzuki; and by additional contributors via the Liveoak Associates program.

Liveoak's editors and staff are sincerely grateful for this support, and for the privilege of working with the Native American organizations which have co-sponsored the project: the Indigenous Environmental Network, the Indigenous Women's Network, the Native American Land Conservancy, the SAGE Council, and the Seventh Generation Fund.

Liveoak Editions also wishes to acknowledge, with thanks, those individuals who provided information and inspiration to the authors of this book. They are Jeannie Alderson, Jim Anderson, John Anderson, Lisa Bellanger, Joe Benitez, Michelle Berditschevsky, Susan Hope Bower, Rodger Boyd, Bob Brown, Lou Bruno, Floyd Buckskin, Mary Ellen Capek, Tarren Collins, the late Ken Cooper (Cha-das-ska-sum), M. Lynne Corn, Lois Sweet Dorman, Tommy Edwards (Xwám-ik-sten), Tom Goldtooth, Mark Good, Fred Harris, Johnny Jackson, Fred Kootswyrewa, Fred Kruegcr, Eli Lee, James Leon, Leland Little Dog, Arvol Looking Horse, Marcus Lopez, James Main Sr., Donald Mazzola, Christopher (Toby) McLeod, Shelley Means, Joe Medicine Crow, Dean and Theresa Mike, Ina Nez Perce, Christopher H. Peters, Agnes Baker Pilgrim, Paul Pommier, Elaine Quiver, Kurt Russo, Joe Sando, Emory Sekaquaptewa, Clifford Long Sioux, Zane and Sandra Spang, Dean Stiffarm, Robin D. Strathy, Dean Suagee, Dalton Taylor, George F. Thompson, Clifford E. Trafzer, Mary Trejo, Mark and Rhonda Vigil, Curly Bear Wagner, Sonny Weahkee, Edward Wemytewa, Dennis and Bonnie White, and Robert Witzman.

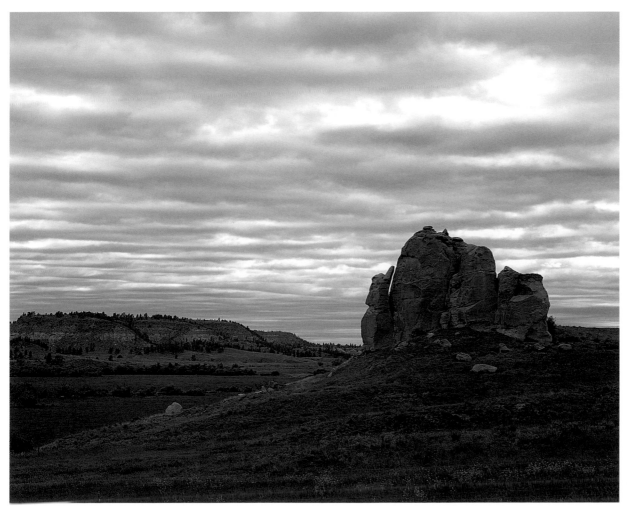

Montana's Deer Medicine Rock, where Sitting Bull had his vision, is protected on privately owned land.

PICTURE CREDITS

THE SACRED LAND FILM PROJECT

Photographs are by David Muench unless otherwise noted.

6–7 Susanne Page; 9 Susanne Page; 12, 13 Dale O'Dell; 14–15 Dale O'Dell; 19 Charles E. Little; 20 Steve Warble; 21 *(top)* James P. Blair, National Geographic Society; 21 *(bottom)* Tom and Pat Leeson; 24 *(left)* Wendy Shattil/Bob Rozinski; 24 *(right)* Tom and Pat Leeson; 25 Kevin Vandivier; 26 Tom Bean; 28–29, 30 Stephen Trimble; 31 William Stone; 32–33 William Stone; 33 William Stone; 36 *(both)* Peter Marbach; 37 Steve Warble; 38–39 Tom Bean; 40 Michael Crummett; 41 *(bottom)* Ted Wood; 52–53 George Wuerthner; 54–55 George Wuerthner; 57 Steve Warble; 58–59 Michael Crummett; 60 George Wuerthner; 62 George Wuerthner; 67 Charles E. Little; 70–71 William Stone; 72–73 George H. H. Huey; 76–77 Chuck Haney; 78 Michael Crummett; 79 Chuck Haney; 80 George Wuerthner; 81 George Wuerthner; 84 David Conklin; 85 David Conklin; 86 Charles E. Little; 87 George Wuerthner; 88–89 Susanne Page; 90 Susanne Page; 91 Tom Bean; 109 *(bottom)* Tom Bean; 110–112 Layne Kennedy; 113 Layne Kennedy; 114 Susanne Page; 115 Layne Kennedy; 120 *(left)* Charles E. Little; 130 Stephen Trimble; 135 Tom Bean; 139 Michael Crummett

The editors are grateful to the following people and photographic agencies for their cooperation in helping illustrate this book: Wendy Glassmire and Neil Philip of the National Geographic Image Collection, Bernadette Rogus, AGPix, Paul Conklin, The Guilfoyle Report, Adventure Photo and Film, Bruce Selyem, and the Viesti Collection.

In the Light of Reverence, a 72-minute documentary on the struggle to preserve sacred sites (broadcast nationally on the PBS "POV" series), is available for use by educators and activists as well as public television airing. Produced by award-winning filmmaker Christopher McLeod and narrated by Peter Coyote, *In the Light of Reverence* tells the stories of three communities and the sacred lands they care for, juxtaposing portraits of Hopi, Wintu, and Lakota elders on the spiritual meaning of place with interviews of non-Indians who have their own ideas about how best to use the land. A project of Earth Island Institute, the documentary is distributed by Bullfrog Films (1-800-543-3764). To contact the producer, write Sacred Land Film Project, P.O. Box C-151, La Honda, CA 94090. Or check the project's website (www.sacredland.org), which provides complete information on the film and follow-up educational activities being conducted in cooperation with Liveoak Editions and others. *In the Light of Reverence* is a presentation of the Independent Television Service in association with Native American Public Telecommunications with funding provided by the Corporation for Public Broadcasting.

SELECTED FURTHER READING

Anderson, Gary Clayton. *Little Crow, Spokesman for the Sioux.* St. Paul: Minnesota Historical Society Press, 1986.

The story of the complicated interrelations of Indian and white culture, need, and sensibility is personified by Little Crow, the Dakota leader forced into a policy of accommodation that could, ultimately, never work for Indian people.

Basso, Keith H. *Wisdom Sits in Places: Landscape and Language Among the Western Apache.* Albuquerque: University of New Mexico Press, 1996.

A personal, spiritual exploration of the Apache sense of place and the language of place and meaning in life, by a noted and prize-winning ethnographer who is also a writer of surpassing skill. Basso's other ethnographic works are among the most accessible means of entering the world of the Apaches.

Black Elk Speaks. As told through John G. Neihardt Lincoln: University of Nebraska Press, 1972.

The religious classic—first published in 1932—this book is a kind of bible for anyone interested in Plains Indian spirituality.

Blackburn, Thomas C., ed. *December's Child: A Book of Chumash Oral Narratives.* Berkeley: University of California Press, 1975.

Classic presentation of Chumash legends, based on material collected by the famed Smithsonian ethnographer, John Peabody Harrington, between 1912 and 1928. For a brief but authoritative overview of Chumash history and culture, see Robert O. Gibson's *The Chumash*, Chelsea House, 1991.

Carlson, Paul H. *The Plains Indians.* College Station: Texas A&M University Press, 1998.

An examination of the culture, economy, and evolution of the Plains tribes from the first white contact in the mid-eighteenth century to the late nineteenth century, when most Plains Indians were living on reservations.

Courander, Harold. *The Fourth World of the Hopis: The Epic Story of the Hopi Indians as Preserved in Their Legends and Traditions.* Albuquerque: University of New Mexico Press, 1987.

Probably the best rendering in English of the main events of the Hopi creation story and their history up to the beginning of the twentieth century. Written by a noted folklorist and novelist, it is considered by most Hopis to be accurate and appropriate (unlike Frank Waters' *Book of the Hopi*, which most Hopis dislike). Other valuable books about the Hopi are Snake Clan member Alph Secakuku's book on the annual kachina cycle, *Following the Sun and Moon* (published by Northland Publishing in Flagstaff, Ariz., 1995) and Susanne and Jake Page's *Hopi* (Abrams, 1982), a rare photographic view of modern Hopi life.

Gulliford, Andrew. *Sacred Objects and Sacred Places.* Boulder: University Press of Colorado, 2000.

A thorough study of sacred places via native oral histories and commentaries by archeologists and curators concerned with cultural preservation. It describes problems, resolutions, and necessary compromises and is an extraordinary source for any person interested in sacred matters.

Horse Capture, George, ed. *The Seven Visions of Bull Lodge, as Told by His Daughter, Garter Snake.* Gathered by Fred P. Gone. Lincoln: University of Nebraska Press, 1992

This record of the spiritual life of Bull Lodge, a Gros Ventre spiritual leader and healer, offers insight into Gros Ventre traditional life.

Hull, Fritz, ed. *Earth and Spirit.* New York: Continuum, 1993.

In a crowded field of essay-anthologies on earth spirituality and the role of organized religion in caring for "the Creation," Hull's book stands out. Notably, the book contains essays by the late Cha-das-ska-dum, writing as Ken Cooper (see page 17), and by the Very Reverend James Parks Morton (see page 122).

Hunn, Eugene S. *Nch'i-Wána, "The Big River": Mid-Columbia Indians and Their Land.* Seattle: University of Washington Press, 1990.

The classic ethnographic study of "The River People," the Indians who lived (and still do) along the Columbia River of the Northwest in its broad middle course. Hunn, a University of Washington anthropologist, undertook the study with the cooperation of James Selam, a Columbia River Indian elder, and his family.

Josephy, Alvin M., Jr., Joane Nagel, and Troy Johnson. *Red Power,* 2nd ed. Lincoln: University of Nebraska Press, 1999.

A documentary history of the American Indian activist movement from the 1960s through the end of the twentieth century. Selections are organized around major issues, including cultural traditions and spirituality.

Medicine Crow, Joseph. *From the Heart of Crow Country.* Lincoln: University of Nebraska Press, 2000.

The first Crow Indian to earn a graduate degree, Joseph Medicine Crow has spent his long life combining Crow historical methods with western anthropology. This wonderful book of stories is one result of a life's work.

Ruby, Robert H., and John A. Brown. *John Slocum and the Indian Shaker Church.* Norman: University of Oklahoma Press, 1996.

A history and explanation of "Shakerism," an American Indian religion established in the Northwest in the late 1800s by John Slocum with some of the trappings of Christianity, but also non-Biblical Native beliefs including a strong association with sacred lands and the origin stories concerning them. The Indian Shaker Church has nothing to do with the Shakers of the American Northeast.

Sando, Joe S. *Pueblo Nations: Eight Centuries of Pueblo Indian History.* Santa Fe, N.M.: Clear Light Publishers, 1992.

A rare and lucid look at the long history of the nineteen Rio Grande Pueblos by an accomplished historian and member of the Sun Clan at Jemez Pueblo, this book is where one needs to start to pursue an understanding of the origins and persistence of Pueblo civilization.

Strong, David. *Crazy Mountains.* Albany: State University of New York Press, 1995.

Here is a passionate plea from a philosopher who knows the Crazies intimately and uses them to present the challenge offered by the sacred values of wilderness to American culture.

Swan, James, and Roberta Swan. *Dialogues with the Living Earth.* Wheaton, Ill.: Quest Books, 1996.

Contains an excellent chapter, "The World Needs This Mountain," by Michelle Berditschevsky and Charles M. Miller, on the 25-year-long struggle to preserve Mount Shasta, the great sacred mountain in California. Northern California Indians hold Shasta to be the "center of the physical, cultural, and spiritual universe." Since 1978, efforts to exploit the mountain by recreational developers have threatened the integrity of Shasta as a sacred landscape.

Trafzer, Clifford E., Luke Madrigal, and Anthony Madrigal. *Chemehuevi People of the Coachella Valley.* Coachella, Calif.: The Chemehuevi Press, 1997.

Indian historian and writer Clifford Trafzer (University of California at Riverside) presents a tribal history of the Twenty-Nine Palms Band of Mission Indians and other Chemuhuevi people of the Coachella Valley (in which Palm Springs is the best-known city). Trafzer's objective, as part of a general economic and cultural renaissance of the Chemehuevis, is to provide an accurate history of the people based on oral accounts.

Vecsey, Christopher, ed. *Handbook of American Indian Religious Freedom.* New York: The Crossroad Publishing Company, 1993.

A collection of writings by Indians, scholars, and lawyers, this book identifies areas in which Indian spiritual practices are undermined by federal, state, and local practices and law, and suggests remedies.

Zolbrod, Paul G. *Dine Bahane: The Navajo Creation Story.* Albuquerque: University of New Mexico Press, 1984.

In all its poetry, adventure, heroics, humor, ribaldry, and drama, this astounding story, told in English with the help of numerous Navajo people, is what might well be the only true American epic. Gladys Reichard's *Navajo Religion* (University of Arizona Press, 1983) remains as rich and rewarding a look at Navajo spiritualism as it was when it first appeared in 1974.

INDEX